ZACK
STARK

The PHANTOM of the OPERA

25th Anniversary Edition

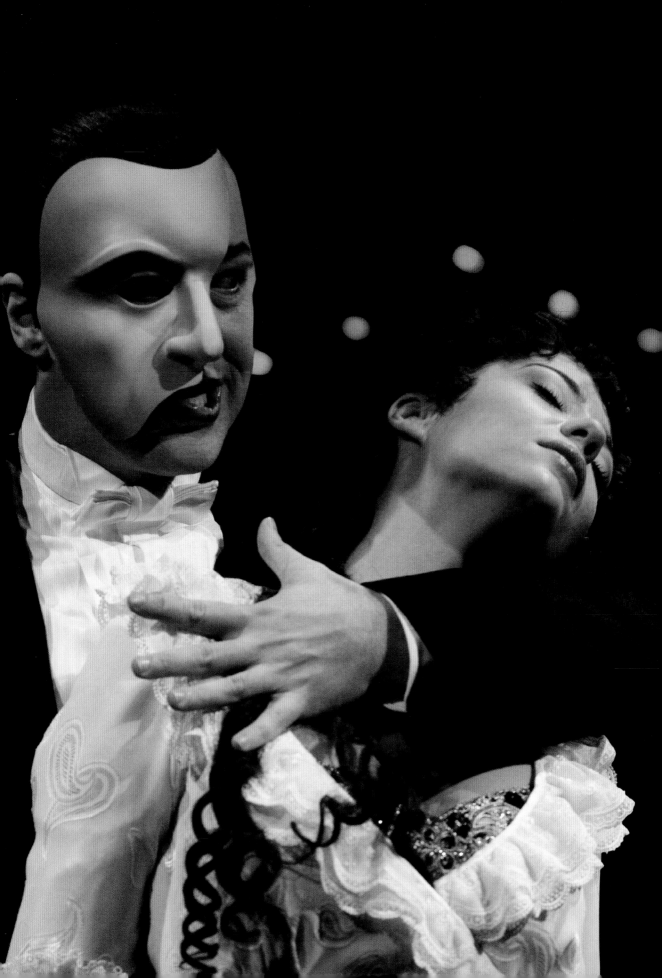

The
PHANTOM
of the
OPERA

25th Anniversary Edition

Michael Heatley

PAVILION

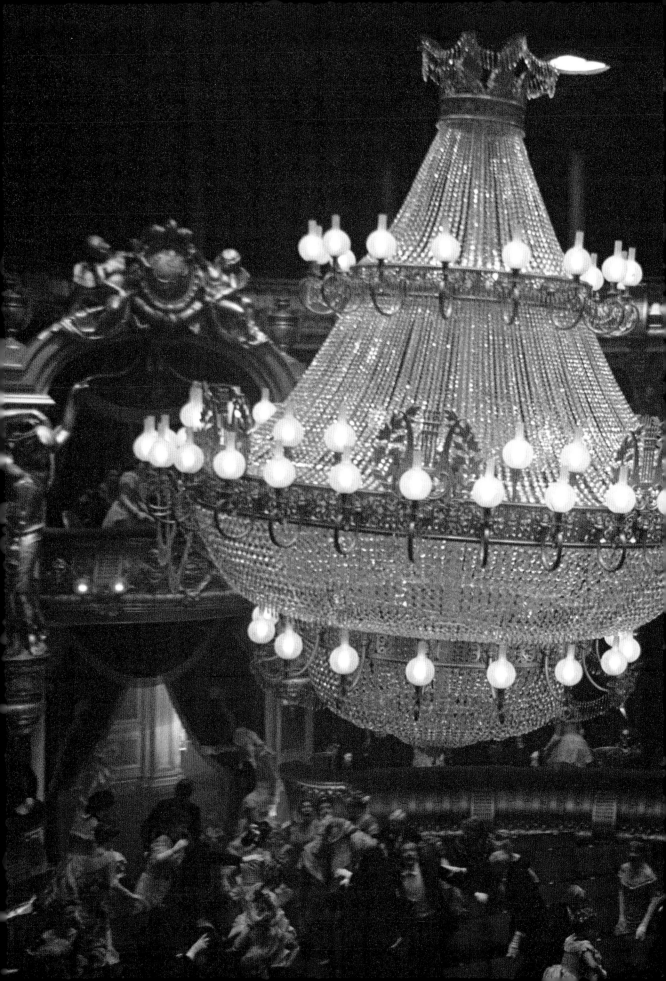

CONTENTS

These pages and previous: Iconic scenes from
the well-loved story. The Phantom and Christine on stage,
London production 2011; the chandelier falls, a scene from the 2004 film.

FOREWORD

ANDREW LLOYD WEBBER

"'Masked balls'. These were the only words uttered by the London *Sunday Times* Drama Critic when he reviewed *The Phantom of the Opera* twenty-five years ago. Most composers, let alone producers, would be suicidal to receive a review like that in a major newspaper. But Cameron Mackintosh was chortling into his toast when he phoned me on that Sunday breakfast time just a few days after we had opened. In fact, he temporarily choked on it.

Like *Cats* a few years before, nothing any reviewer said could remotely alter the fact that *Phantom* had chimed with its audience and was unstoppable. Just like *Cats*, *Phantom* did not get great across the board reviews. They were wildly polarised between those who really did or really wouldn't surrender to the music of the night. But unlike even *Cats*, whose first previews were thrilling but bumpy, the audience reaction to *Phantom*'s first preview suggested an unstoppable hit was in our hands. Hal Prince, our brilliant showman director, was so sure that he jokingly suggested that we all take a holiday and came back for opening night.

Although it's true that *Phantom* is the only show I have ever been involved with that was entirely unchanged during previews, I wish I could say I truly had the best time of my life during those heady days.

Two years before I had married Sarah Brightman, the ex-Hot Gossip girl who had a huge hit with 'Starship Trouper'. Notwithstanding that she had fantastic reviews for the Charlie Strouse opera *Nightingale* at the Lyric Theatre, Hammersmith, everyone was ready to snipe and say that she only got the role of Christine because she was my wife. When in previews she got ill and missed a performance, the chattering started big time. I shudder to think what would have happened if the Net had been around with its malicious and often fake or professional bloggers.

Big opening nights, even when you feel sure you have the public with you, are when you feel your most vulnerable, the night that you want your

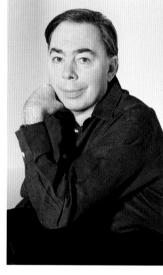

Above:
Andrew Lloyd Webber.

Opposite: Sarah Brightman as Christine in the original London production of *The Phantom of the Opera*, 1986.

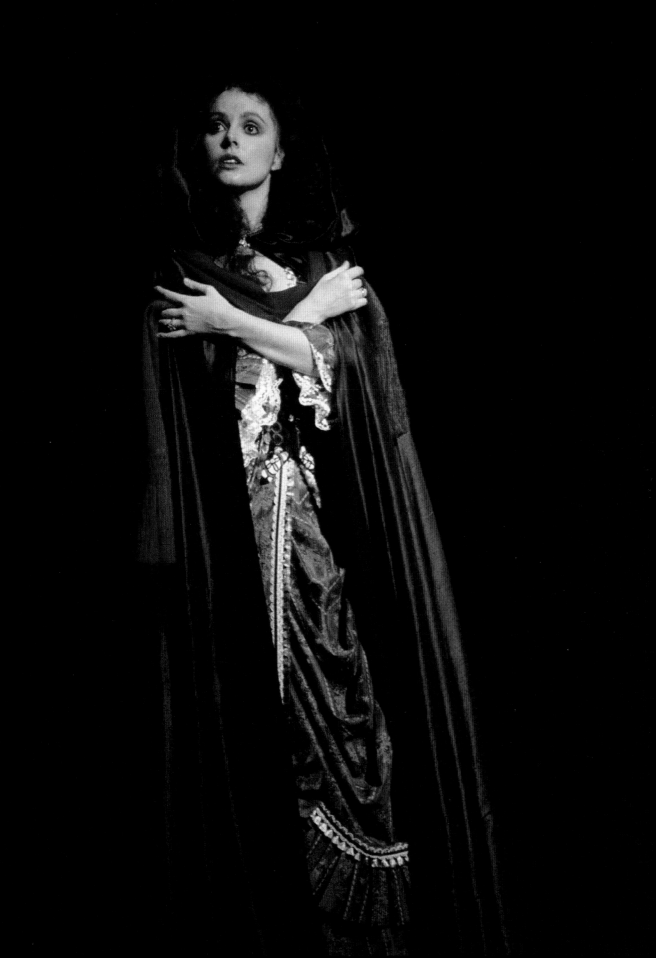

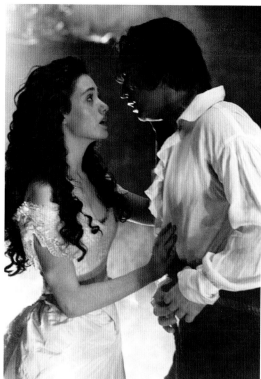

closest loved ones around you. But when your loved one is a woman who is perceived by even some of your closest friends to have broken a marriage and she is playing the leading role in your new musical (having previously been a kitten in the world's then biggest musical, *Cats*), goodness knows I felt alone and frightened whilst all around were celebrating. I couldn't even bear to sit through the show. Cameron brought me back to the theatre to see the curtain calls.

So when I read the first review, that of the late Jack Tinker of the *Daily Mail*, in which he said that he could think of no other actress than Sarah who could have premiered the role, frankly I cried. I had to wake Sarah up to show her. Jack in those days was the most powerful and respected critic of musicals. His continued support for Sarah and the show is something I will always cherish.

Of course the only Achilles heel that we had on our move to Broadway was Sarah. It was such a blindingly easy way to get to me. There was the refusal of American Equity to allow the girl without whom there would have been no *Phantom* to play the role on Broadway. And of course the hurtful fact that she was the only major ingredient of the show not to be nominated for a Tony. I felt

Above: Emmy Rossum as Christine and Gerard Butler as the Phantom in the 2004 film.

Above left: Poster celebrating the 25th anniversary of the London stage production, 2011.

– 9 –

Right: Michael Crawford, Sarah Brightman and Andrew Lloyd Webber on a publicity trip to the Opéra Garnier in Paris – also known as the Palais Garnier, after architect Charles Garnier – in 1986.

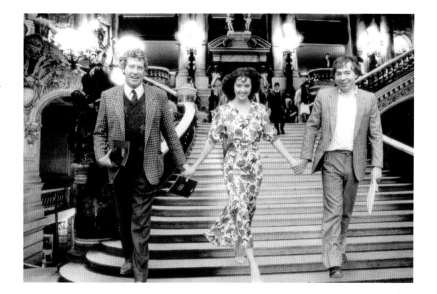

Sarah's slight as if it were directed at me. Jack Tinker continued his championing of Sarah when he wrote after the Tonys that Sarah was the real Tony Award winner with a performance like precious porcelain.

But all of that is nearly twenty-five years ago. I am struck when I look at the phenomenon that *Phantom* became, how perilously small is the fine line between success and failure in musical theatre. What if Maria Bjornson hadn't designed the show? Would another choreographer have understood the period and style as Gillian Lynne did, in her brilliantly understated way?

Hal Prince is the master showman of the last four decades of musical theatre. *Phantom* truly has a huge element of hokum. Would a director who tried to intellectualise the story rather than simply direct it for real have brought the whole fragile edifice crashing down along with the chandelier? And would any other producer than Cameron Mackintosh have the chutzpah to pull the whole confection into life? I remember one potential director said to Cameron and I that the opening 'chandelier moment' could never work.

I believe that it is the most theatrical moment that I have ever conceived, a moment that can only be achieved in live theatre.

Love, passion and live theatre are what *Phantom* is all about. I am profoundly grateful that my masked balls struck such a deep chord throughout the world. I still get goosebumps every time that chandelier comes alive like some alien spaceship and infuses the theatre with something that only happens when design, direction and music are completely at one."

ALW, June 2011

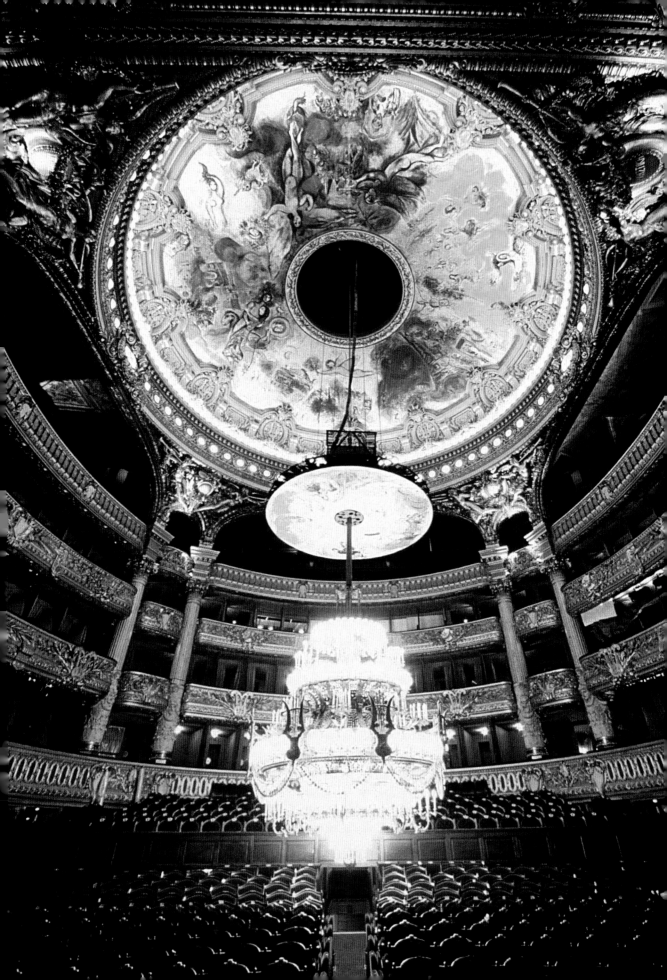

ACT I

"Gaston Leroux pillaged his story from all over the place, from the tale of Paganini at one point; from every conceivable penny dreadful. But actually deep inside it somewhere is a marvellous confection that works brilliantly."

Andrew Lloyd Webber

Opposite: Auditorium of the Opéra Garnier in Paris, including its enormous chandelier, restored in 1996.

THE FIRST STORY

The novel grabs the reader from the very start. "The Opera ghost really existed. He was not, as was long believed, a creature of the imagination of the artists, the superstition of the managers, or a product of the absurd and impressionable brains of the young ladies of the ballet, their mothers, the box-keepers, the cloak-room attendants or the concierge. Yes, he existed in flesh and blood, although he assumed the complete appearance of a real phantom; that is to say, of a spectral shade."

Those who knew Gaston Leroux well were aware of the author's darker side – one preoccupied with the mysteries of death, the afterlife and reincarnation. This had been reinforced when he returned to the house where he was born only to discover that it was, in fact, an undertaker's shop. In his own words, "There, where I sought a cradle, I found a coffin."

The author of the novel *The Phantom of the Opera* came into the world on 6 May 1868. His birth was every bit as unconventional as the rest of his life proved to be. His parents were travelling from Le Mans to their home in Normandy when, while changing trains in Paris, Marie-Alphonsine went into labour and was taken to a nearby house to give birth. A baby boy was safely delivered and was given the name Gaston Louis Alfred Leroux.

He was raised in Normandy, spending much of his childhood in St Valéry-en-Caux where his family was involved in the shipbuilding industry. As a young boy he loved nothing more than to sail in fishing boats and help bring in the herring catch. He was educated at a local grammar school and developed a love of literature, writing poems in his spare time, for which he won several awards. His parents and teachers thought that he would make an excellent lawyer and, on successfully achieving his baccalaureate, he was sent to Paris to study law.

He never gave up his love of short stories and poetry, however, and while a student Leroux submitted his writing to Left Bank magazines. Major success finally came when *L'Echo de Paris* published a sonnet he had written as an

Above: Gaston Leroux (1868–1927), author of *Le Fantôme de l'Opéra* (1911).

Opposite: Bomb attack by the anarchist Auguste Vaillant, 1893, whose trial Leroux covered.

Le Petit Journal

TOUS LES JOURS
Le Petit Journal
5 Centimes

SUPPLÉMENT ILLUSTRÉ
Huit pages : CINQ centimes

TOUS LES VENDREDIS
Le Supplément illustré
5 Centimes

Quatrième Année SAMEDI 23 DÉCEMBRE 1893 Numéro 161

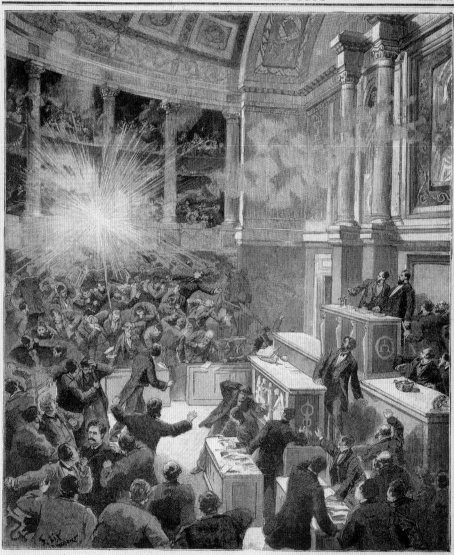

LA DYNAMITE A LA CHAMBRE
L'EXPLOSION

ode to a leading Parisienne actress. It was clear that his heart was no longer set on a career in the legal profession.

In 1889, the year that Leroux gained his law degree, his father died, leaving him a million francs – a substantial fortune, especially for someone so young. Leroux managed to fritter away much of it inside a year, indulging in his passion for drink, gambling and unsuccessful speculations. Paris was at that time the centre of the Belle Époque, and the Latin Quarter in particular was the place to be for a young aspiring writer with a love of good food, fine wine and the theatre. The young Leroux was known for his sense of fun. Realising he could no longer sustain the lifestyle of a bon viveur without an income, and dissatisfied with his work as a lawyer, Leroux gained a position with *L'Echo de Paris*, the newspaper that had previously published his poetry. His legal training enabled him to cover trials in the Paris courts and one notable report, on the trial of the anarchist Auguste Vaillant, was so well received that the respected daily *Le Matin* offered him a position. This gave him the opportunity to exercise his abilities as an investigative journalist, fast becoming his greatest strength.

It was in this role that he achieved one of his finest scoops: the interview of a prisoner held on remand for a serious crime and facing the death penalty. By forging papers showing himself to be a prison anthropologist, he gained access to the man, conducting an interview that formed the basis of an in-depth article showing him to be innocent. It was a dangerous thing to do, as Leroux ran the risk of being caught and charged with forgery, but in the eyes of the public it was a triumph and, more importantly, a thrilling story.

Leroux had the ability to get on with people, no matter what their position in life. It was a skill invaluable to a journalist, and he was soon being applauded for his daring and dramatic scoops and exclusive interviews with the rich and famous. There were elements of reporting, however, that he found extremely unpleasant, in particular covering executions by guillotine. For Leroux, the first of these was that of Auguste Vaillant, whose trial he had covered with such success, and it was this that turned him into a lifelong opponent of capital punishment – an unusually liberal view in nineteenth-century France.

Below: Poster for *Le Matin* by Henri de Toulouse-Lautrec, 1893. As a young man in Paris Leroux funded his indulgence in the pleasures of the demimonde by becoming a reporter on this newspaper.

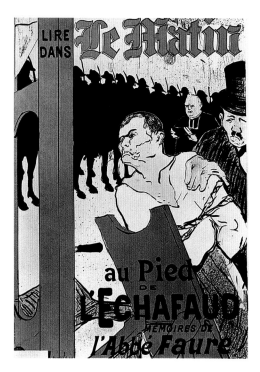

Right: Execution of Vaillant outside the depôt des condamnés, rue de la Roquette, 11 February 1894. Leroux covered the event for *Le Matin*, in the process becoming an opponent of the death penalty, despite his interest in the macabre.

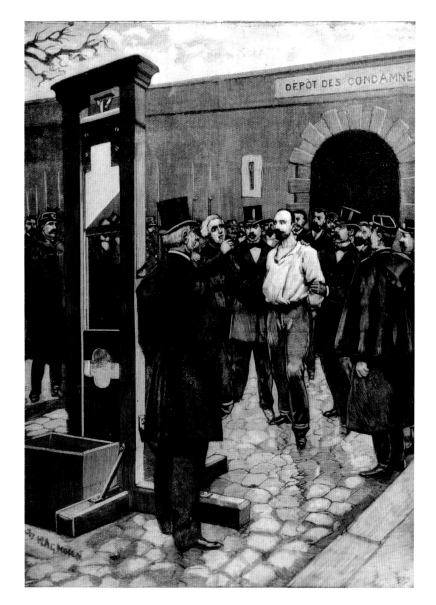

He was eventually promoted to a role as roving reporter, travelling the world covering the big stories of the day. New and faster communications, such as the telegraph, had changed the face of journalism and he travelled across Europe, Russia, Asia and Africa, frequently wearing disguise to pursue a good story for the readers back home. His adventures resulted in exciting, dramatic and entertaining copy – so much so that Leroux himself became something of a celebrity. Gaston Leroux was the readers' eyes and ears at world events, running great risks to perform that role. He witnessed Turks slaughtering Armenians, the Russians fighting the Japanese, rioting in Odessa and St Petersburg and the bloody violence that followed, and,

dressed as an Arab, he was the only Westerner present at the riots in Fez. He even stood in the crater of Vesuvius as it erupted.

"No one can equal the reporter's zest for life," he announced, "since nobody else possesses such a delight in observation…The reporter watches on the world's behalf, he is a spy-glass of the world. Oh, how I love my profession!"

This delight was not to last, however. Shortly after returning from a particularly gruelling foreign assignment, his editor rang at 3am to tell him to take the night train to Toulon where a French battleship had been damaged in an explosion. His response was to bellow "Oh shit!" and slam the phone down, ending his illustrious journalistic career at a stroke.

Leroux decided to become a full-time novelist. His first book, *The Seeking of the Morning Treasures* (1903), was based on the real-life adventures of eighteenth-century robber Louis Cartouche. The story was serialised in *Le Matin*, and was well received by the readership – particularly after the newspaper hid seven hoards of treasure, one worth seven thousand francs, around Paris for readers to find from clues hidden in the story.

It was *The Mystery of the Yellow Room* (1907) that justified Leroux's decision to leave journalism. An early example of a 'locked room' mystery, in which a murder is committed behind seemingly impenetrable doors, it was an homage to two writers he greatly admired, Edgar Allan Poe and Sir Arthur Conan Doyle. The hero, a Gallic version of Sherlock Holmes called Joseph Rouletabille, was presented with a problem as perplexing as any faced by the English detective, and the story showed the author's talent for clear, logical thought. Rouletabille appeared in seven more novels.

Leroux was also an admirer of literary greats including Stendhal, Dumas and Victor Hugo, writing *The Mystery King* (1908) as tribute to Dumas and

Opposite: Gaston Leroux interviews a soldier at the arrival of the 'March of the Army', 29 May 1904.

Below: Workers march through St Petersburg, 1905. Leroux's position as a roving reporter took him as far as pre-revolutionary Russia, from where he reported on this story and the riots in Odessa.

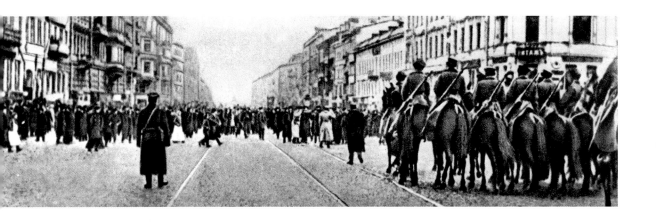

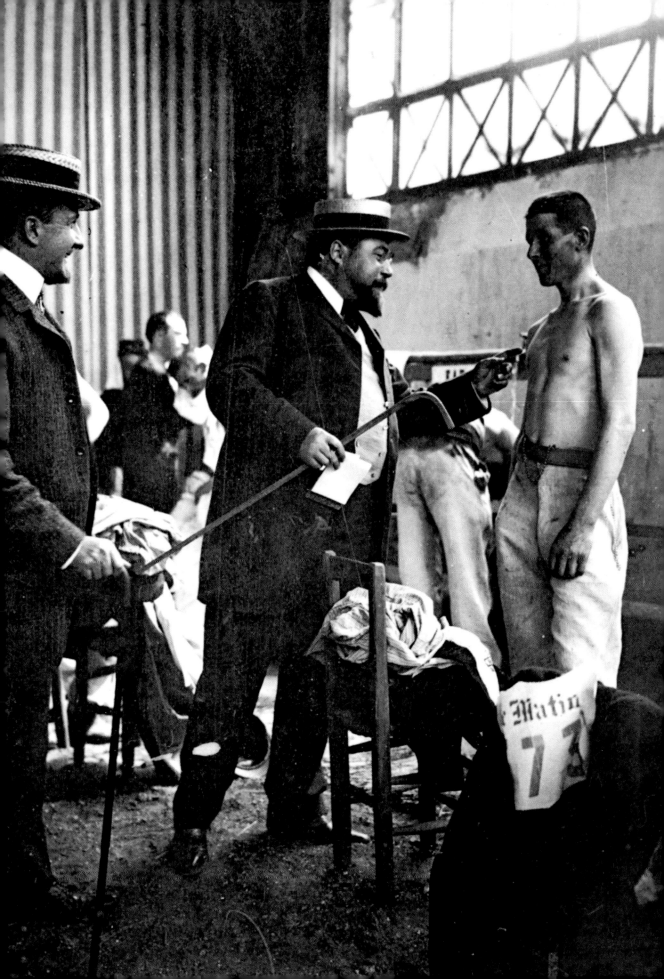

Above: Book covers from the series of adventures of Joseph Rouletabille, which first brought Gaston Leroux success as a novelist. L–R, top to bottom: *Le Mystère de la chambre jaune* (1903; 1908 and 1930 editions shown), *Le Château noir* and *Les Étranges noces de Rouletabille* (1914; 1922 editions shown), *Rouletabille chez Krupp* (1917).

Above: Illustration from the first Joseph Rouletabille novel, *Le Mystère
de la chambre jaune* (first published 1903), by Gaston Leroux.

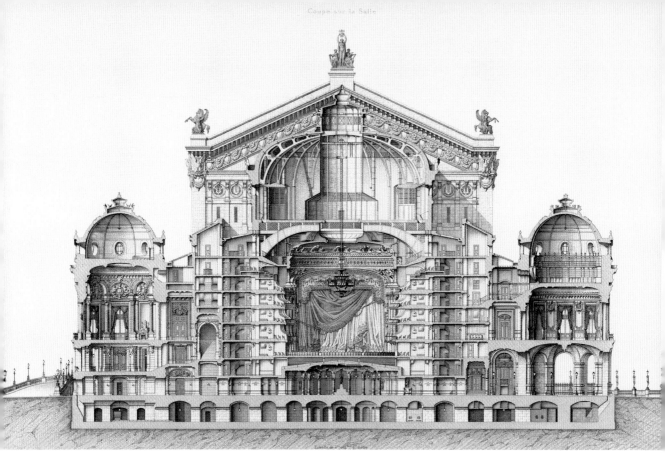

citing Hugo's narrative construction as a great inspiration. He wrote not only detective stories but romances, fantasies and even horror stories – and at a rate of at least one per year.

In 1908 Leroux moved from Paris to Nice where the climate suited him better – and the proximity of the casinos. He was by now a prosperous author, but he was never to be a rich man because of his gambling habit, something he saw as one of life's pleasures. If he lost heavily, he knew he had only to write another book and the debt would be paid. In his own words, "I work only under contract. I have to be pushed by deadlines."

Leroux was also a playwright and, although his first play ran for only ten performances, his subsequent works, including a dramatic adaptation of *The Mystery of the Yellow Room*, were more successful. Several plays were made into films, first as silent movies and later on as talkies. He even formed his own film company in 1919 with René Navarre, an actor famous for his portrayal of a master criminal in the weekly serial *Fantômas*. Leroux wrote a serialised drama for this company called *The New Dawn*, which he also adapted for weekly publication in *Le Matin*. Despite his prolific writing and contemporary fame as a journalist, author and playwright, the larger body of

Above: Cross-section of the Opéra Garnier, 1880. The enormous size of the building, including its cellars, is apparent.

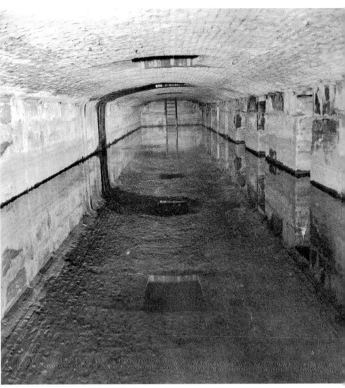

– 21 –

Above: Charles
Garnier (1825–98),
architect of the Opéra
Garnier.

Above right: The
'Grange Batelière'
reservoir beneath
the Opéra Garnier,
site of a natural
subterranean lake.

work by Gaston Leroux is now mostly forgotten. Very few of his books are still
available in print, even in France, and translations are hard to come by.

In 1911 Leroux published the work that was to guarantee his immortal-
ity. Surprisingly, *The Phantom of the Opera* attracted very little attention in
its first few weeks. Leroux claimed it was written after a visit to the Opéra
Garnier in Paris, where he gained access to the lower depths of the building,
the labyrinth of cellars and the mysterious underground lake visible only
through grilles in the floor. He felt it had an atmosphere that would be perfect
as the backdrop to a story. There were still traces of the building's use as a
prison during the Franco-Prussian war: some of the cellars had been turned
into dungeons from which the prisoners had no chance of seeing daylight.
It took little dramatic invention to imagine their plight. Leroux was also
inspired by reports of an horrific accident that had taken place in 1896 when
one of the massive central chandelier's counterweights had fallen into the
audience during a performance, killing a woman below.

He began the book by telling the readers that the Opéra ghost really
existed. The rest of the story was based on that assumption and told as if the
author were presenting his research. Writing in the style of a journalist, he

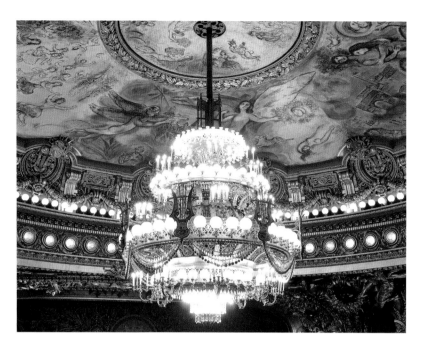

Left: Ceiling mural
by Marc Chagall
(1887–1985), unveiled
in 1964 as a new
addition to Charles
Garnier's interior.

Opposite: View of
the grand staircase,
at the inauguration
of the new Opéra
Garnier, 5 January
1875, marked with
a lavish ball.

put together a variety of documentary items and a great deal of background information, which gave the story a truthful air. Leroux was an exponent of what has become known as the 'faction' style of writing, in which real characters and events are interspersed with fiction to create a seamless story in which the line between reality and fiction becomes blurred.

It is perhaps the journalistic style of the novel, accompanied by sensational images of the Phantom swinging on a chandelier or playing his organ, that made the story better suited to the serialisation it received in the newspapers of France, Britain and the United States. Leroux would not have been unduly worried about the lack of enthusiasm for the novel; after all, he was already well under way with his next book by the time of its publication.

It is likely that *The Phantom of the Opera* would have faded into obscurity, along with most of his other novels, had it not been chosen as the basis of a movie released by Universal Studios in 1925. Both the film and star Lon Chaney's performance in it were to have a massive impact in creating the story's fame.

Leroux lived long enough to enjoy the renewed interest this brought his novel, although his health was already failing by the time of its release. On 15 April 1929 he died unexpectedly, after an operation, and was buried overlooking Nice and the Bay of Angels.

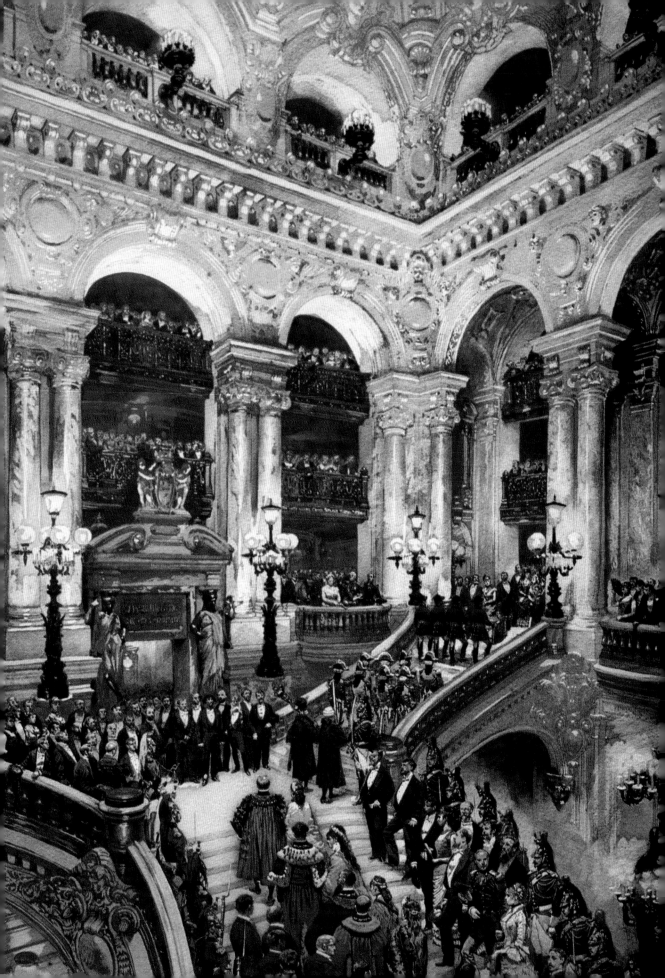

THE NOVEL

GASTON LEROUX BEGINS BY TELLING THE READER THAT THE GHOST
OF THE PARIS OPÉRA REALLY DID EXIST AND THAT HE FOUND
THE EVIDENCE WHILE CARRYING OUT RESEARCH IN THE ARCHIVES OF
THE NATIONAL ACADEMY OF MUSIC.

Opposite: Cover of the first edition of *Le Fantôme de l'Opéra* (The Phantom of the Opera) by Gaston Leroux (1911).

"When I began to ransack the archives…I was at once struck by the surprising coincidences between the phenomena ascribed to the 'ghost' and the most extraordinary and fantastic tragedy that ever excited the Paris upper classes; and I soon conceived the idea that this tragedy might reasonably be explained by the phenomena in question. The events do not date more than thirty years back; and it would not be difficult to find at the present day, in the foyer of the ballet itself, old men of the highest respectability, men upon whose word one could absolutely rely, who would remember as though they happened yesterday the mysterious and dramatic conditions that attended the kidnapping of Christine Daaé, the disappearance of the Vicomte de Chagny and the death of his elder brother, Count Philippe, whose body was found on the bank of the lake that exists in the lower cellars of the Opéra on the Rue Scribe side. But none of those witnesses had, until that day, thought that there was any reason for connecting the more or less legendary figure of the Opéra ghost with that terrible story."

Leroux adds to the journalistic air with tales of how he met a magistrate involved in the case and how he tracked down and interviewed a mysterious Persian who was able to produce documentary evidence, in particular letters from Christine, which he compared to other examples of her handwriting to prove their authenticity.

His story then travels back to the 1880s and we are introduced to Christine Daaé, the talented daughter of a gifted Swedish peasant fiddler. When Christine is six, her mother dies and her father is brought to rural France by a powerful patron, Professor Valerius. During Christine's child-hood, which is described in the early chapters of the book, her father tells her many stories featuring an "Angel of Music" who, like a muse, is

the personification of musical inspiration. Christine is befriended by the young Raoul, Viscount of Chagny, who also enjoys her father's stories, their favourite being one of Little Lotte, a girl with golden hair and blue eyes who possesses a heavenly voice and is visited by the Angel of Music. On his deathbed, Christine's father tells her that he will send the Angel of Music to her from heaven.

After his death, Christine lives with the elderly widow of her father's benefactor. When old enough, she is given a position in the chorus at the Opéra Garnier in Paris. Not long after she arrives, she begins hearing a beautiful, unearthly voice that sings and speaks to her. She believes this must be the Angel of Music. The Voice agrees that he is and offers to teach her "a little bit of heaven's music". The Voice, however, belongs to Erik, a disfigured genius who was one of the contractors who built the opera house and has been living in secret in the cellars. He is the fabled ghost of the Opéra who has been extorting money from the management for many years.

Above: Architectural detail, the Opéra Garnier, Paris.

On the night of a gala performance to celebrate the retirement of the old managers, Debienne and Poligny, leading lady Carlotta is taken ill. Christine is asked to step in and, with the help of the Voice, gives a triumphant performance. Raoul, her childhood friend, is in the audience and remembers his love for her. Backstage he reminds her of their first meeting, but she says she is too unwell to speak to him. Later, still loitering by her dressing room, he hears through the door the voice of a man telling Christine that she must love him. Christine then sweeps out past him, leaving behind an empty room.

The new managers, Richard and Moncharmin, are passed a letter from the Ghost requiring a fee of 20,000 francs per month and the empty box five for every performance. Leroux speculates that the story of this letter, presented by him as an extract from one of the managers' memoirs, is the reason the old management retired – the Ghost's demands were just too unreasonable. Convinced the letter is a hoax, the new managers offer the box to their predecessors for the next performance by Christine. The Ghost (who signs himself O.G.) responds with a letter demanding his allowance and the old managers refuse the offer of the box. Furious, the new managers allow the box to be sold for all performances, which leads to the evening's show being disrupted by maniacal laughter.

The managers call for Madame Giry, the woman in charge of the boxes, and she tells them they have angered the Ghost. She recounts other instances of the Ghost taking revenge, but they think her mad and decide to dismiss her from the Opéra.

Having confided in Raoul her belief that she is being visited by the Angel of Music, Christine makes her way to her father's grave. In the dead of night, she is called there again, as if in a trance, followed by Raoul who hears perfect music that draws them onwards. Suddenly Raoul is attacked by a spectre with a death's head and left unconscious.

The Paris Opéra performs *Faust* and the managers decide to watch the Saturday performance from box five. No sooner have they made this decision than they receive a letter from O.G. ordering the return of Madame Giry, repeating his plea for his money and demanding that Christine replace Carlotta in the lead role. He threatens that if his terms are not met the house will be cursed.

Suspecting a plot by her rival Christine, Carlotta insists on singing, but loses her voice during the performance; she is only able to produce strange, toad-like sounds.

"The house broke into a wild tumult. The two managers collapsed in their chairs and dared not even turn round; they had not the strength; the ghost was chuckling behind their backs! And, at last, they distinctly heard his voice in their right ears, the impossible voice, the mouthless voice, saying:

'She is singing tonight to bring the chandelier down!'

With one accord, they raised their eyes to the ceiling and uttered a terrible cry. The chandelier, the immense mass of the chandelier, was slipping down, coming toward them, at the call of that fiendish voice. Released from its hook, it plunged from the ceiling and came smashing into the middle of the stalls, amid a thousand shouts of terror. A wild rush for the doors followed.

The papers of the day state that there were numbers wounded and one killed. The chandelier had crashed down upon the head of the wretched woman who had come to the Opéra for the first time in her life, the one whom M. Richard had appointed to succeed Mme Giry, the ghost's box-keeper, in her functions! She died on the spot and, the next morning, a newspaper appeared with this headline:

'Two hundred thousand kilos on the head of a concierge!'

That was her sole epitaph!'"

After the chandelier crashes, Erik kidnaps Christine, takes her to his home in the cellars and reveals his true identity. He plans to keep her there only a few days, hoping she will come to love him – and, despite herself, Christine becomes attracted to her abductor. But she causes Erik to change his plans when she unmasks him and, to the horror of both, beholds his face. Furious, he tells her of his despair and love. Fearing she will leave him, he decides

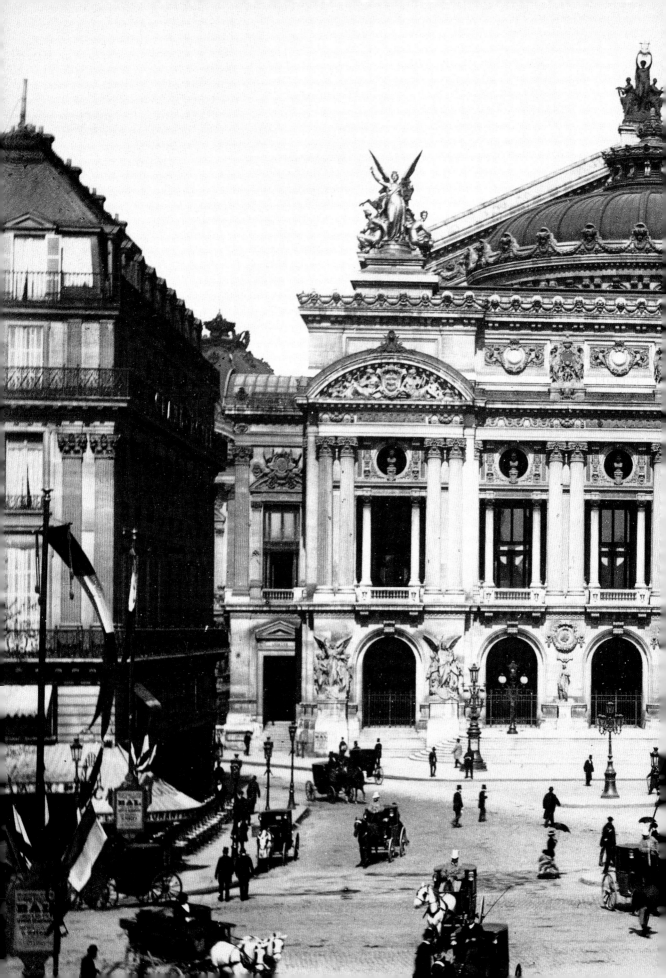

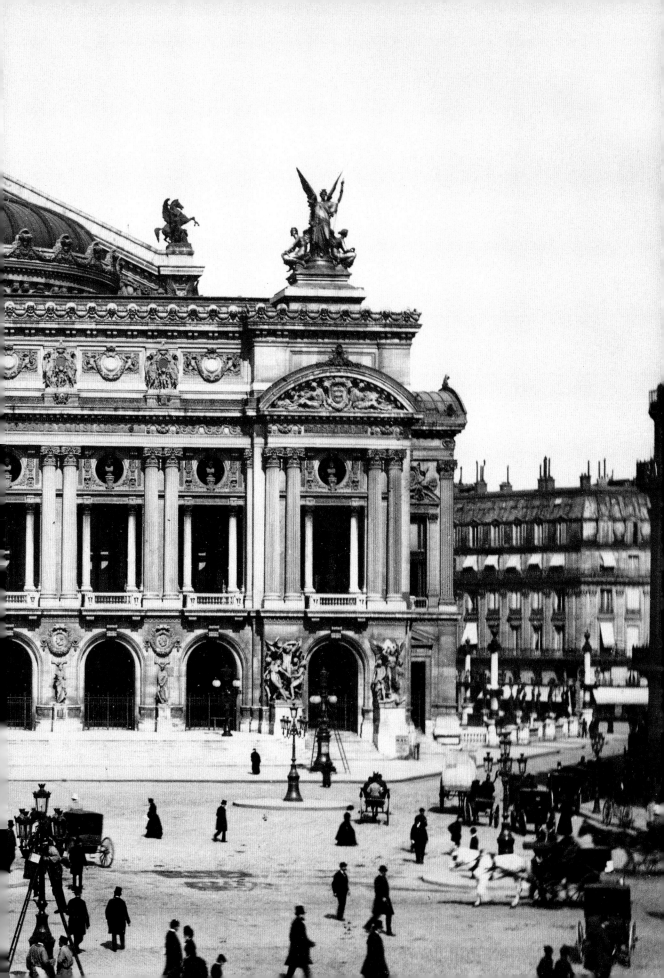

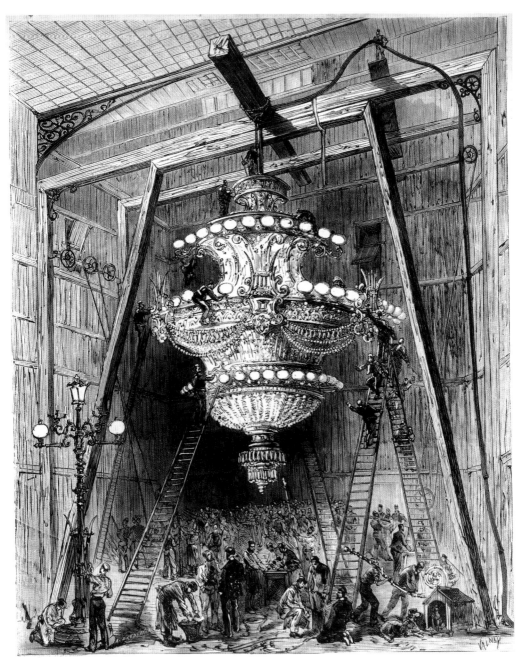

LE NOUVEL OPÉRA. — Les ateliers de construction et de montage du grand lustre de la salle. — (Dessin de M. Valney.)

Above: The chandelier at the Opéra Garnier during its initial construction in the 1870s. An incident from 1896, in which the counterweight fell and killed a woman in the auditorium, inspired one of the most dramatic moments in Gaston's novel.

Previous pages: Exterior of the Opéra Garnier, designed by architect Charles Garnier, photographed *c.* 1875.

to keep her with him forever, but when Christine appeals for her release he agrees, on condition that she wears his ring and remains faithful to him.

During the Opéra masked ball Christine and Raoul narrowly avoid a sinister figure dressed in red and wearing a death's head, Red Death, who Raoul recognises as his assailant. Escaping up to the roof of the Opéra, Christine tells Raoul about her abduction. Raoul promises to take her away to a place where Erik can never find her. He tells Christine he shall act on his promise the very next day, to which Christine agrees, but she pities Erik and will not go until she has sung for him one last time. The couple leave, neither aware that Erik has been listening to their conversation and that it has driven him into a jealous frenzy.

The following night, Erik kidnaps Christine again during a production of *Faust*. Back in the cellars, he tries to force Christine into marrying him. If she refuses, he threatens, he will destroy the entire Opéra using explosives planted in the cellars, killing everyone in it. Christine continues to refuse until she is told that Raoul and an old acquaintance of Erik's, known only as 'The Persian', have been trapped in Erik's torture chamber after attempting in vain to rescue her. She talks to them through the walls.

In order to save the two men and the people above, Christine agrees to marry Erik and kisses him. Erik releases the Persian and the young Raoul. Erik, who admits that he has never before in his life received a kiss — not even from his own mother — is then overcome with emotion. He lets Christine go and tells her "go and marry the boy whenever you wish," admitting, "I know you love him." They cry together, and then she leaves. The Persian, an old acquaintance, is told all these secrets by Erik himself and, at his express request, announces Erik's death in the newspapers. Leroux's epilogue fills in the story of Erik's life, as told to him by the Persian as an old man, of a man born a monster who became an architect and constructed concealed passageways and cellars under the Opéra as a place to hide himself away.

"I am certain, quite certain that I prayed beside his body, the other day, when they took it from the spot where they were burying the phonographic records. It was Erik's skeleton. I did not recognize it by the ugliness of the head, for all men are ugly when they have been dead as long as that, but by the plain gold ring which he wore and which Christine Daaé must have slipped on his finger, when she came to bury him in accordance with her promise."

THE PHANTOM'S
EARLY INCARNATIONS

THE FIRST FILM VERSION OF *THE PHANTOM OF THE OPERA* FOLLOWED LEROUX'S ORIGINAL STORY CLOSELY. WITH A MAJOR STAR OF SILENT CINEMA AS A GROTESQUE AND HORRIFYING PHANTOM, THE 1925 RELEASE WAS A HUGE SUCCESS FOR UNIVERSAL PICTURES.

I n 1922 Carl Laemmle, the president of Universal Pictures, travelled to Paris where he visited the Opéra Garnier. On meeting Gaston Leroux a few days later, he mentioned how enthralled he had been and Leroux, seeing his enthusiasm, gave him a copy of *The Phantom of the Opera*. It is believed that Laemmle stayed up all night reading the book and, by next morning, had decided the studio would turn it into a film. At that time it was cheaper and easier to build a replica of the Opéra back home at Universal Studios than to send a cast and crew all the way to Paris. In any case, his crew were already committed to building a huge set for *The Hunchback of Notre Dame*, complete with a gigantic reconstruction of the cathedral.

The star of *Hunchback* was Lon Chaney (born in 1883), already famous for his ability to undergo remarkable and fearsome physical changes in order to play his roles and a star of the silent screen. A master of makeup, he was known as "the man of a thousand faces" – yet his acting skill was such that he was able to win the sympathy of his audience despite his often grotesque appearance. He was a martyr to his art, prepared to suffer whatever it took to fulfil his roles – including wearing a 40 lb hump and 30 lb harness to twist his body into the shape of Quasimodo.

Laemmle knew Chaney would be perfect for the role of the Phantom and vital to the film's success, but Lon had been lured away to rival studio Metro-Goldwyn-Mayer. Laemmle was forced into lengthy and expensive negotiations to borrow him back for the film. Eventually an agreement was reached and Chaney was delighted to be back at his old studio with a much higher salary.

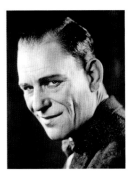

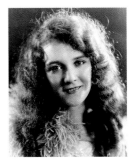

Above: Lon Chaney (1883–1930) and Mary Philbin (1903–93), stars of the 1925 film.

Opposite: Chaney terrified Philbin during filming.

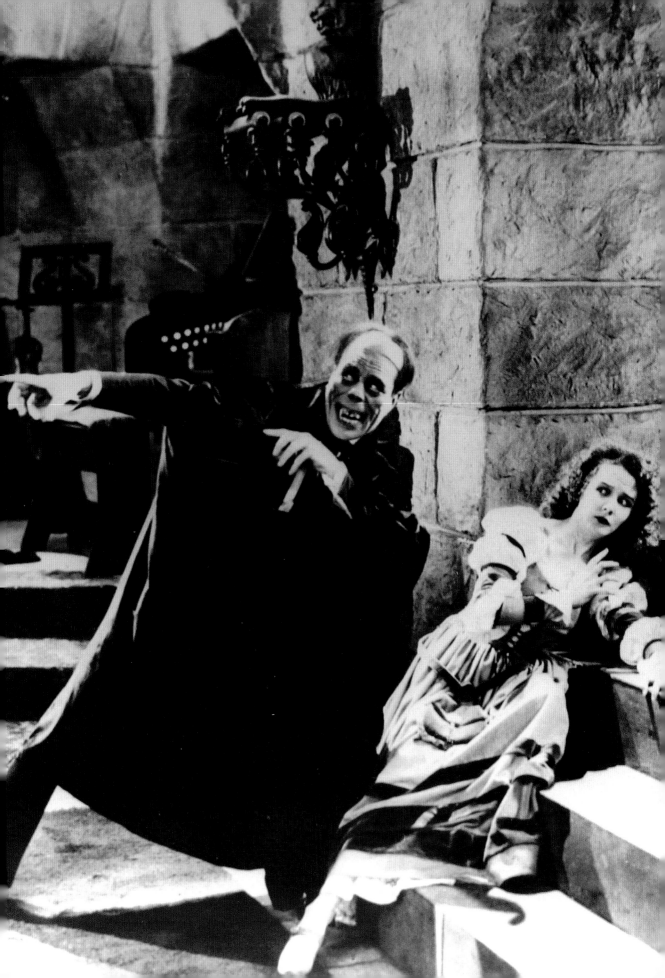

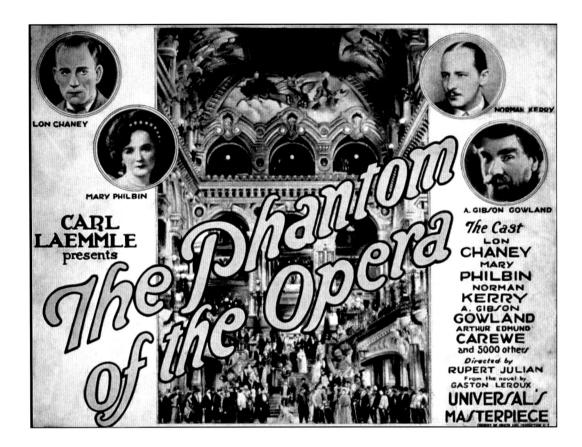

Chaney's leading lady was former beauty queen and aspiring actress Mary Philbin. Born on 16 July 1903 in Chicago, Illinois, Mary began her film career with *Where is this West?*, *The Age of Desire*, *The Temple of Venus* and *The Thrill Chaser*. But it was not until 1924, after playing Marianne in *The Rose of Paris* that she was cast in the best-remembered film role of her career. Laemmle chose her from an elite list of Hollywood starlets (among them Lillian Gish, Madge Bellamy, Betty Bronson, Patsy Ruth Miller and Mildred Davis). He believed her sweet and gentle nature would be perfect for the role of young Swedish soprano Christine Daaé. Philbin had never met Lon Chaney before and was initially very shy and nervous around him. He, in return, was demanding in the extreme, determined at all costs to coax a good performance from her.

During the filming of the crucial scene of the Phantom's unmasking, he turned on her with a barrage of insults. Mary, deeply hurt but too proud to cry, was on the verge of reporting him to Carl Laemmle. Then Chaney raised his hand to strike her and Mary fell back screaming, remembering "the wild rage in his eyes", putting her hand to her face and letting the tears flow. Once it had been caught on film Chaney began to comfort her, explaining that he

Above: A poster from the 1925 release. The cast of 5000 others that characterised a major studio production is credited along with the main players, whose publicity shots show them out of character.

Above: Stage 28 under construction at Universal Studios, Hollywood, 1924.

had done it for the good of the film. After that she came to adore him and he, in his turn, made sure he was on set for her scenes, even those in which he did not feature.

The principal location, for the majority of scenes, was to be the Opéra itself, and work started on a replica of Garnier's Parisian Palais at Stage 28 of the lot at Universal Studios. The auditorium was designed to have five tiers of boxes filled with crowds of extras, meaning that the normal construction method using a wooden framework would be unsafe. The set was therefore built using a steel framework and concrete foundations. So sturdy was its construction that the set has never been taken down and has since been used by a long list of famous films – from a remake of *The Phantom of the Opera* in 1943 to *The Sting* with Robert Redford in 1973. It is still there today, visited by thousands from all over the world as part of the Universal City Tour.

The sets also included the spectacular grand foyer with its sweeping double staircase, the rooftop with a massive statue of Apollo (the Paris skyline was added using painted glass mounted in front of the camera) and an enormous water tank was built beneath the stage for the lake and Phantom's lair scenes.

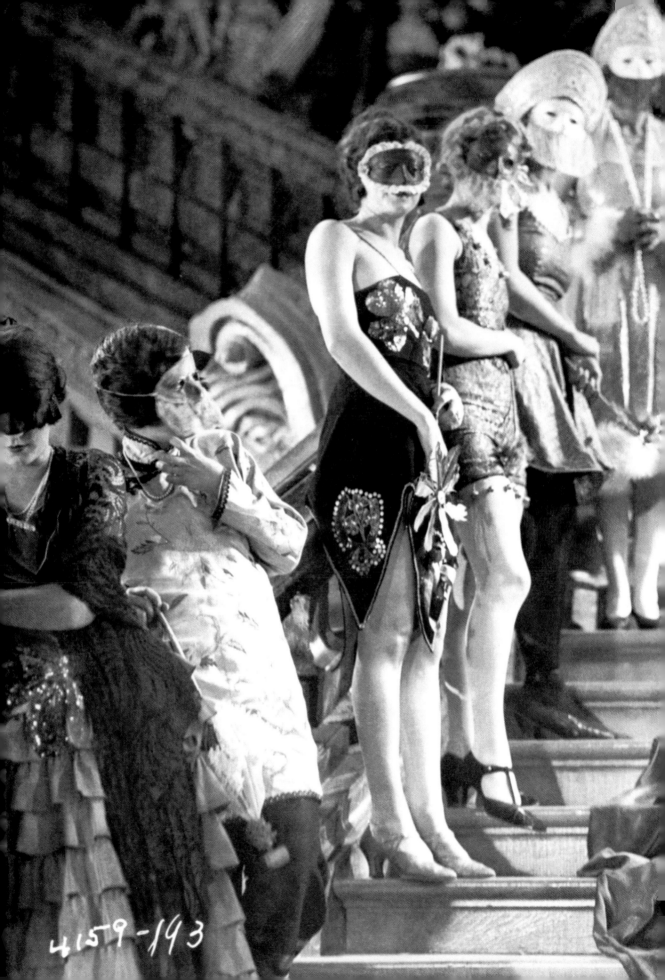

41-59-143

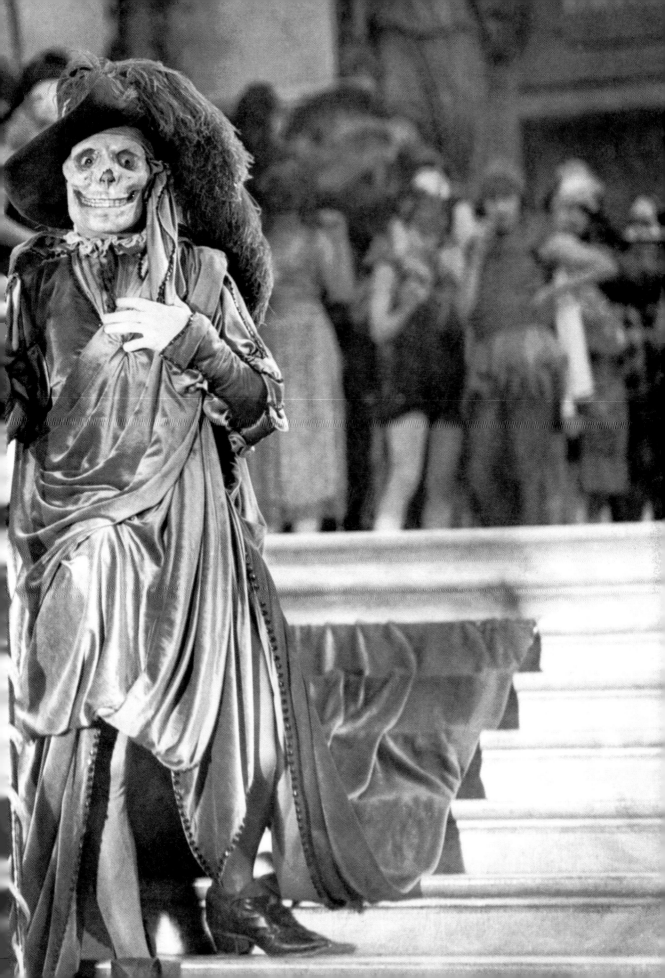

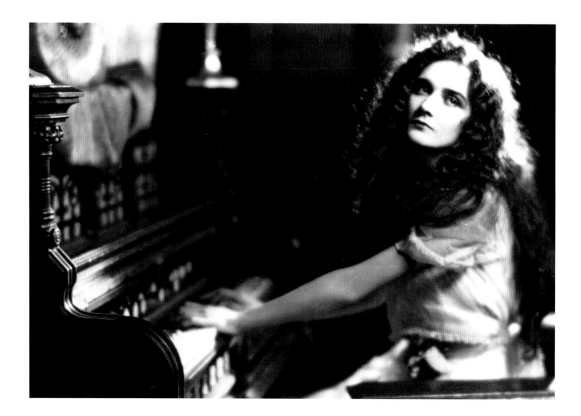

Shooting began late in 1924, but did not go smoothly. The relationship between the star, well known for his exacting standards, and director Rupert Julian broke down and they were barely on speaking terms. Ten weeks after filming began Laemmle replaced Julian with Edward Sedgwick, an action and comedy director. He is responsible for the mob and chase scenes towards the end of the film, and he also added in a number of comic scenes later removed after complaints from the film's backers.

The 1925 release's prints show that the film had undergone a great deal of tinkering. Some sequences, such as the opening ballet and the masked ball, were filmed in the two-colour Technicolor process, while the rest was filmed in black and white, occasionally with tinted film stock. Despite its chequered production history, the film was a huge box-office success across America. Much of this can be put down to the strength of Chaney's performance, which was enough to overcome any lapses in continuity. Cleverly, Chaney had obtained an order forbidding the release of any photos of his Phantom's makeup before the release of the film, heightening the mystery and increasing the shock factor when he appeared on screen. Awestruck audiences were provided with smelling salts.

Above: Former beauty queen Mary Philbin as Christine Daaé.

Previous pages: In a central scene, the Phantom visits the Opéra ball dressed as Red Death.

Right: Lon Chaney as the Phantom. Chaney, "the man of a thousand faces", was known for his ability to distort his looks, which he achieved without masks or prosthetics.

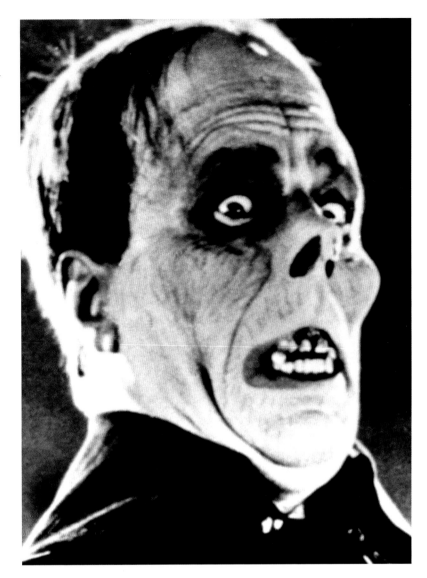

Chaney as the Phantom was enough to make the film a hit. What makes his performance all the more incredible is that, rather than using a mask, or the prosthetics actors might use today, he manipulated his own face, using a wire device to force his nostrils to flare and his nose to turn up, celluloid discs inside his cheeks to change the shape of his face and eye drops to give himself a pop-eyed look. He created one of the most iconic images of the silent movie era. Chaney, being a perfectionist, set himself a goal that would have daunted most actors of his day – to create a repulsive, frightening creature projecting so much sorrow that the audience could not help but feel compassion for it.

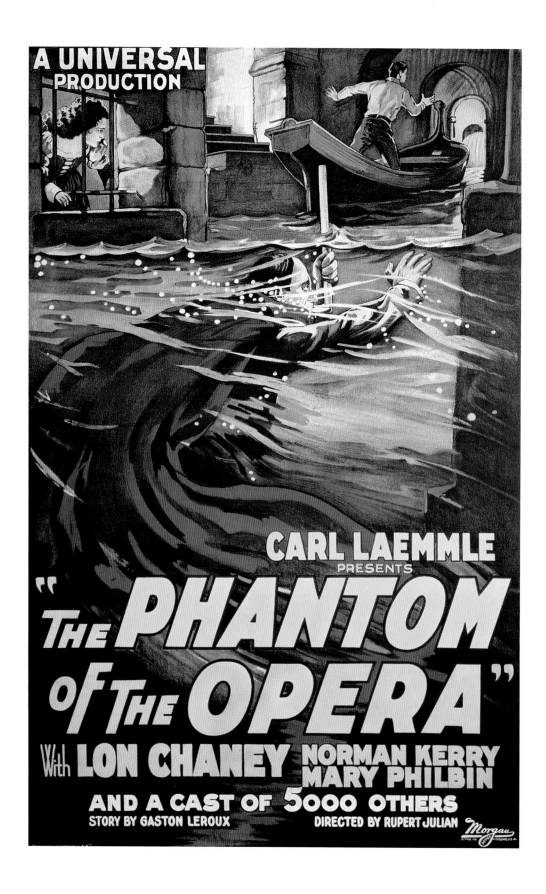

The Phantom of the Opera

Above: Carl Laemmle (1867–1939), president of Universal Pictures, whose trip to Paris in 1922 inspired the Lon Chaney film.

Opposite: This poster for Universal's 1925 release *The Phantom of the Opera* depicts the tense scenes that take place in the Phantom's underground lair.

It is interesting to note that Chaney's parents had both been deaf mutes, which meant that, from a very early age, he had learned to express his feelings though the use of gesture and expression, a personal form of sign language. This was a factor that obviously contributed to his enormous success as a silent-movie star. He was only to make one talking picture before he died from bronchial cancer in 1930.

The American success of the film was not mirrored in the UK, where its launch was overshadowed by a badly misjudged publicity stunt. For weeks, British newspapers had been reporting on the scenes of horror-struck American audiences queuing up night after night ready to be shocked by the Phantom. This created a considerable degree of excitement over the film's upcoming release, and in an effort to build even more tension an over-eager publicist for the European Motion Picture Company arranged for a contingent of soldiers to escort the first reels of film from Southampton docks to London, attracting attention to the precious cargo.

The plan backfired. Letters were written to *The Times* newspaper complaining that the escort was a gross misuse of the time and resources of the British Army. The Cinematograph Exhibitors' Association responded by banning the film in the name of patriotism and the British Empire. The ban was finally lifted in November 1928 following a personal plea from Universal's president, Carl Laemmle, but by that time the excitement over the film had all but disappeared.

Two years after Universal released *The Phantom of the Opera*, Warner Brothers released *The Jazz Singer*, the first full talking picture, and with that the silent-picture business was over. Studios rushed to produce their own talking films, and, in an effort to cash in, looked to see which of their existing films would be suitable for the addition of a soundtrack. *The Phantom of the Opera* was one film to receive this treatment, with newly filmed dialogue sequences added to the whole along with music and sound effects. Some sections were cut and singing voices were added to the scenes from the opera *Faust*.

Mary Philbin, the actress playing Christina, was replaced in the songs due to her poor singing voice and Lon Chaney was also voiced by another actor (despite rumours that it was actually his voice, he did not play a part in the rework and was seriously ill by this time). Although only a third of the film had dialogue and singing, it was re-launched with the slogan "Talking! Singing! Dancing! Sound effects! Music! Colour!". So *The Phantom of the Opera* was given another chance to thrill audiences. It would not be its last.

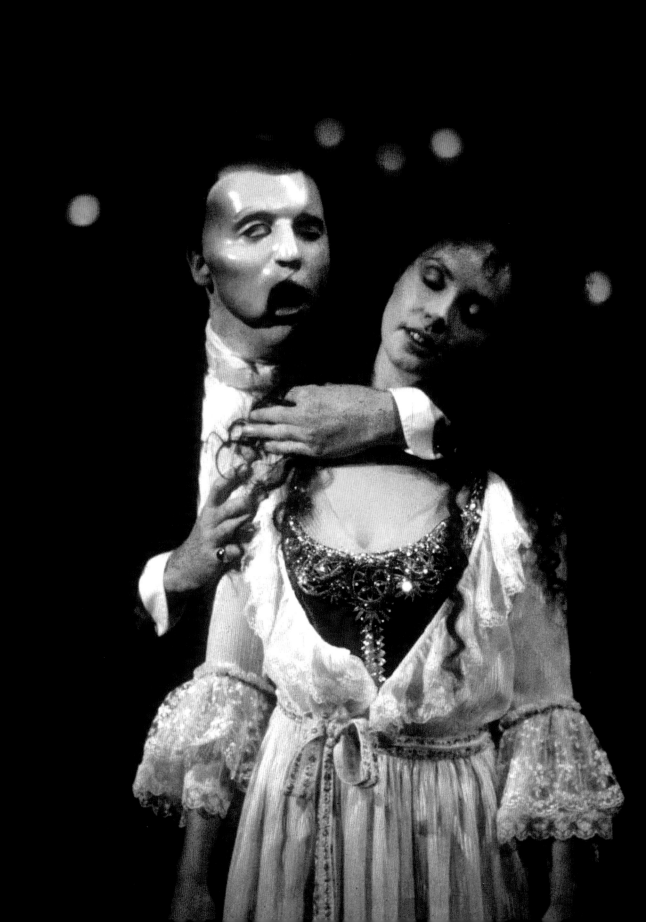

ACT II

"I just wanted something where I could really let myself go and write a full-blooded romantic musical. So I did."

Andrew Lloyd Webber

Opposite: Michael Crawford as the Phantom, with Sarah Brightman as Christine, in the original London stage production, 1986.

THE MUSICAL

"I WAS TRYING TO WRITE A MAJOR ROMANTIC STORY AND HAD BEEN TRYING TO DO THAT EVER SINCE I STARTED MY CAREER, BUT I HAD NEVER BEEN ABLE TO FIND THE PLOT THAT COULD BE MY – ER – AS IT WERE – SOUTH PACIFIC. THEN, WITH THE PHANTOM, IT WAS THERE. I CALLED CAMERON AND SAID 'I THINK IF I FOLLOW THE ROMANCE IN THE NOVEL IT COULD BE THE PLOT I AM LOOKING FOR – I'LL GIVE IT A GO.'"

In the spring of 1984, the first London stage production of *The Phantom of the Opera*, a boisterous and unashamedly camp version, opened at the Theatre Royal, Stratford East. Directed by Ken Hill, it was structured around the music of Verdi, Gounod and Offenbach. Hill had offered the part of Christine Daaé to a 23-year-old singer–dancer, Sarah Brightman. Brightman had declined the part, due to other commitments, but the offer brought the show to the attention of her future husband, Andrew Lloyd Webber.

Having read rave reviews of the show in the *Daily Telegraph*, he contacted his friend Cameron Mackintosh, producer of a string of successful West End and Broadway shows including *Little Shop of Horrors*, *Side by Side by Sondheim* and *Les Misérables*, and with whom he had previously collaborated on the globally successful hit *Cats* and on *Song & Dance*. As Mackintosh recalls, "I was lying in the bath when Andrew rang. His first words were: 'If I said to you *The Phantom of the Opera*, what would you say?' I remember answering, 'I think it's a good idea.'"

Mackintosh arranged for a screening of the original 1925 Lon Chaney movie, which they both found inspiring. They also went to see Hill's production. The idea was forming of developing it into a West End show using existing out of copyright classical music for the score. At that point, Lloyd Webber had no intention of composing the score, having "something nearer the *The Rocky Horror Show* in mind." Richard O'Brien's 1973 musical *The Rocky Horror Show* was a camp, sexy stage hit, which was later released in 1975 as a film directed by Jim Sharman. Mackintosh had also had an association with *The Rocky Horror Show*, being co-producer with Michael White of the first UK tour in 1979. Lloyd Webber and lyricist Tim Rice had worked with Sharman

– 44 –

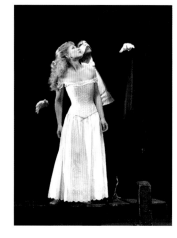

Above: Christina Collier and Peter Straker, stars of Ken Hill's 1984 production of *The Phantom of the Opera*, in a revival at the Shaftesbury Theatre, 1991.

Opposite: Poster for the original London stage production of *The Phantom of the Opera*, 1986.

CAMERON MACKINTOSH and
THE REALLY USEFUL THEATRE COMPANY LTD
present

The PHANTOM of the OPERA

Music by
ANDREW LLOYD WEBBER
Lyrics by **CHARLES HART**
Additional lyrics by **RICHARD STILGOE**
Book by **RICHARD STILGOE & ANDREW LLOYD WEBBER**
Based on the novel 'Le Fantôme de l'Opéra' by
GASTON LEROUX
Production design by **MARIA BJÖRNSON** Lighting by **ANDREW BRIDGE**
Sound by **MARTIN LEVAN** Production Musical Director **DAVID CADDICK**
Orchestrations by **DAVID CULLEN & ANDREW LLOYD WEBBER**
Musical Staging & Choreography by **GILLIAN LYNNE**
Directed by **HAROLD PRINCE**

HER MAJESTY'S THEATRE
HAYMARKET LONDON SW1
A REALLY USEFUL THEATRE

DESIGNED AND PRINTED BY DEWYNTERS

previously on *Jesus Christ Superstar* (both the original Australian and later 1972 London productions). While attending the 1984 opening of *Cats* in Tokyo, Mackintosh and Lloyd Webber met up with Sharman to discuss his interest in a show they envisaged would have the excitement of *Raiders of the Lost Ark*, which had burst onto screens in 1981, setting subterranean chases to a score arranged from works by Delibes, Massenet and Gounod. Sharman, however, had recently been engaged as the director of mainstream opera and theatre in his native Australia and was forced to turn down the offer. He recalls telling Lloyd Webber, "You're missing a great romantic plot – you should compose the score."

Above: Popular Gothic romance – Bram Stoker's *Dracula* (1897).

Some months later, Lloyd Webber came across an old translation copy of Gaston Leroux's original novel, *Le Fantôme de l'Opéra*, on a bookstall in New York. On reading the book, his attitude to the story was transformed: though it was an unusual choice of material with an incredible and paranormal storyline, one he knew an audience would have to buy into, the Gothic romance of the original story enthralled him. Leroux's novel also contained a sexual frisson and weird possessiveness that Lloyd Webber compared favourably with Bram Stoker's *Dracula* or Mary Shelley's *Frankenstein*. "Gaston Leroux pillaged his story from all over the place, from the tale of Paganini at one point; from every conceivable penny dreadful. But actually deep inside it somewhere is a marvellous confection that works brilliantly."

The book was not only out of print, but also out of copyright, meaning it could be adapted without any legal wrangling. Lloyd Webber could also see how touches of Leroux's humour could be picked up in musical terms to add further dimension to the narrative's romantic core. He decided it was the story he had been looking for.

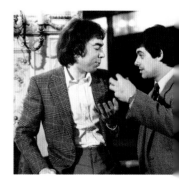

Above:
Andrew Lloyd Webber and Cameron Mackintosh during a rehearsal for *Song & Dance*, 1982.

As they started on the project, Lloyd Webber and Mackintosh discussed several directors, but Lloyd Webber had a chance meeting with Harold Prince, who had directed or produced many legendary musicals, among them *West Side Story* (1961), *Fiddler on the Roof* (1971) as well as his own musical, *Evita* (1978). As Lloyd Webber recalls, "Hal told me that what he wanted to do was a great romantic musical. I said, 'What do you think about *The Phantom of the Opera*?' He said, 'Sounds terrific, what have you done?' I said, 'I haven't really done anything yet, but come and see me in England.'"

The Phantom of the Opera musical, or at least an early draft of the first act staged by Mackintosh and Lloyd Webber, was to get its first airing in 1985 before an invited audience at Lloyd Webber's annual music festival at his home at Sydmonton Court, Berkshire. The lyrics were composed by Richard

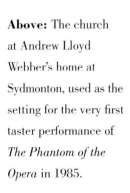

Above: The church at Andrew Lloyd Webber's home at Sydmonton, used as the setting for the very first taster performance of *The Phantom of the Opera* in 1985.

Stilgoe, an accomplished writer and musician who had worked with Lloyd Webber on *Starlight Express*. The cast was mostly borrowed from the imminent Mackintosh/RSC production of *Les Misérables*, with Colm Wilkinson playing the part of the Phantom. Sarah Brightman played Christine, a role that was developed to make the most of her pure, soaring voice.

Real sets were built in the tiny deconsecrated church at Sydmonton that had been converted into a theatre, designed by the brilliant Maria Björnson, the first member of the production team to come on board. Björnson had not designed for mainstream commercial theatre before, but her work with the Royal Opera House and the Royal Shakespeare Company had made huge impact. Her sensationally theatrical evocation of the Phantom's world was to play a major part in the show's success. Such was her ingenuity that even in the church she managed to include the falling chandelier at the end of the act.

The performance at Sydmonton, while a mere taster of the show to come, was hugely encouraging. "The festival revealed that it was potentially a great romantic musical," Lloyd Webber commented, "and that a campy approach would have been counter-productive to the whole thing. It made me decide it would be right to go with Hal because a romantic musical was what he really

ALAN JAY LERNER

March 31st, 1986

Andrew Lloyd Webber, Esq.,
c/o Palace Theatre,
Cambridge Circus,
London W.C.2.

Dearest Andrew,

Who would have thought it? Instead of writing "The
Phantom of the Opera" I end up looking like him.

But, alas, the inescapable fact is I have lung cancer.
After fiddling around with pneumonia they finally reached
the conclusion that it was the big stuff.

I am deeply disconsolate about "The Phantom" and the
wonderful opportunity it would have been to write with
you. But I will be back! Perhaps not on time to write
"The Phantom", but as far as I am concerned this is a
temporary hiccup. I have a 50/50% chance medically and
a 50/50% chance spiritually. I shall make it. I have
no intention of leaving my beautiful wife, this beautiful
life and all of the things I still have to write. As far
as I am concerned it is a challenge, and I fear nothing.

But I shall be thinking of you, and Sarah, and Richard,
and Cameron all the way, and I know you will have the
success God knows you deserve. It is a wonderful score
and I am heartbroken that I cannot get a crack at it.

I will be in touch with you over the summer just to let
you know I am up and around and thinking of you, and I
hope with all my heart that one day we will have a chance
to work together.

Blessings always to you and Sarah.

Aye,

Alan

wanted to do, and his experience as an opera director meant that he under-
stood clearly every resonance that we were talking about. I have never felt so
strongly as I did over *Phantom* – it *had* to be Hal." Prince was also sure that
The Phantom of the Opera was the right show for him. "I said 'Yes' immediate-
ly. I don't usually say 'Yes' right away. It was exactly the sort of show I wanted
to do – I felt there was a real need for a romantic show. I had done several
that were hard-edged and bitter; even *Evita* is like that. I wanted a change as
much for the theatregoer as the director."

Prince took it upon himself to visit the Opéra Garnier in Paris, spend-
ing many hours researching every inch of the building from the rooftop with
its view of the Paris skyline to the subterranean lake, even crawling along
dangerous narrow catwalks unsupported by handrails. Björnson also made
the journey, accompanied by her assistant, taking hundreds of Polaroid
pictures to act as source material for the sets.

The show's title song "The Phantom of the Opera" was released as a single
featuring Sarah Brightman with Steve Harley of the group Cockney Rebel as
the Phantom, with lyrics by Richard Stilgoe and a lavish video created by
Ken Russell, famous for his musical films, *The Boyfriend* and *Tommy*. The

Above: Letter from
Alan Jay Lerner.

Above top left: Sarah
Brightman and Steve
Harley's duet was a
teaser released several
months before the
production opened.

Above left: Michael
Crawford in "The
Music of the Night".

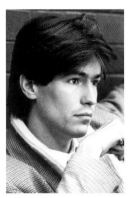

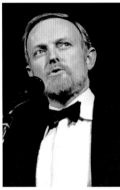

Above: Richard Stilgoe.

Top: Charles Hart.

Below: The cover of the Sydmonton programme, July 1986.

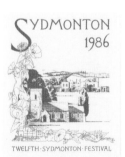

SYDMONTON 1986

TWELFTH·SYDMONTON·FESTIVAL

video's flamboyant style was a perfect foil for the song and helped propel it to number seven in the British charts in February 1986. The success of the single built anticipation for the full score.

Now that the score was well under way, Lloyd Webber knew that developing the story would benefit from further creative input. "Richard Stilgoe is a good lyricist," he said, "and he knows a lot about opera, but I believed that he would not be able to do it on his own. Romance is a tightrope, and it's very hard to write. It was something that in the end was my own decision, because, as a composer, you must get the libretto you want."

He first approached Tim Rice, his collaborator on *Evita*, but Rice was heavily involved in his own new show, *Chess*, and was forced to decline. Lloyd Webber and Mackintosh then decided to approach Alan Jay Lerner, an old friend of them both and a giant of the musical world whose career had begun back in 1947 with the musical fantasy *Brigadoon* and spanned such other greats as *An American in Paris* (1951), *My Fair Lady* (1956) and *Gigi* (1958 film, transferred to the stage in 1973). Lerner was keen to help, saying he thought it was Lloyd Webber's "best score so far", but three weeks later, on 20 March 1986, he wrote to decline the invitation due to failing health. "When I am finally, truly well and no longer look like The Phantom of the Opera, I will call. If there is still time to do one or possibly two lyrics, perhaps I can throw in a few rhymes." He passed away on 14 June that same year.

Finally, a lyricist was chosen to complete the libretto: an unknown 24-year-old writer who had caught the eye of Cameron Mackintosh with his entry for the Vivian Ellis Prize, given by the Performing Right Society to encourage young composers and librettists. Charles Hart, had entered an unproduced show about the life of Moll Flanders, for which he had written both the words and music. Hart had not won, but Mackintosh could see that he had great talent, saying, "A good lyricist is a rare beast." Richard Stilgoe was equally generous saying, "Charles (Hart) did an absolutely brilliant job in starting again, and yet keeping a lot of my stuff. And neither he nor I when we go and see the show is absolutely certain which of us wrote which bit."

Hart immediately grasped the romance of the story and the potent situation of a young woman caught in an emotional triangle between her dead father, her lover Raoul and the Phantom. He worked around the clock to keep up with the flow of Lloyd Webber's music, and the two conversed on a musical level. As a result, the lyrics were finished in just three months. And when several songs were premiered at Sydmonton in July 1986, the opening night in London was only three months away.

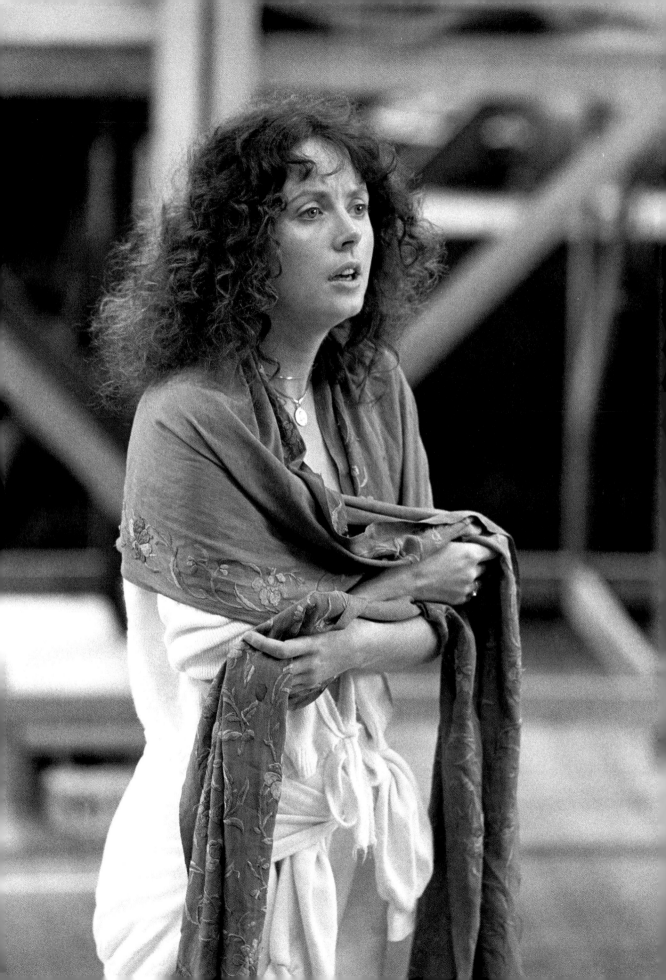

BEHIND THE SCENES

"THE ROLE OF CHRISTINE IS ONE OF THE MOST DEMANDING I HAVE EVER WRITTEN,"
SAID LLOYD WEBBER. "IT INVOLVES NOT ONLY BEING ABLE TO SING MUSIC
COVERING AN ENORMOUS RANGE FOR A CONSIDERABLE LENGTH OF TIME, BUT ALSO
DEMANDS THAT THE ARTIST CAN DANCE 'EN POINTE'. MY CHRISTINE IS A MEMBER
OF THE *CORPS DE BALLET*. THE PHANTOM BELIEVES IN HER VOICE BECAUSE IT
REPRESENTS A NEW SOUND IN MUSIC, PURER THAN A CONVENTIONAL SOPRANO."

Above: Michael
Crawford.

Opposite: Sarah
Brightman during
rehearsals for her
role as Christine in
the original London
production of 1986.

Andrew Lloyd Webber had never tried to hide the fact that he had his
then wife, Sarah Brightman, in mind when he was writing the role of
Christine Daaé. Her selection was still subject to rigorous audition-
ing, however. The demands of the role were high, and Brightman's physical
frailty, which made her ideal for the role, called for the use of an alternate of
comparable quality. It was agreed from the outset that no lead artist should
take on all performances, a policy Lloyd Webber and Harold Prince had
introduced eight years before with *Evita*.

Brightman was trained as a dancer as well as singer, meaning she could
use her expertise in both areas; however she found that it was not easy. "The
way that I use my muscles as a dancer is quite different to the way I use them
as a singer. Both methods work against each other and it was hard for me to
separate the two. It is essential that Christine, a ballet girl suddenly plucked
from the chorus to sing a leading role, develops her voice as the plot moves
on if Andrew's idea of character is to work. I had to control my voice and
develop it as Christine would have done, so I couldn't start off too strong."

When it came to casting the show, nothing was a foregone conclusion.
The role of the Phantom had been sung by Steve Harley on the teaser hit
single with Brightman, but in the end the stage role went to Michael Crawford.
Lloyd Webber had heard Crawford singing while collecting Sarah Brightman
from a class held by their teacher Ian Adam and was impressed by his wide
vocal range.

Crawford was highly experienced in physically demanding roles, having
already played the title roles in the original West End productions of *Billy*

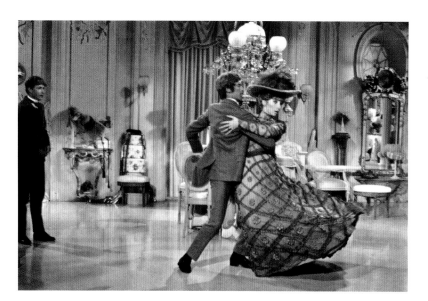

(1974) and *Barnum* (1981). His enormously varied career over the previous
two decades had taken him to Broadway opposite Lynn Redgrave in Peter
Shaffer's *Black Comedy* (1965) and to the big screen for Richard Lester's
film version of *A Funny Thing Happened on the Way to the Forum* (1966).
Following the film *Hello, Dolly!* (1969) he made an acclaimed return to the
West End stage in *No Sex Please, We're British* (1971). Crawford had become
a household name during the 1970s playing the accident-prone Frank
Spencer in *Some Mother's Do 'Ave 'Em*, a TV sit-com on which he carried

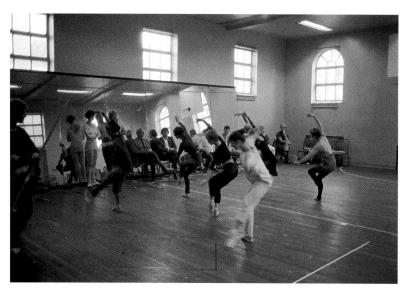

Above: Steve Barton, who auditioned at Gillian Lynne's request.

Below: Rehearsals for the London production in 1986. L–R, ensemble choreography; the three principals; choreographer Gillian Lynne and director Harold Prince with Andrew Lloyd Webber.

out all his own stunts. When the call came, Crawford was in the West Indies on his first holiday for four years. After three days of frantic telephoning he decided to return to London to meet up with Lloyd Webber and Mackintosh.

It was to prove a brilliant casting; not only did he have a powerful, versatile voice, he was an actor with the physical ability to express himself when his face was mostly covered by a mask. As a seasoned stunt performer, he had the daring to hang suspended over the heads of an audience on a gilded angel or employ a traditional trap door to exit suddenly from the masked ball.

To enhance his performance still further, the illusionist Paul Daniels was brought on board to devise special effects including fireballs that shot from a staff and the dramatic disappearance of the Phantom, in front of the audiences' eyes, at the end of the show. Crawford was delighted to be involved. "It was great to be in at the beginning of something. It has been the greatest adventure of my career without a doubt, to be there as it grew."

The third principal, Christine's high-born lover Raoul, was cast at the suggestion of Gillian Lynne, who was responsible for the show's musical staging and choreography. Several actors had been auditioned, but none of them really stood out as being right for the role. Lynne remembered a young American who had been a dance captain in one of her shows and who was working in Vienna and Berlin.

– 53 –

She encouraged him to audition and invited him to stay at her flat to save the cost of a hotel. He did so, and for his audition performed "I Am What I Am" from *La Cage Aux Folles*, in German. Partway through, Harold Prince

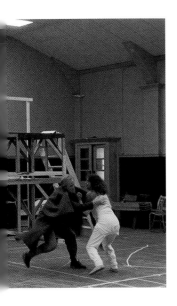

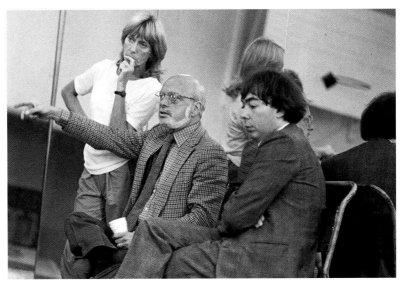

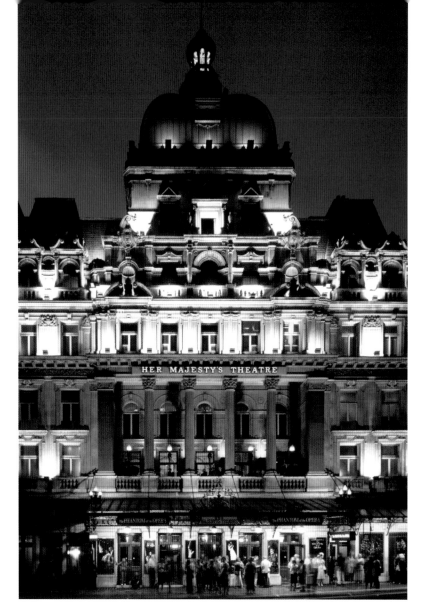

Left: Her Majesty's Theatre, Haymarket, home to the original London production of *The Phantom of the Opera*, and where it is still playing today.

turned to Lynne, said "That's it!", and Steve Barton joined the cast as Raoul, playing in the original London production and reprising the role when the show opened on Broadway. Sadly, Barton died from heart failure at the age of just 47, in 2001.

The choice of London theatre in which to stage the show was a delicate one to make. Andrew Lloyd Webber would have liked The Palace, a Victorian theatre built for Richard D'Oyly Carte as The Royal English Opera House on Shaftesbury Avenue. The Palace, however, was home to *Les Misérables*, which had transferred there from the Barbican and looked destined for a very long run (in fact, that production ran there for 7,602 performances, until 2004, when it transferred to the Queen's Theatre).

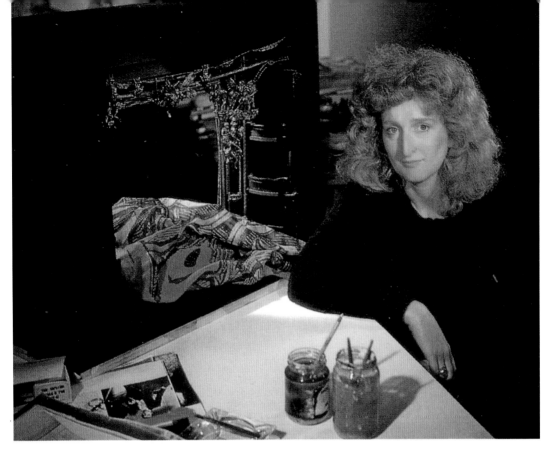

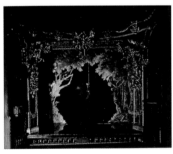

Above: Maria
Björnson (1949–2002)
with her set designs,
which she created in
miniature.

The smaller Her Majesty's on Haymarket was available, however, and also
had a rich musical heritage, as home to the original London productions of
West Side Story (1958) and *Fiddler on the Roof* (1967), among others. With
the exception of the Theatre Royal, Drury Lane, the site of Her Majesty's
had been associated with stage productions longer than any other theatre in
London. Over its 305-year history, with four different buildings, numerous
name changes and an early life as an opera house, it made it a fitting home
for *The Phantom of the Opera*. The current building, completed in 1897, is a
fine example of late Victorian architecture and the only West End theatre with
its original wooden machinery still intact beneath the stage. Maria Björnson
incorporated some of its character into the set.

Having spent hours investigating every inch of the original Opéra Garnier in Paris and taking endless photographs, Maria Björnson was determined that the London set should match the opulence of the original Opéra. She was described by her assistant, Jonathan Allen, as "a crazy genius to work for, always tearing her hair out about some terrible detail that wasn't going right – but you put up with it because the final product was going to be amazing!" Björnson was a demon for detail. Initially she created the sets in miniature and displayed them in a model of the stage space, a process that was a great help to Harold Prince, who preferred to use a model to work out his blocking of the action. Prince's ideas, too, had a bearing on how the set was designed.

"I was watching a BBC documentary about people who were physically incapacitated," said Prince "…and I sensed that the thing that united them all was a very normal, healthy sexuality. And that's what Maria and I wanted to put up there. It affected the design of the proscenium, with its statues intertwined in some moment of passion which the audience both sees and absorbs."

Andrew Lloyd Webber was intimately involved at all stages of the process. Harold Prince recalled, "I also talked to Andrew about the show's rhythm. I

Above left: Director Harold Prince worked with Maria Björnson on the proscenium design for the original London production, inspired in part by a BBC documentary he had seen.

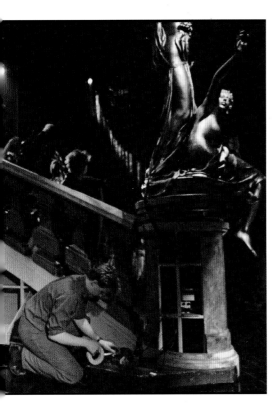

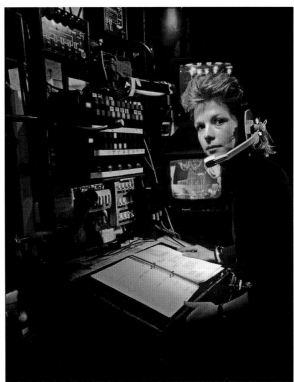

Above: Even the staircase folds away, maximising the tight backstage space at Her Majesty's Theatre.

Above right: Deputy Stage Manager Anni Partridge gave 350 cues during every performance of the original London stage show in 1986.

wanted to keep it moving with a strong pulse, because the people are almost paralysed by fear and a sense of...vulnerability." Björnson and Prince took advantage of the working Victorian machinery, creating the show that made full use of it. As Prince said, "We could have staged it in the same way had we opened when the theatre was first built."

Key to the story is the massive chandelier. Made up of 6,000 beads, 35 to each string, it weighs one ton and took five people four weeks to build. It begins the show in a crumpled heap on the stage, as a lot in an auction taking place many years after the main action of the story. Raised to its position high above the audience, it then sets the scene for the introduction of the Phantom, transforming the gloomy auction scene into the glittering, glamorous Opéra of its heyday. Later, at the climax to the first Act, the chandelier plummets down over the audiences heads.

Understandably the local council was not too keen on the idea of the chandelier falling over the heads of the audience, concerned about the risks of a real disaster. Production manager Martyn Hayes was worried that, if the council refused them permission, the show would be ruined – but, after scrutiny of the mechanisms and a safe first preview, the show was allowed to

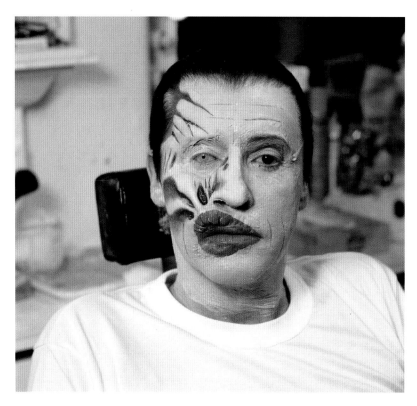

Left: Michael Crawford's makeup. Created and designed by Christopher Tucker, it was constructed from latex during a process lasting two to three hours before every performance during the original 1986 London production.

Opposite: Maria Björnson's detailed and beautiful drawings for the costume designs, complete with fabric samples attached.

go ahead as planned. The dramatic effect is, in fact, achieved quite simply – using a cat's cradle of invisible wires and motors to control the chandelier's descent – but is frighteningly realistic to anyone seated underneath and certainly a big draw as far as audiences were concerned.

The set relies on a talented team of backstage crew (20 stage crew and 10 flymen), all working in unison to ensure a smooth performance. The wing space at Her Majesty's is quite small, so the sets were devised with this in mind, collapsed wherever possible and stowed away until needed. Even the massive staircase from the masquerade ball folds away concertina-style to maximise space. There are thousands of things that can go wrong, but procedures cover every one of them to make sure the audience is unaware of the problem; thankfully they have rarely been needed.

Among the many technical challenges of staging the show was the Phantom's makeup. It had to be striking enough that even audience members at the back of the upper circle could appreciate its full horror, but not so horrific that it destroyed the sympathy they felt for the unfortunate creature. Crucially, it also needed to be flexible enough to avoid restricting the actor underneath. Initially, Crawford tried a Lon Chaney approach, manipulating

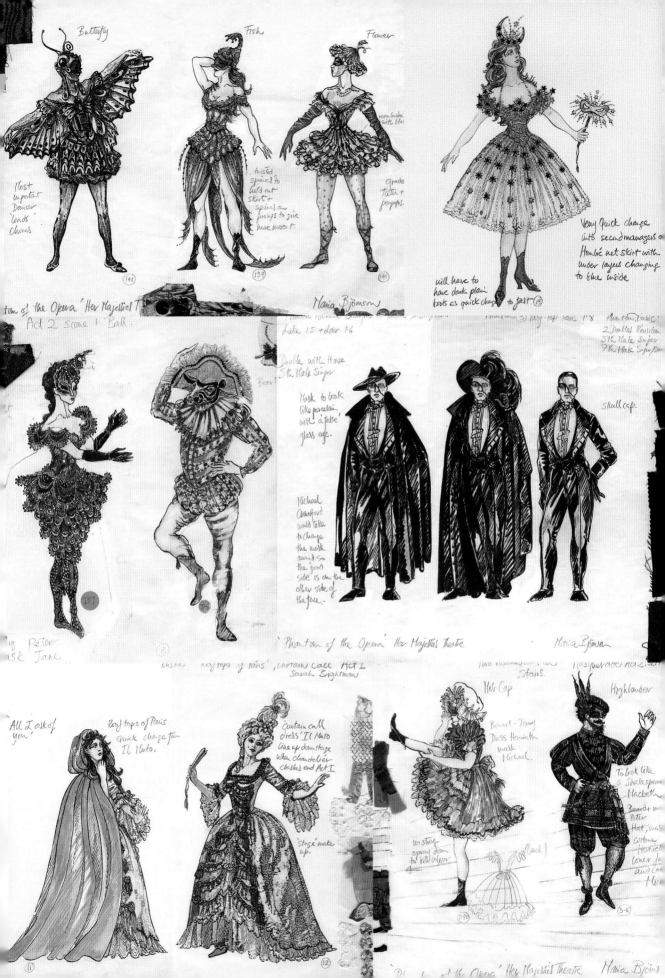

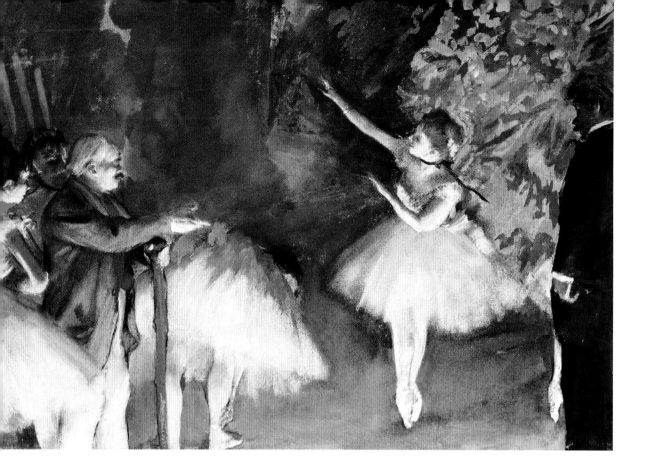

the shape of his face with padding stuffed in his cheeks. However, this made singing an impossibility. "We tried it," said Crawford, "but I sounded like Marlon Brando in *The Godfather*."

Eventually, a decision was taken to ask makeup artist Christopher Tucker, the man responsible for John Hurt's makeup in *The Elephant Man* (1980), to create the deformed features from latex. These were applied to Crawford's face in a marathon three-hour process (thankfully later reduced to two hours after a few months' practice). The inspired addition of a vertical half-mask, which left part of his face visible, added to the suspense for the audience in wondering what the Phantom might look like underneath. The discomfort of being enclosed in a double layer of latex and a wig, however, was acute, particularly on days when there were two performances. "It's like being trapped in a lift," said Crawford. "Quite horrendous."

As well as devising the set, Maria Björnson was responsible for design- ing the costumes. She sketched each one in beautiful detail and, working closely with a team of costumiers from all over Britain, created the opulent, rich costumes that give the show its sumptuous feel. Björnson paid particular attention to historical accuracy, most notable in what appear to be among the

Above: Dégas, *Ballet Rehearsal*, 1875.

Above: The corps de ballet in historically accurate tutus, London production, 1986.

simplest costumes in the show, the ballerinas' tutus. These she created in the pre-Russian ballet style made famous by Edward Dégas in his paintings and statues of young ballerinas. The skirts were made from 40 ft of tartalan, the stiffened muslin traditionally used, while the bodices were made of linen. The number of costumes for the production was enormous (the exact number was 230), with each cast member having an average of seven changes. Every costume was made from between 40 and 50 ft of fabric and anything up to nearly 200 ft of braid. So much braid was required that the costume supervisor's car, which was used to collect the materials from the supplier, became known as the "braid wagon". Outfits were minutely detailed and put together with literally thousands of adornments and accessories to complete the look.

The Phantom's opera suit posed problems of its own, taking into account Crawford's physical performance and allowing him freedom of movement in his more athletic sections of the show. In order to maintain a clean line, the Phantom's shirt was designed to button between the legs to stop it riding up when he reached up. Every aspect of his costume was carefully considered. Even his boots, tight-fitting and extended up above the ankles, were designed to accentuate his awkwardness and give his feet a narrow, pinched look.

THE PHANTOM TRIUMPHANT

BEFORE THE OPENING ADVANCE BOOKINGS WERE FAIRLY MODEST AND MANY
PEOPLE THOUGHT *THE PHANTOM OF THE OPERA* WOULD BE LESS THAN
FANTASTIC. THE LATTER STAGES OF PRE-PRODUCTION BECAME HIGHLY
NEWSWORTHY. SPECULATION WAS RIFE OVER EVERY ASPECT OF THE CASTING AND
EVERY MINOR TECHNICAL HITCH AND THE PRESS LAPPED UP RUMOURS OF
A 'CURSE OF THE PHANTOM', BUT FROM OPENING NIGHT *THE PHANTOM OF
THE OPERA* WAS A HIT.

The month before curtain-up had seen all the elements of *The Phantom of the Opera* fall into place. The 32-strong cast and 28-piece orchestra that had been rehearsing elsewhere in the capital were brought together for the first time, while the chandelier was hoisted, via six strong steel wires, into the roof of Her Majesty's Theatre. Work was going on out of sight under the stage too with a grave trap, three bridges, pulleys, weights and hydraulic machinery all refurbished and ready for use. The giant elephant prop was ferried in from mid Wales, where a local craftsman had made it as a one-off.

The theatre's bars and foyers were being refurbished for the production's arrival, but it was in the auditorium itself, where statues, gargoyles and Gothic angels had taken up residence, where the effect was most obvious. Around 30 different contractors were working on site round the clock and right up to the very last minute.

Director Harold Prince was at the heart of it all, with glasses perched on the top of his head in trademark fashion. Set designer Maria Björnson and choreographer Gillian Lynne were at his shoulder as he took the vital nip-and-tuck decisions that would affect how the show would eventually look to the public.

But progress was necessarily slow at first. The initial technical run-through took almost two days, with Harold Prince and Cameron Mackintosh present to provide encouragement. Andrew Lloyd Webber admitted to anxiety, despite his vast experience. "It never gets any better. I'm still nervous despite all the shows I've done in the past." Problems continued to

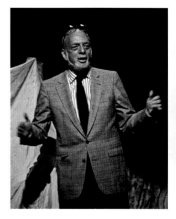

Above: Director Harold Prince.

Opposite: The Phantom appears in disguise at the masked ball, on stage in the original London production, 1986.

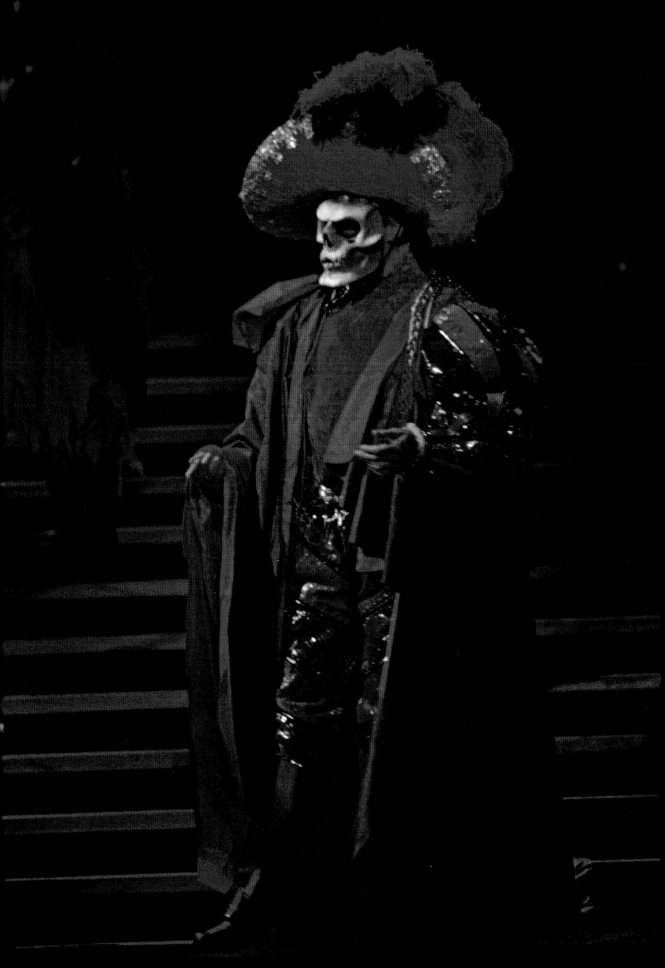

We beg to submit for your considerable pleasure and approbation

The PHANTOM of the OPERA

A Most Remarkable and Unique
Evening of Entertainments
at and around Her Majesty's Theatre in the
Haymarket, London,
on Wednesday the 8th October 1986

The Gala Performance will be Graced by the Presence of
HER ROYAL HIGHNESS
THE PRINCESS OF WALES.

In aid of Help the Aged.

Item: The Gala Performance of Andrew Lloyd Webber's
New Grand Musical Spectacle The Phantom of the
Opera, with Miss Sarah Brightman and Mr. Michael
Crawford.

Item: Many Street Entertainments, Surprises and
Happenings around the Theatre Before the
Performance.

Item: Champagne and Wine Flowing Free in the
Theatre Bars during the interval.

Item: Many Gifts and Fancies for the Patrons.

Item: For the Discriminating and the Particular, Glorious
Champagne Buffet Supper in the Gorgeous Splendour
of the nearby Royal Automobile Club and Oxford
and Cambridge Club, by Gracious Permission
of their Managements.

– 64 –

Above: Invitation to the gala preview performance, on Wednesday, 8 October 1986.
The performance was followed by a champagne buffet supper at the
Royal Automobile Club and Oxford and Cambridge Club.

Opposite: Invitation to the grand dinner that followed the world premiere
performance, on Thursday, 9 October 1986.

Opposite far right: "Phantom Champagne" label for the celebratory bottle, 1986.

I have instructed my Managers, Mr. Andrew Lloyd Webber, Mr. Cameron Mackintosh, and The Really Useful Theatre Company to hold a Grand Dinner, to which you are bidden attend.

This occasion will take place in the Stalls Bar of the Palace Theatre, Shaftesbury Avenue, London, W1 (Romilly Street Entrance) from 10:30pm. on Thursday October 9th, following the World Premiere performance at Her Majesty's Theatre of the musical written by Messrs Lloyd Webber and Hart, based upon my legend 'The Phantom of the Opera'.

After midnight, there will be further revelry across the road at 'Limelight' to which you are invited.

Your Obedient Servant

The Phantom

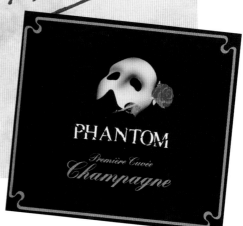

Gentlemen will wear Black Tie.

The Ladies are requested to dress in a manner befitting the occasion.

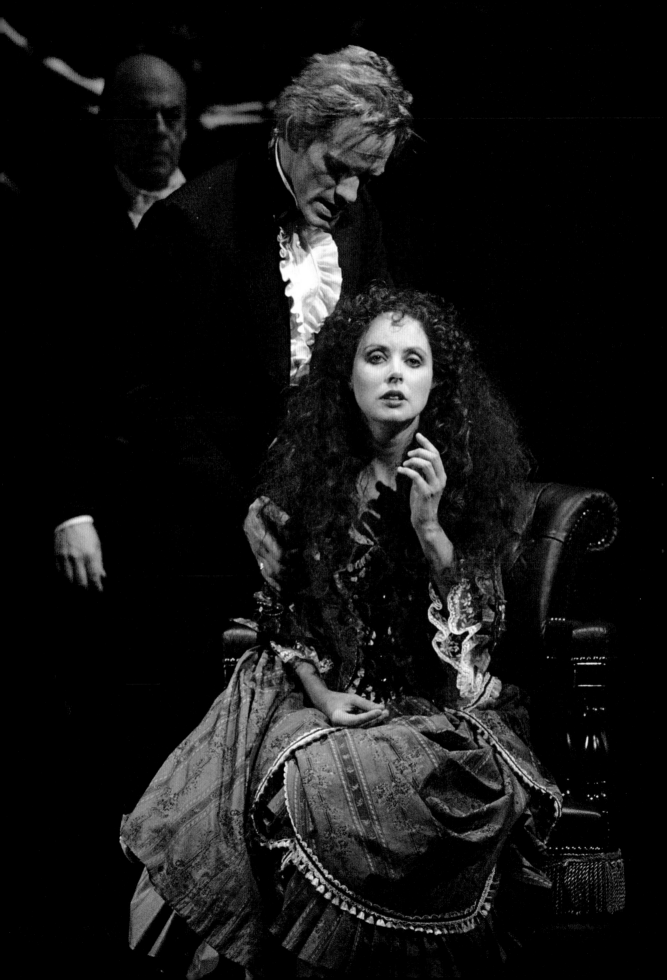

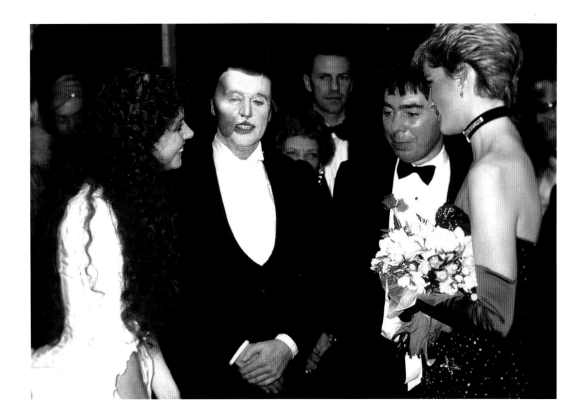

Above: Sarah Brightman, Michael Crawford and Andrew Lloyd Webber with HRH The Princess of Wales, at the gala performance in 1986.

Opposite: Steve Barton and Sarah Brightman on stage as Raoul and Christine in the original London production of *The Phantom of the Opera*, 1986.

crop up during the run-up to first night when the theatre's sprinkler system malfunctioned, flooding the stage and destroying a valuable cloth. The previews saw Sarah Brightman lose her voice and miss two performances, leaving understudy Claire Moore to step in. Press speculation grew.

A gala performance, the day before the opening, was attended by HRH The Princess of Wales. On opening night – Thursday, 9 October 1986 – the performance received a ten-minute standing ovation. Andrew Lloyd Webber and Cameron Mackintosh were so nervous they missed much of it. "We'd seen every preview and couldn't take it any more, so we went around the corner," they told reporters after emerging, smiling, from a nearby bar.

The pairing of Michael Crawford and Sarah Brightman worked perfectly. Crawford's discipline and energy made it seem as though the Phantom was a presence pervading the atmosphere even when he wasn't on stage. His tender, hypnotic voice and the tortured movements of a man constrained both emotionally and physically gripped audiences with a hold as powerful as that of the Phantom over Christine. Sarah Brightman, as Christine, delighted audiences with her frailty and the precision and bell-like clarity of her soprano voice. Lloyd Webber described the company as "one of the strongest

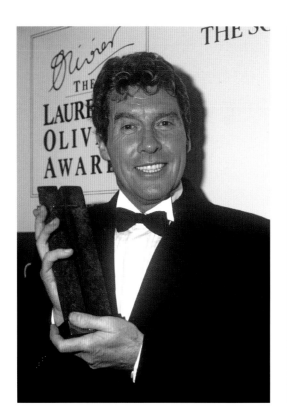

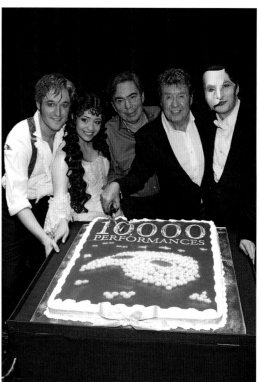

I have ever worked with. It was very exciting, as it was really the first time I had been involved with so many artists who came almost exclusively from an operatic background."

The success of the show was a consequence of the creative fusion of some of the most notable talents at work in the theatre. But there were other factors at work – including Andrew Lloyd Webber's and Cameron Mackintosh's unerring sense of timing, a true theatrical instinct allowing them to sense an audience's appetite and tastes. What the public now hungered for was romance and spectacle, glitz and glamour. They wanted tunes they could remember – and, with the *The Phantom of the Opera*, they got them in spades. The audience would go home with heads full of memorable melodies such as "All I Ask of You", "The Point of No Return", "The Music of the Night" and, of course, the title song itself. Producer Cameron Mackintosh's sure touch and nose for a hit had helped deliver a true classic of contemporary musical theatre.

Cementing box-office and critical success, later that year *The Phantom of the Opera* was acclaimed Best Musical of the Year at the 1986 Laurence Olivier Awards, and Michael Crawford was named Best Performer in a

Above: The 10,000th London performance was celebrated in 2010 by current cast members, with Andrew Lloyd Webber and Michael Crawford.

Above left: Michael Crawford with his Olivier Award for Best Performer in a Musical, 1986.

THE CAST

The Phantom of the Opera	MICHAEL CRAWFORD
Christine Daaé	SARAH BRIGHTMAN
Raoul, Vicomte de Chagny	STEVE BARTON
Monsieur Firmin	JOHN SAVIDENT
Monsieur André	DAVID FIRTH
Carlotta Giudicelli	ROSEMARY ASHE
Madame Giry	MARY MILLAR
Ubaldo Piangi	JOHN ARON
Monsieur Reyer	PAUL ARDEN GRIFFITH
Auctioneer	BARRY CLARK
Porter/Marksman/Fop (in *Il Muto*)	DAVID DE VAN
Meg Giry	JANET DEVENISH
Monsieur Lefèvre	DAVID JACKSON
Joseph Buquet	JANOS KURUCZ
Don Attilio (in *Il Muto*)/Passarino	JAMES PATTERSON
Slave Master (in *Hannibal*)	PETER BISHOP
Flunky/Stagehand	JUSTIN CHURCH
Policeman	MOSTYN EVANS
Page (in *Don Juan Truimphant*)	SUE FLANNERY
Porter/Fireman	ANDREW GOLDER
Page (in *Don Juan Truimphant*)	JANET HOWD
Wardrobe Mistress/Confidante (in *Il Muto*)	PEGGY ANN JONES
Princess (in *Hannibal*)	MARIA KESSELMAN
Madame Firmin	PATRICIA RICHARDS
Innkeepers Wife (in *Don Juan Truimphant*)	JILL WASHINGTON
The Ballet chorus of the Opera Populaire	SALLY ASHFIELD
	LYNN JEZZARD
	NICOLA KEEN
	PATRICIA MERRIN
	NAOMI TATE
	ALISON TOWNSEND
	DINAH JONES

Above: Cameron Mackintosh and Andrew Lloyd Webber, pictured in 2007.

Above right: The original cast recording is the best-selling cast album of all time.

Musical. The production was also named Best Musical in the annual *Evening Standard* Awards.

The Phantom of the Opera has gone on to become the longest-running production on Broadway as well as the longest-running show at Her Majesty's where on 23 October 2010 it celebrated its 10,000th performance.

The original cast recording was the first in British musical history to reach number one in the charts and has to date sold over 40 million copies worldwide, making it the best-selling cast recording album ever. The show's impact has been global, becoming the highest grossing musical ever and without doubt one of the most successful musicals of all time and is still packing them in having celebrated its 25th anniversary in October 2011.

THE MUSICAL
AROUND THE WORLD

IN ADDITION TO ITS SUCCESS IN ENGLISH, INCLUDING PRODUCTIONS IN BRITAIN, AMERICA AND AUSTRALIA, *THE PHANTOM OF THE OPERA* HAS BEEN TRANSLATED INTO 14 LANGUAGES FOR PRODUCTIONS IN NATIVE TONGUE, IN ARGENTINA/SPAIN, AUSTRIA, BELGIUM, BRAZIL, DENMARK, GERMANY, HOLLAND, HUNGARY, JAPAN, KOREA, MEXICO, POLAND, SWEDEN AND SWITZERLAND.

Once successfully established in London's West End, *The Phantom of the Opera* turned its sights westward. The show opened at New York's Majestic Theater on 26 January 1988 and, with original cast members Michael Crawford, Sarah Brightman and Steve Barton reprising their West End roles, was destined to be a success from the outset. It has since become the longest-running production in Broadway history, having surpassed the previous record-holder, *Cats*, in 2006.

On 11 February 2012 *The Phantom of the Opera* celebrated its 10,000th performance, the first Broadway show ever to do so, and on 26th January 2013 its 25th anniversary.

Stateside success was just the start of an international phenomenon that has seen *The Phantom of the Opera* circle the globe in inimitable and impressive style since 1986. At the time of writing, over 65,000 performances have been seen, by an audience worldwide topping 130 million people. The musical has played on six continents to audiences in 27 countries and 145 cities, all but Poland and Hungary using the original sets, costumes, staging and direction.

The show's advance across the globe from its first West End production was no chance phenomenon. Once a proposal had been approved, Andrew Lloyd Webber's Really Useful Group and Cameron Mackintosh Ltd would take an active role in helping the local producers assemble a creative team. The original director, choreographer, lighting designer and production and

Above: Michael Crawford with his Tony Award for Best Actor in a Musical, 1988.

Opposite: *The Phantom of the Opera* at the Majestic Theater in New York.

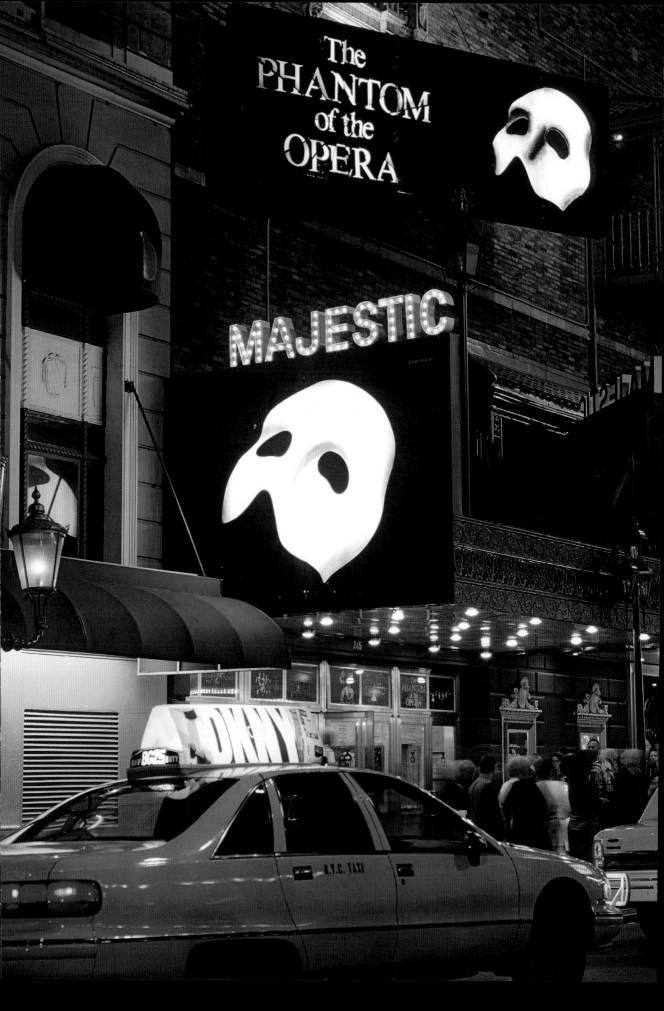

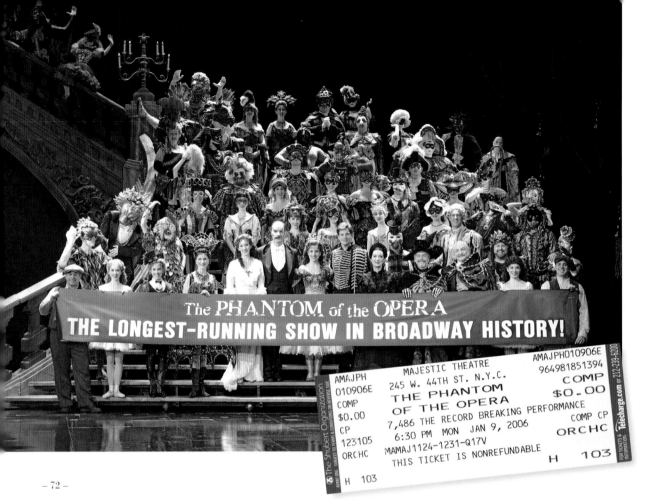

The PHANTOM of the OPERA
THE LONGEST-RUNNING SHOW IN BROADWAY HISTORY!

AMAJPH
010906E
COMP
$0.00
CP
123105
ORCHC

H 103

MAJESTIC THEATRE
245 W. 44TH ST. N.Y.C.
THE PHANTOM
OF THE OPERA
7,486 THE RECORD BREAKING PERFORMANCE
6:30 PM MON JAN 9, 2006
MAMAJ1124-1231-Q17V
THIS TICKET IS NONREFUNDABLE

AMAJPH010906E
964981851394
COMP
$0-00

COMP CP

ORCHC

H 103

sound designers were always consulted, in many cases seconding their own assistants or associates to give expert advice.

While the Broadway production continued its record-breaking run, further productions also opened in Los Angeles (1989) and San Francisco (1993), lasting four and six years respectively. A touring company that launched in Seattle in 1992 was even more successful, only closing 18 years later at Hollywood's Pantages Theater, on 31 October 2010. Andrew Lloyd Webber, Sarah Brightman and others were there to see nine-year veteran Tim Martin Gleason take his final bow as the Phantom. Three different productions in the USA ran concurrently for over five years. With 27 trucks required to take the 20-year-old sets from city to city, there are plans in the pipeline for a more compact tour after the 25th anniversary, reaching out to audiences in smaller theatres across the world.

North of the border, the original Toronto production of *The Phantom of the Opera* played to 7.1 million people in 4,226 performances between September 1989 and October 1999. A touring company then took the show to such far-flung territories as Hawaii, Alaska, Singapore and Hong Kong. The first Australian production of *The Phantom of the Opera* premiered in

Above: The cast photograph taken to mark the longest-running show in Broadway history. A ticket stub shows the landmark was reached with the 7,486th performance in 2006.

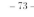

Above: *The Phantom of the Opera* fever sweeps America. San Franciscans marked their show's first anniversary in 1994 with a proclamation from the mayor.

Above right: Tim Martin Gleason on stage for his final bow as the Phantom, at the Pantages Theater in Hollywood in 2010.

Melbourne on 8 December 1990, Anthony Warlow playing the Phantom opposite Marina Prior. The elegant 19th-century Princess Theatre, restored in the late 1980s, proved the perfect setting. The production then toured Australasia for a record-breaking eight years. It made Anthony Warlow and Rob Guest, who replaced him as the Phantom, such stars that the production returned for another triumphant run in July 2007.

The Phantom of the Opera has been translated into 14 languages. The translation process is, as would be expected, rigorously overseen by Really Useful; after a selection of the best translators has been obtained by local producers, their samples are "back translated" in London and sent to lyricist Charles Hart for comment. Only then will a full translation go ahead and this, too, is translated back into English for scrutiny. Additional refinements take place during rehearsal, when translated lyrics are set to the score and any that don't scan or sound right are changed.

The first country to translate the show into their own language was Japan in 1988, and the result proved such a hit that the show has been running there almost continuously ever since. While actors in Europe and the United States take their bow and are called back, the cast in Japan waves to the

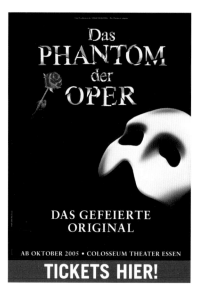

Above, left to right, from top: Promotional material from replica productions in Melbourne, Buenos Aires, São Paulo, Shanghai, Stuttgart and Essen.

Below, left to right: Tickets to the premieres in Melbourne and Sydney.

Above: *The Phantom of the Opera* in Melbourne, 2007, with Ana Marina as Christine and Anthony Warlow as the Phantom.

audience after the third curtain call. Cast members then exit the stage still waving, the last to disappear being the Phantom himself. Interestingly the Swiss performances were six a week in German and two in English during the production's 21-month run at Basle's Musical Theatre Messe from 1996. This was largely because, as with traditional opera audiences, there was a demand to hear the show in its original language. This, in turn, led to many very subtle changes in choreography and staging necessitated by the different rhythms and cadences of the language. Also in the mid-1990s, Holland's Circus Theatre in Scheveningen staged over 1,000 performances of *Het Spook van de Opera* with Henk Poort as the Phantom. Several albums have been recorded by the international casts, including Japanese, Dutch, German and Spanish.

The usual rehearsal period for a production of *The Phantom of the Opera* is six to eight weeks. The first four or five weeks are spent on the music, staging and choreography; then come two weeks of technical rehearsals before previews in front of an audience and final adjustments. By the time of the 25th anniversary *The Phantom of the Opera* had been staged in most major territories.

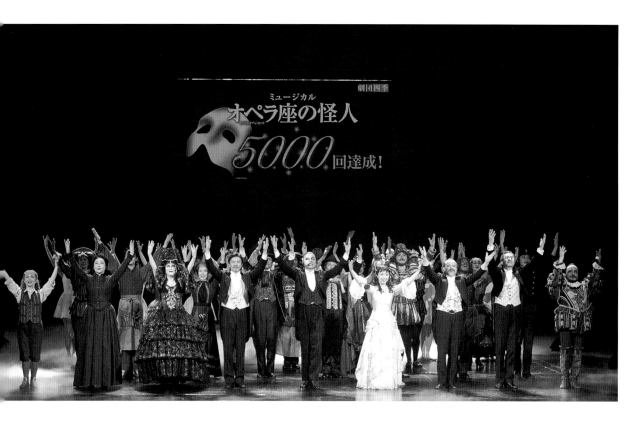

Since *The Phantom of the Opera*'s last visit to South Africa the hi-tech Teatro at Montecasino in Johannesburg has been built especially for large-scale musical productions. It is one of the biggest lyric theatres in the world and together with Cape Town's Artscape Theatre has recently hosted a production with an all South African cast and crew.

A previous international tour had commenced in Cape Town in April 2004 and transferred to Pretoria before going to China and Korea. Andre Schwarz reprised the role of the Phantom, while Jonathan Roxmouth, playing Raoul, was the alternate Phantom. Roxmouth had been inspired to become an actor when he first saw *The Phantom of the Opera* as a child and describes it as his 'dream show and part'.

Alongside putting on the original production in these major venues there was also a growing need for a newly conceived version that could be toured more economically. Andrew Lloyd Webber, with David Cullen, had already re-orchestrated the show from a 28-piece to a 19-piece ensemble and Cameron Mackintosh developed a new staging, retaining Maria Björnson's costumes, that opened in the UK in spring 2012. In moving the show in new directions there is of course a balancing act required between maximising

Above: The Japanese-language production in Kyoto, celebrating 5,000 performances on 13 December 2009.

THE PHANTOM OF THE OPERA

the show's remaining potential to reach audiences without giving up too much control of the style and quality of the production.

The first of the new productions of *The Phantom of the Opera* to differ from the London original was staged in Hungary at Budapest's Madách Theatre, with considerable assistance from the state. This production began in 2003 and featured entirely new set designs by Kentaur and costume designs by Vágó Nelly.

Poland's premiere of *The Phantom of the Opera* took place in March 2008 at Warsaw's Teatr Muzyczny Roma. Some critics felt it borrowed from the 2004 movie – a collaboration between Andrew Lloyd Webber and director Joel Schumacher – in which scenes such as the swordfight were added, while screens with images projected on them formed part of the stage backdrop. During the overture, this included a picture of the staircase of the actual Opéra Garnier in Paris and later, during the title song, images of its basements. The production ran until June 2010. A new production is planned for Prague.

In 2006 Harold Prince staged *Phantom – The Las Vegas Spectacular*. Adapted from the original it was condensed into a 95-minute performance with no interval and ten shows a week could be performed over six days: the roles of the Phantom, Christine and Carlotta were each played by two different cast members. The cuts were made personally by Lloyd Webber and Prince, with reprises, verses and even dialogue being trimmed. All the

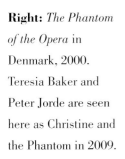

Right: *The Phantom of the Opera* in Denmark, 2000. Teresia Baker and Peter Jorde are seen here as Christine and the Phantom in 2009.

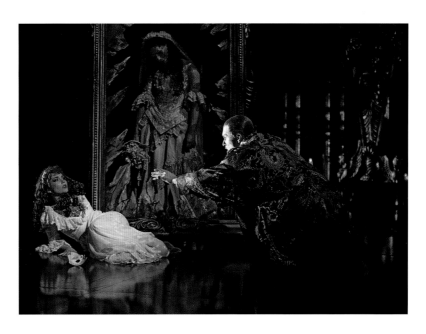

THE PHANTOM OF THE OPERA

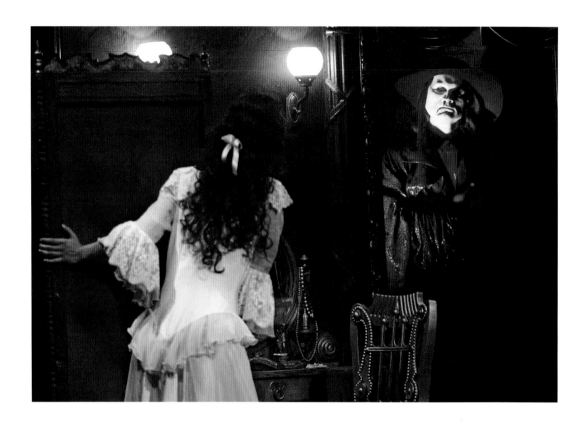

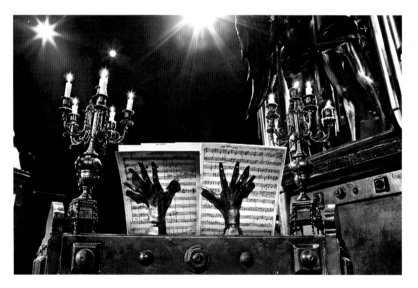

Above: *The Phantom of the Opera* at Budapest's Madách Theatre, which opened in 2003, with Andrea Mahó as Christine and Atilla Csengery as the Phantom.

Left: Warsaw has its own, 'non-replica' – but fully approved – version of the musical, with sets designed by Pavel Dobrzycki, 2008.

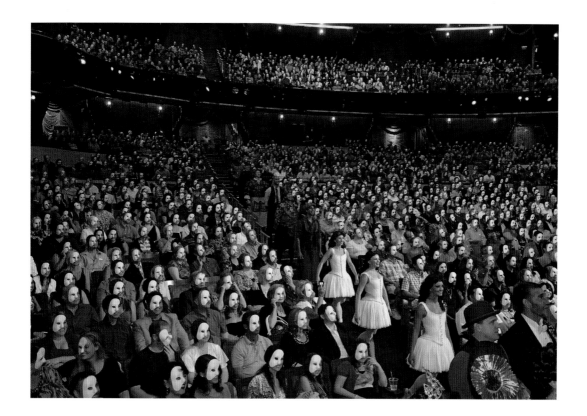

Above: Celebrations for the fourth anniversary of the Las Vegas production in 2010 included the audience donning Phantom masks.

Overleaf: The enormous chandelier, costing $7.2 million, at the Venetian Theatre, built to house *Phantom – The Las Vegas Spectacular*.

musical numbers, however, remained. The result was what the *Los Angeles Times* called "one part Broadway, one part amusement park and one part circus extravaganza." Harold Prince was delighted at the result, chuckling "They wanted surprises, we gave them surprises." A $7.2 million chandelier made from Swarovski crystals represented a substantial chunk of an impressive production budget of $35 million that, added to the $40 million cost of building the Venetian Theater to stage it, made *Phantom – The Las Vegas Spectacular*, at the time of its opening, one of the world's most expensive musical productions.

The Phantom of the Opera's worldwide grosses to date are estimated to total in excess of $5.6 billion – far surpassing the highest-grossing film of all time, the $2.7 billion *Avatar*. But while numbers can tell only part of the story, the fact that the Harvard Business School constructed a case study on the show in 2007 suggests *The Phantom of the Opera*'s worldwide success has been based on a combination of creativity and commercial acumen. Its combination of timeless story and wonderful music will surely continue to enthral audiences all over the world.

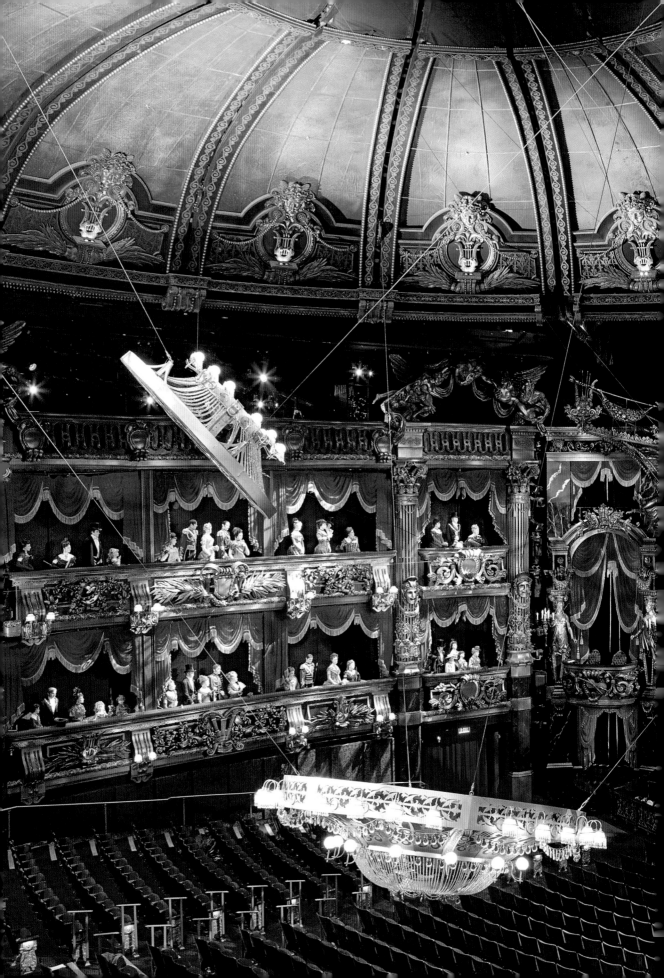

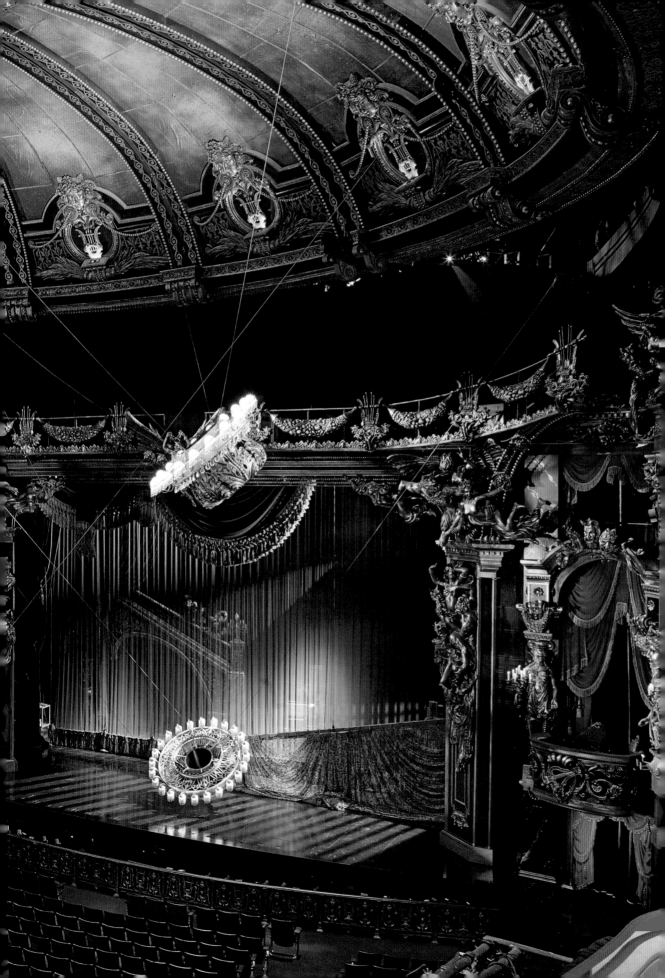

25
Y E A R S

THE BRILLIANT ORIGINAL
PHANTOM
of the
OPERA

ACT III

"It is amazing to think that The Phantom of the Opera *has already celebrated a record breaking run of more than 25 years. From the very first performance, audiences have fallen in love with the unique alchemy of Andrew Lloyd Webber's score and Maria Björnson's fabulously beautiful design, so brilliantly staged by Hal Prince and Gillian Lynne."*

Cameron Mackintosh

Opposite: Poster announcing 25 Years of the London production.

25 YEARS ON

THE WORLD HAS CHANGED SINCE 1986, BUT *THE PHANTOM OF THE OPERA*
HAS REMAINED A RARE CONSTANT FOR MORE THAN 25 YEARS. AND ANDREW
LLOYD WEBBER HAS REMARKED "I KNOW FOR CERTAIN I'LL NEVER HAVE
ANYTHING AS BIG AS *THE PHANTOM* AGAIN".

A quarter of a century on, and in the middle of a new recession, *The Phantom of the Opera* continues to draw audiences in search of a great story and memorable tunes. Andrew Lloyd Webber's intuition in developing the lyrics and tone, emphasising the tragic love story, has also been validated.

To mark the extraordinary milestone of 25 years Andrew Lloyd Webber and Cameron Mackintosh planned a special production to take place at London's Royal Albert Hall in October 2011. Sierra Boggess, who starred in the show's Las Vegas production in 2006, was reunited as Christine with Phantom Ramin Karimloo. Both artists have been an outstanding Phantom and Christine in recent productions and have also enjoyed huge success together as the stars of *Love Never Dies* (2010).

"Though this staging was naturally drawn from the brilliant original, it was both a spectacular and unique production", said Mackintosh. It was an ambitious project with only three days' access to the vast venue allowed before curtain up.

Designer Matt Kinley said " When I was originally asked to design this event, I thought it was to be a concert for the 25th Anniversary, in the same way as I had done for the 25th Anniversary of *Les Misérables* at O₂ but Cameron quickly made it apparent that the show needed to be completely staged in this uniquely theatrical venue as he and Andrew Lloyd Webber felt it would not work unless it was a whole show rather than a concert. The prospect of designing a staged show at the Albert Hall was daunting as the space is

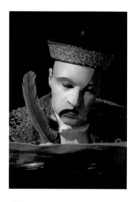

Above: The 2011 London Phantom, John Owen-Jones, who has played the role over 1,500 times.

Opposite: Sierra Boggess and Ramin Karimloo, seen in *Love Never Dies*, London, 2010, who starred in the 25th anniversary concerts.

– 84 –

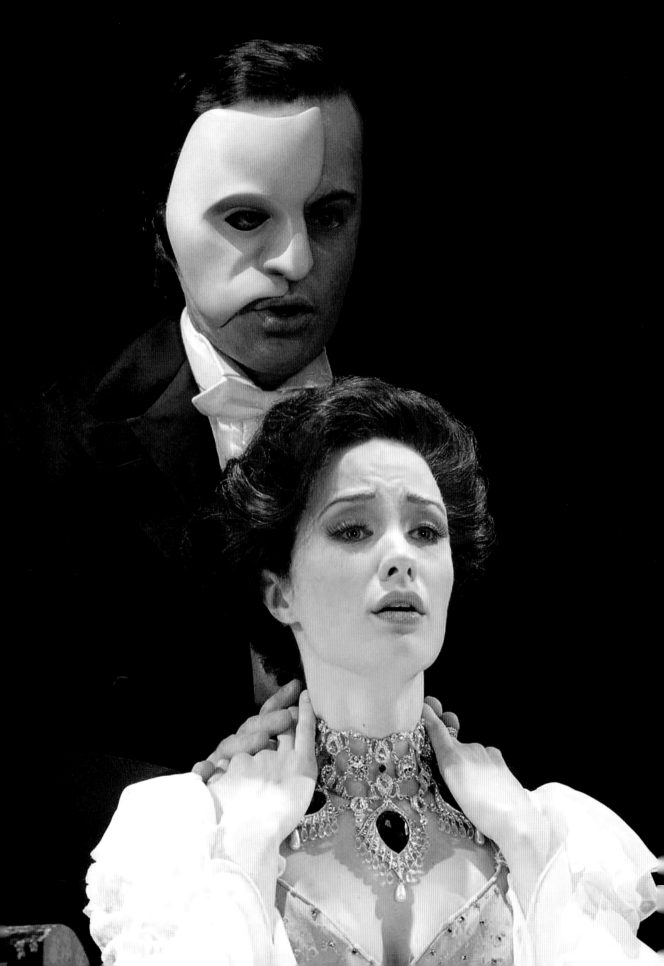

not an easy one to translate a proscenium show into. We also had to try and produce something that was a suitable tribute to Maria Björnson's extraordinary original design. The solution was to use the edge of the Albert Hall balconies to build uprights to form an opera house proscenium with boxes on each side for our own singers. This allowed us to use the elaborate proscenium sculptures from the original show and we also created a version of the original 'travelator' that descended from the opera boxes on either side for the Lair journey and backstage scenes. The orchestra was elevated on a platform and backed by a gauze onto which we projected the opera sets and the heavy drape work, filmed directly from the show at Her Majesty's. This gauze could also reveal the Phantom playing the huge Albert Hall pipe organ behind it."

The lavish production of *Phantom of the Opera at the Albert Hall* featured a cast and orchestra of over 200 – including Hadley Fraser as Raoul, Wendy Ferguson as Carlotta, Barry James as Monsieur Firmin, Gareth Snook as Monsieur André, Liz Robertson as Madame Giry and Wynne Evans as Piangi – as well as some special guest appearances. The production was directed by Laurence Connor, with musical staging and choreography by Gillian Lynne, lighting by Patrick Woodroffe and Andrew Bridge and sound by Mick Potter.

Above: The Royal Albert Hall, scene of the 25th anniversary celebrations in October 2011: "Phantom of the Opera at the Albert Hall".

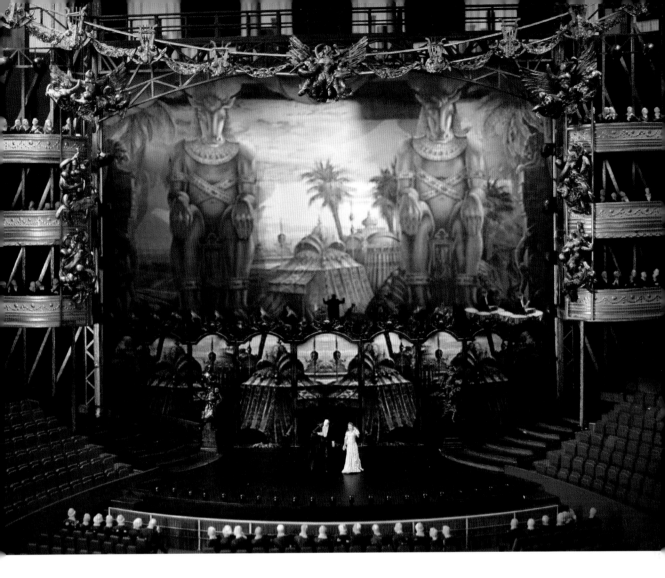

Above: Model designed by Matt Kinley for the Hannibal scene, Royal Albert Hall, 2011.

Cameron Mackintosh told the press at the launch, "The success of the show has become the stuff of theatrical legend and there could be no better 19th-century theatrical auditorium in London for this occasion than the Royal Albert Hall. With its Victorian red plush and celebrated, magnificent organ it is the perfect place for the Phantom to haunt."

Tickets for the three celebratory perfomances sold out within five hours of going on sale and so in order to enable more people to see this spectacular production it was relayed live to cinemas around the world and subsequently released on DVD and Blu-Ray.

The productions being staged around the world in London, New York and Las Vegas continue. From September 2010 a version of *The Phantom of the Opera* has been licensed to schools and youth groups in America and Canada. An impressive total of 180 schools and colleges had signed up to

Now Celebrating

22Years

www.thephantomoftheopera.com

Designed and printed by Dewynters

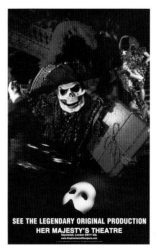

Above and opposite: Posters celebrating various milestones in the history of the London production.

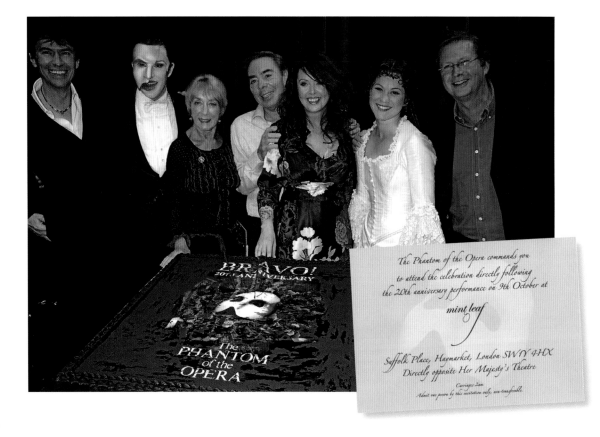

The Phantom of the Opera commands you
to attend the celebration directly following
the 20th anniversary performance on 9th October at

mint leaf

Suffolk Place, Haymarket, London SW1Y 4HX
Directly opposite Her Majesty's Theatre

Carriages 2am
Admit one person by this invitation only, non-transferable.

stage the show by summer 2011. Following this success the initiative was rolled out to the UK and Eire in Autumn 2011. Academic schools, colleges and university groups can apply for licenses to perform the show further spreading the word and introducing the immortal story to new generations.

From the first act of the show being trialled in front of an audience at a private summer festival to a quarter of a century's uninterrupted West End run and productions worldwide, *The Phantom of the Opera* has been a theatrical success story like no other. A new production of *The Phantom of the Opera* began a UK tour in February 2012 opening at the Theatre Royal, Plymouth with John Owen Jones as the Phantom. It retained Maria Björnson's wonderful costumes with a brilliant new design by Paul Brown that enables the production to play in theatres around the world no longer able to sustain the original. Thus the show started a new life reaching out to an even wider global audience.

Above: Charles Hart, Gillian Lynne, Andrew Lloyd Webber, Sarah Brightman and Andrew Bridge celebrate the 20th anniversary with London cast members in 2006.

Opposite: *Phantom of the Opera at the Albert Hall*, October 2011.

Overleaf: The Phantom as Red Death, London 2011.

CAMERON MACKINTOSH'S
UNIQUE SPECTACULAR STAGING
OF **ANDREW LLOYD WEBBER'S**
MUSICAL PHENOMENON

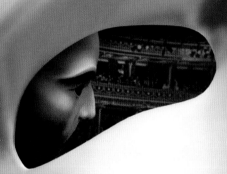

IN CELEBRATION OF

Y E A R S

PHANTOM
OF THE OPERA
at the
ALBERT HALL

A CAMERON MACKINTOSH
& THE REALLY USEFUL
THEATRE COMPANY PRODUCTION

ROYAL
ALBERT
HALL

A CAST
AND ORCHESTRA
OF OVER 200

1 & 2 OCTOBER 2011
phantom25th.com • 0845 401 5031

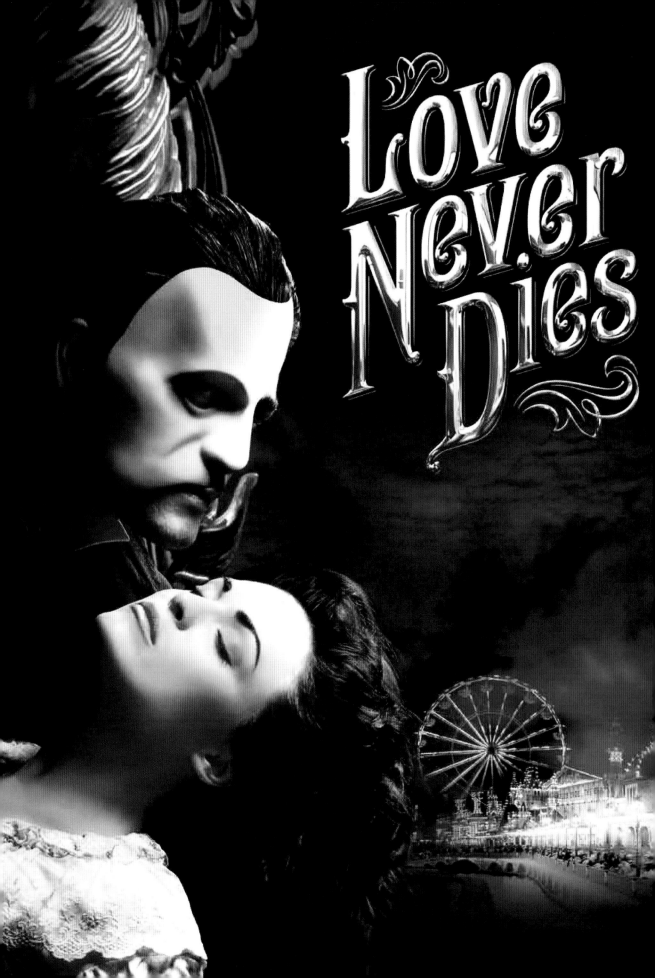

LOVE NEVER DIES

WHEN ANDREW LLOYD WEBBER'S *LOVE NEVER DIES* OPENED AT LONDON'S ADELPHI THEATRE IN MARCH 2010 IT MADE HISTORY AS THE FIRST MUSICAL SEQUEL TO BE STAGED IN THE WEST END. IT HAD TAKEN TWO DECADES OF GESTATION FOR THE CONTINUING STORY OF THE PHANTOM AND CHRISTINE TO ARRIVE ON THE STAGE.

Above: Frederick Forsyth's 1999 novella is a continuation of the Phantom's story.

Opposite: Poster for *Love Never Dies*, 2010.

A sequel to the phenomenally successful *The Phantom of the Opera* was in gestation, on and off, for twenty years.

In roughly 1990 Lloyd Webber had the idea of continuing the story of the Phantom and Christine and setting it in New York at the end of the nineteenth century. He had a discussion, which he described as "thrilling", over dinner with the late Maria Björnson, who created the brilliant design of the original production of *The Phantom of the Opera*, in a strange restaurant in the grounds of Chelsea Football Club. She was very excited about a New World location. They felt the key to the piece could be setting the story in New York and that this time the Phantom lived above his realm, perhaps in Manhattan's first penthouse. But where in America could the Phantom have first gone to? Where could he have been unnoticed and yet been a part of the community?

Having seen a documentary about Coney Island the answer to this question became clear to Lloyd Webber. Here was the Phantom's new home among the freaks and the oddities who were such a part of Coney. Lloyd Webber also had the thought that perhaps Christine came to America with her son and knew how he believed the piece had to end.

Before Maria died so tragically young, Lloyd Webber discussed these ideas with the novelist Frederick Forsyth. They had known each other for many years and Lloyd Webber had composed the score for the 1974 film version of Forsyth's novel *The Odessa File*. Forsyth developed the ideas and published his own version as a novella, *The Phantom of Manhattan*. By then Lloyd Webber had moved on to other projects because although he sensed the seeds of a story for a show, he couldn't make the plot work for himself as a composer. Nonetheless he found it very difficult to leave the story alone.

– 95 –

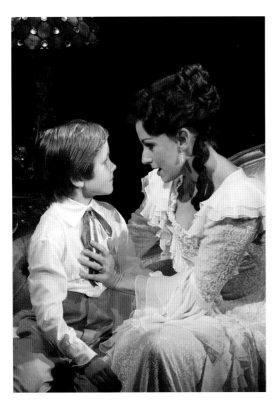

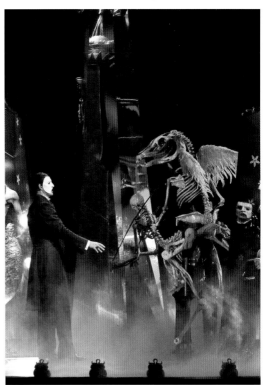

It was in 2006, after producing several new musicals, revivals and pioneering casting for theatre by television, that Andrew seriously decided to look at the story again. He discussed it with several writers and directors, to no avail until he outlined the problems he had with the plot to his old friend and colleague Ben Elton. Lloyd Webber and Elton had collaborated in 2000 on *The Beautiful Game*, which premiered at the Cambridge Theatre in London and has since been re-worked and performed in Canada and South Africa with the new title *The Boys in the Photograph*.

It was Elton who found the way through the roadblock. He pointed out that the first thoughts for a new plot contained several new characters and suggested that any continuation of the story must be about the protagonists of the original show. So the new characters were axed and Gustave, Christine's son, is the only new principal character in *Love Never Dies*. Come the autumn of 2007, Elton had shaped a story outline that Lloyd Webber felt could be made to work.

Lyricist Glenn Slater, original director Jack O'Brien, choreographer Jerry Mitchell, set and costume designer Bob Crowley, lighting designer Paule Constable and sound designer Mick Potter were all brought on board to help

Above: *Love Never Dies* in Melbourne, 2011, with Ben Lewis as the Phantom.

Above left: Celia Graham as Christine with Jack Costello as her son Gustave, London production of *Love Never Dies*, 2011.

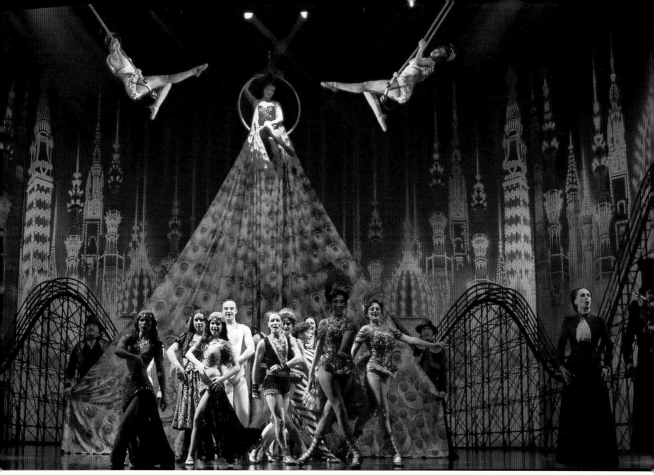

Above: Cast of *Love Never Dies*, London production, 2011.

Below: Ben Elton with Andrew Lloyd Webber, collaborators on *Love Never Dies*.

create the stage production, final flourishes being added by projection designer Jon Driscoll and Scott Penrose who devised the special effects.

When at last Andrew was content he had a story, he made a decision about the new show's structure and musical shape. He thought it would be daft not to have a flavour of the original show occasionally. But only very occasionally. He decided that none of the main melodies of *The Phantom of the Opera* would appear in *Love Never Dies*. This seemed appropriate as the story is set roughly ten years on at a time when the world was experiencing enormous change. With a few short exceptions, Andrew stuck firmly to his rule in composing the show.

However, the history of one of the melodies requires a little more explanation. It is "Love Never Dies" itself. This was the only tune Lloyd Webber wrote at the time when he first thought of continuing the Phantom and Christine's story. It was performed by Kiri Te Kanawa under the title "The Heart is Slow to Learn" at Lloyd Webber's 50th birthday concert at the Royal Albert Hall. Even though Andrew had given up on the new *The Phantom of the Opera* at the time, some second sense told him not to release the Kiri Te Kanawa recording, although it did subsequently appear on a limited edition compilation. But with *The Phantom of the Opera*'s sequel definitely abandoned in his mind, he used the chorus of the

melody in *The Beautiful Game*. Lloyd Webber has since said, "Frankly I felt it stuck out like a sore thumb from the rest of the score, and it was eventually cut and replaced by 'The Boys in the Photograph', now the title of the show when it is revived". However, the dramatic situation in the story of *Love Never Dies* is exactly the same as the one for which he had originally composed the melody and once the new plot was firmly in place the song was restored to its rightful home.

Otherwise all of the main melodies in the score for *Love Never Dies* were composed during 2008 and 2009 for the story that Elton unlocked. Workshops were held with cast and creatives to fine-tune the score and storyline and the unusual step of taking over the proposed venue for three weeks in order to try out technical effects and illusions all helped to build anticipation for the arrival of the show in the West End.

The full score was recorded with most of the original principal cast and released as a CD before *Love Never Dies* premiered at the Adelphi Theatre in London on 9 March 2010.

The Phantom was played by Ramin Karimloo, who went almost straight into rehearsals having completed an extended run playing the same role in the original show at Her Majesty's Theatre. He also appeared briefly as Christine's father in the 2004 film and previously played the role of Raoul, making him the

Above: The set model for *Love Never Dies*, seen in front of the actual set itself being built on stage, Melbourne production, 2011.

only person to have played all three of the men in Christine's life. Sierra Boggess, as Christine, had first come to Andrew's attention in America where she played the same role in *Phantom – The Las Vegas Spectacular*. Joseph Millson as Raoul, Liz Robertson as Madame Giry and Summer Strallen as Meg completed the principal line-up.

During the show's previews a small group of fans who were opposed to even the idea of a sequel ran an aggressive internet campaign against the production and a negative internet review, published before the show had opened, was widely circulated by the international press with an undoubtedly upsetting effect on the public attitude towards the production. This was the first time the efficacy and viral spread of internet content had a tangible influence on a West End production but it has since been widely acknowledged as a problem for theatre in general. Despite this, on opening the show received some five star reviews and general praise for the lush score and orchestrations – but the general critical response was mixed.

Andrew himself went through a personal crisis during the run-up to the production when he was diagnosed with prostate cancer. He has recently been reported as saying, "With hindsight we should have said, 'Let's put the whole thing on hold until I'm 100% again.' Frankly I wasn't feeling very well."

Never one to let setbacks pull him down, and unashamed to say that *Love Never Dies* is the most personal of all his stage works to date, Lloyd Webber has since allowed the show to develop even further.

In November 2010 the London production was re-worked slightly with a change of order, some additional lyrics from Charles Hart and subtle staging differences to provide a stronger narrative drive. It was nominated for seven Olivier Awards in February 2011 but closed on 27 August of that year.

In the months following the West End opening, Tim McFarlane (who runs Really Useful Company Asia Pacific) approached Lloyd Webber to see whether he would consider a brand new production of the show, with an Australian creative team that would then open in Melbourne. Without hesitation, Lloyd Webber immediately gave the go-ahead and met with Australian director Simon Phillips (Artistic Director of the Melbourne Theatre Company with credits ranging from new plays to Shakespeare and musicals to opera, and whose production of *Priscilla Queen of the Desert The Musical* was running in London). Impressed by the frank responses he received from Simon about the West End production he had no hesitation in entrusting him with helming a brand new production of the show. In Simon Phillips' own words, "At our first meeting, Andrew was saying 'I want it to be different'." So that was the brief Phillips

worked on with designer Gabriela Tylesova, choreographer Graeme Murphy and lighting designer Nick Schlieper.

"The exquisitely unfolding score", said Phillips, "carries the audience on a journey rich with passion and beauty but also enlivened by the gaudy and grotesque world of Coney Island. It's hard to imagine a setting that could match the opportunity the Paris Opera House offered its creative team, but Coney Island was an inspired idea… When Gabriela and I got together to start work on the piece, ideas rampaged into life." The final design included a vertiginous roller coaster, moving carousel animals and a huge mask-inspired proscenium arch that dominates the stage. Ben Lewis played the Phantom opposite Anna O'Byrne as Christine.

This new envisioning of the story opened to acclaim on 28 May 2011 at the Regent Theatre in Melbourne. The production won three Helpmann Awards (the Australian Tony) for Best Costume, Scenic and Lighting Designs. On seeing the production Lloyd Webber stated, "I have the great joy of being able to say that I think this production is probably the finest one I could ever, ever hope for" and was widely reported as saying that he hoped this version might eventually make it to Broadway and beyond.

There is a curious parallel with the history of *Love Never Dies* so far and one of the world's best-loved operas. When Giacomo Puccini was working on *Madam Butterfly* everybody expected it to be his greatest success, even more popular than *La Bohème* and *Tosca*. To everyone's surprise when *Madam Butterfly* premiered at La Scala, Milan in February 1904 it was very poorly received. The hostile reaction was largely orchestrated by an opera claque. Some of the immediate naysayers were considered the composer's rivals and could definitely be viewed as the turn of the twentieth century's equivalent to today's internet bloggers. Puccini immediately withdrew the libretto and score and returned to work on the piece, restructuring it completely. When his second version opened in Brescia just three months later the reception was much better. In all Puccini created five versions of *Madam Butterfly* before arriving at the version which is performed and loved the world over today.

Reaction has been far more positive to the Melbourne production of *Love Never Dies* (effectively Andrew's third) and, soon after opening, Lloyd Webber flew out to Australia to supervise personally NBCUniversal's filming of the production for global release on DVD and Blu-ray in 2012. Is it possible that *Love Never Dies* could become Lloyd Webber's *Madam Butterfly*?

Opposite: The Melbourne production of *Love Never Dies*, including Ben Lewis as the Phantom, Anna O'Byrne as Christine, Simon Gleeson as Raoul, Trent Heath and Kurtis Papadinis as Gustave, Sharon Millerchip as Meg Giry, Emma J Hawkins as Fleck, Paul Tabone as Squelch, and Dean Vince as Gangle.

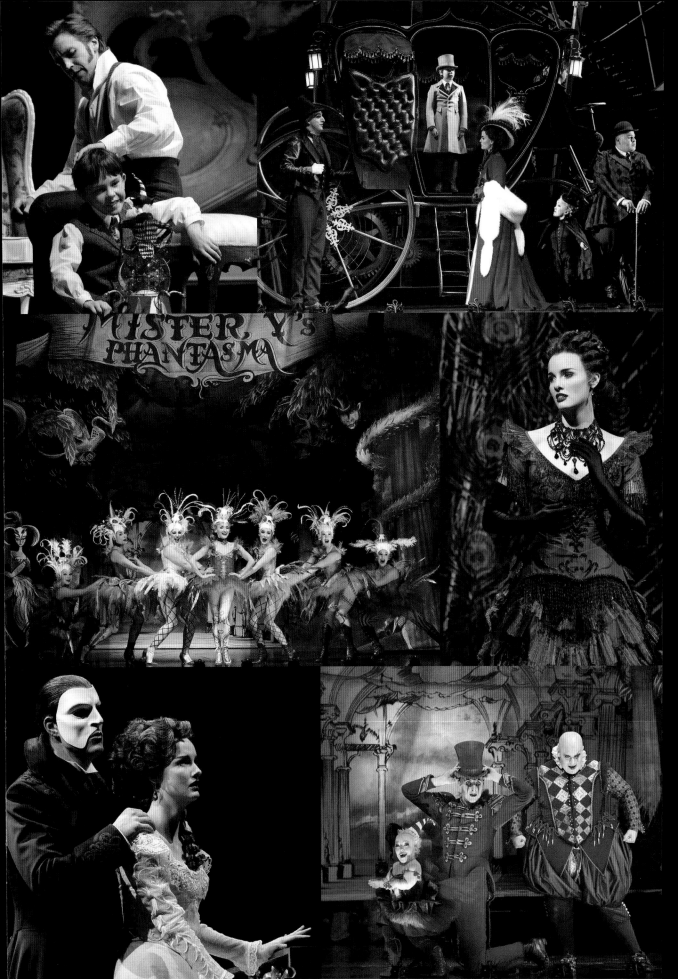

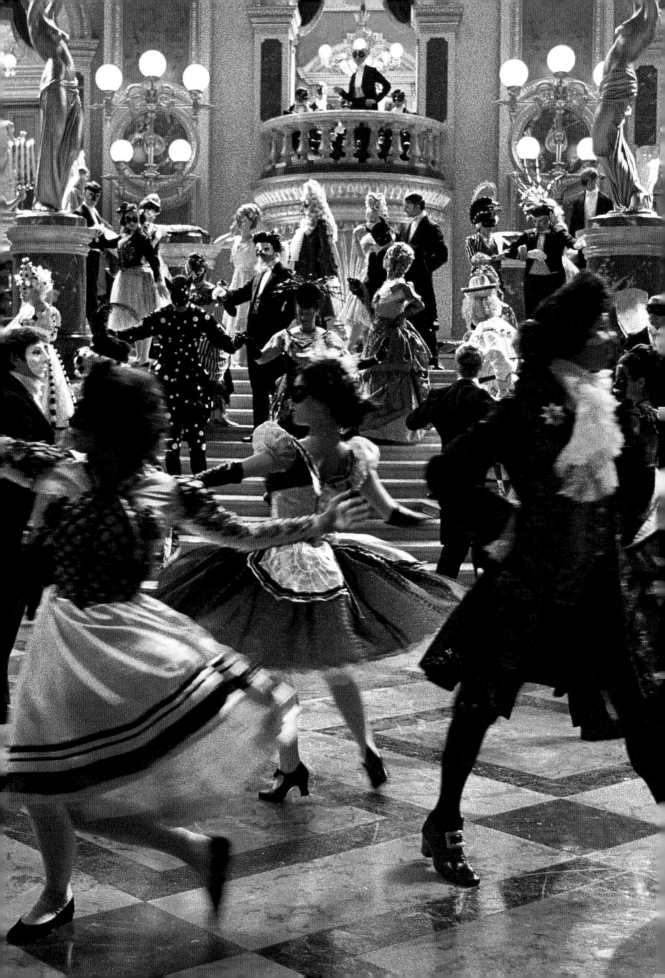

ACT IV

"My job is to hire people that are more talented than I am... And you work with them, it's a collaboration. You have a great group of enormously gifted people, hopefully, and you're creating something that you are very, very passionate about."

Joel Schumacher

Opposite: The masked ball scene, *The Phantom of the Opera* film produced by Andrew Lloyd Webber and directed by Joel Schumacher, 2004.

THE PHANTOM ON FILM

WHEN NEW IDEAS ARE HARD TO COME BY, HOLLYWOOD TENDS TO REACH INTO
ITS BACK CATALOGUE AND RESURRECT PAST TRIUMPHS. THOSE THAT SUCCEED IN
BEING AN IMPROVEMENT ON THE ORIGINAL ARE FEW AND FAR BETWEEN.
IN 1943 IT WAS THE TURN OF *THE PHANTOM OF THE OPERA*, MADE AS A
SILENT FILM SOME 18 YEARS EARLIER, TO FACE THIS TREATMENT.

B y the early 1940s Universal had seen a decline in fortunes and was
struggling to compete with glamorous rival studios Metro-Goldwyn-
Mayer, Paramount and Warner Brothers. Its stock-in-trade was the
second-feature film rather than the main event, and the studio specialised
in Deanna Durbin musicals, Abbott and Costello comedies and a successful
series of Sherlock Holmes movies starring Basil Rathbone and Nigel Bruce.

The studio hoped the new *Phantom of the Opera* film would signal a
change in their fortunes. Consequently, the production values were extrava-
gant for a film made during World War Two, its budget of $1.75 million quite
considerable for the time: a large cast of singers, lavish costumes and a vast
selection of musical numbers were filmed in glorious Technicolor.

Directed by Henry Koster, the original intention was to create a musical
extravaganza, a vehicle for young singing star Deanna Durbin, billed as
Christine opposite Broderick Crawford as the Phantom. However, Broderick
(today best known for his Oscar-winning role in the 1949 film *All the King's
Men*) was drafted into the army in 1941 and was therefore unavailable.

Second choice was Charles Laughton, an English actor with immaculate
diction who had recently had a massive hit with the studio's remake of *The
Hunchback of Notre Dame* (1939), directed by William Diertle. A delay in
making a start on the film, however, caused the original cast and production
team to break up and the studio was forced to go back to the drawing board.

In 1943 the project was restarted, this time with Claude Rains as the
Phantom opposite relative newcomer Susanna Foster, a young singer who had
made her debut in 1940, aged just 15, in *The Great Victor Herbert*. Arthur
Lubin, whose career highpoint had so far been Abbot and Costello comedies,

Above: Claude Rains
(1889–1967); Susanna
Foster (1924–2009).

Opposite: Italian
poster for the 1943
Universal release,
distributed worldwide.

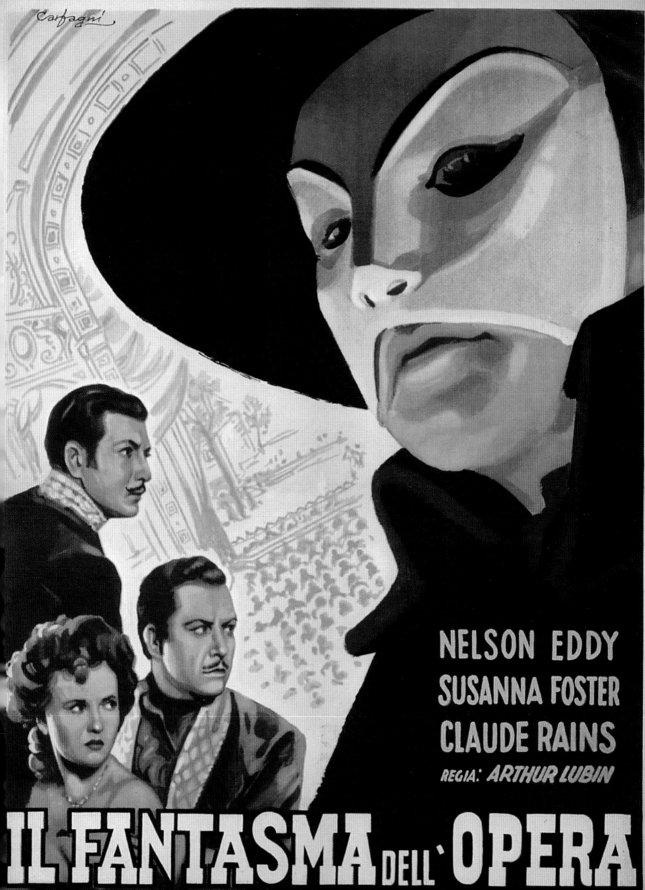

NELSON EDDY

SUSANNA FOSTER

CLAUDE RAINS

REGIA: *ARTHUR LUBIN*

IL FANTASMA DELL'OPERA

IN TECHNICOLOR

UN FILM "UNIVERSAL„

G. MENAGLIA - ROMA

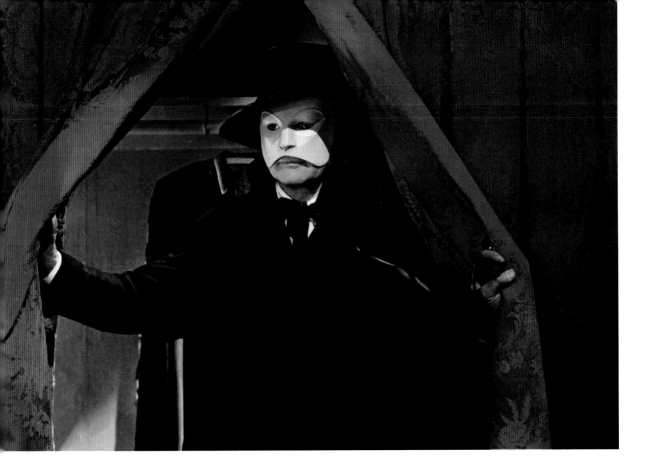

was given the task of directing. It was perhaps an odd choice, but then all the ablest young men had been drafted. The resulting film, while not exceptional, is regarded by many as the best Lubin ever made.

The original Leroux storyline was completely revised and the names of the characters changed. The Phantom was not Erik, a deformed genius, but a middle-aged violinist called Erique Claudin. He was no longer deformed from birth but rather disfigured by a tray of etching acid thrown in his face. There is little of the terror of the original 1925 film. Even the revelation of Claude Rains' disfigured face is unspectacular when compared with the original Lon Chaney makeup, looking more like an unpleasant skin complaint than an horrific disfigurement. There was a lack of enthusiasm from the critics.

Yet audiences loved it. It was a luxurious production in an austere time and an antidote to the hardship of the war years. In spite of stringent budget restraints keeping the amount that could be spent to a mere $10,000, the set was ingenious. The producers had a stroke of luck in that another sumptuous opera was already being filmed on Stage 28 and much of the set could be re-used with a few minor alterations to make it suitable for Technicolor. The

Above: Claude Rains as Erique Claudin, 1943.

Below: Director Arthur Lubin (1898–1995).

Above: Herbert Lom
as the Phantom, 1962.

Below: Director
Terence Fisher
(1904–80).

Phantom's lair was far less convincing, looking more like a disused mine than the basement of an opera house – and although there was a lake present, the actors merely ran around the edge of it. It was impossible to create the grand foyer on such a small budget, so the masked ball scene was cut entirely.

The Phantom of the Opera made its next film appearance in 1962, this time courtesy of the London-based Hammer company, which had made its name creating horror films on a shoestring. The director was Terence Fisher, the Phantom Herbert Lom, with Heather Sears as his Christine. It was more like the 1943 version than the 1925 version, with one significant difference: the Phantom was now a completely innocent figure, being blamed for the misdeeds of a new antagonist, the Dwarf. He dies trying to save the heroine from the falling chandelier. The film lacked the tension of even the 1943 version and was panned by critics.

There have been other variants of the film, some so far removed from the original that Leroux's name does not even get a mention in the credits. One of the more interesting was Brian De Palma's 1974 rock movie, *The Phantom of Paradise*. Paul Williams, who also composed most of the music, appeared as Swan, a Machiavellian record impresario, with William Finley as Winslow

Above: William
Finley as Winslow
Leach, the Phantom of
Brian de Palma's 1974
rock opera.

Opposite: Poster
for Hammer's 1962
release.

Leach, an unknown composer whose music Swan steals for his new rock
palace, the Paradise.

The film has energy but lacks cohesion, being part rock spectacle, part
camp comic-strip romp. It was a complete failure when first launched and
attempts to remarket it also failed to drum up any enthusiasm. It has since
become something of a cult hit, however, and continues to be a popular draw
at late-night student showings.

What is notable in all of the film versions that have come after Universal's
1925 Lon Chaney release is that the Phantom is always the victim of an
accident. He is never congenitally deformed as in the original Leroux story.
Directors seem to have felt the need to explain his condition rather than
accept he was born that way, his psychological state a consequence of his
need to hide away from the world – a change that diminishes his obsession
with Christine and makes his underground existence more difficult to under-
stand. But scriptwriters, and perhaps audiences too, have also found it easier
to deal with the story of a normal man suffering a great wrong than to present
his situation and events as a part of the true character of the Phantom.

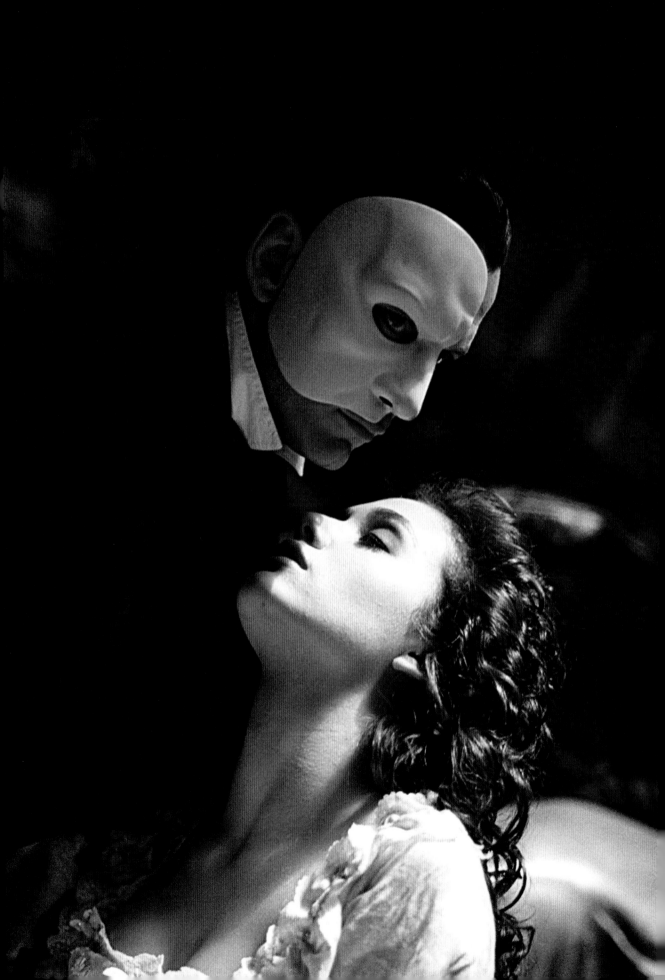

THE MAKING OF THE
REALLY USEFUL FILM

THE IDEA OF A NEW MOVIE VERSION OF *THE PHANTOM OF THE OPERA* WAS FIRST DISCUSSED BY ANDREW LLOYD WEBBER IN 1990. HE HAD BECOME FRIENDS WITH JOEL SCHUMACHER, THE AMERICAN DIRECTOR RESPONSIBLE FOR VAMPIRE FANTASY *THE LOST BOYS*. THEY TALKED AND SCHUMACHER WAS OFFERED THE JOB, BUT IT WAS NOT UNTIL 2002 THAT THE FILM GOT OFF THE GROUND.

Above: Director Joel Schumacher, executive producers Austin Shaw and Andrew Lloyd Webber.

Opposite: Gerard Butler as the Phantom and Emmy Rossum as Christine in the 2004 release *The Phantom of the Opera.*

Over the intervening years the two men had kept in touch and, while the idea would occasionally raise its head, both were busy with other projects. Then, in 2002, Lloyd Webber called Schumacher and asked him if he was still interested in directing the film. Schumacher recalls: "I remembered how exciting the whole project was years ago and I thought it would be great to make it now, so I said yes. I guess you could say that this was about fifteen or sixteen years in the making."

Schumacher knew the story would make an intensely powerful and romantic film. "Andrew's music is lush and searingly romantic," he said, "and the story is a great love story. But it's also dark, it's got a Gothic horror side to it, and that appealed to me. I think above all Andrew's version makes the Phantom much more of a tragic lover – a sensitive romantic, not just a creature of horror and fear. Christine's relationship with Raoul is really her romantic awakening as a teenager. But I think that her pull towards the Phantom is a very sexual, very deep soulful union."

The cast was drawn from both sides of the Atlantic, and Lloyd Webber was keen they should be able to sing their own parts to the standard expected. Only Carlotta, the operatic diva played by English singer–actress Minnie Driver, was to be dubbed (by Margaret Preece) due to the technical difficulty of the part. Andrew Lloyd Webber wrote original material, for which he and lyricist Charles Hart were later twice nominated in the following awards season, at the Oscars and the Golden Globes, for Best Original Song (for "Learn to be Lonely"). Gerard Butler, who played the Phantom, was so keen

– 111 –

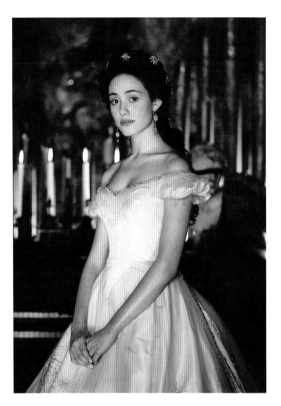

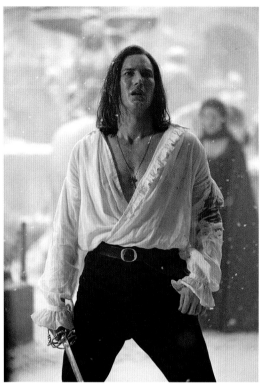

to get the part that he took singing lessons, flying back and forth to London during the filming of another movie to squeeze in as many as possible.

Emmy Rossum was chosen to play Christine. At only 18, she had the naïve, ethereal beauty of Lloyd Webber's vision and a voice that had been honed by many years as a member of the New York Metropolitan Opera in the Children's Chorus. Virginia-born Patrick Wilson was to play Raoul; an experienced Broadway performer, he had first earned attention in the off-Broadway musical *Bright Lights, Big City* (1999). He was the first actor Schumacher cast, and for the director it was a fairly easy decision. "I knew his work. He has the looks, he's extremely talented and he has the voice of an angel. He was just perfect for the part."

Rather than try to film on location, a theatre was specially built at Pinewood Studios outside London. Production designer Tony Pratt created an opera house they called the Opéra Populaire. Pratt, whose credits include *The End Of The Affair* (1999) and *Band Of Brothers* (2001), was drawn to the film because it offered huge scope for an art department. His work on *The Phantom of the Opera* was recognised with a nomination, jointly with set decorator Celia Boback, for Best Art Direction at the 2005 Academy Awards.

Above: Patrick Wilson as Raoul.

Above left: Emmy Rossum as Christine.

Opposite: The film in production. Clockwise from top left: Emmy Rossum as Christine, on the lake; Schumacher and Lloyd Webber on set; Gerard Butler as the Phantom; adjustments to costume; recording the soundtrack; the set at Pinewood Studios.

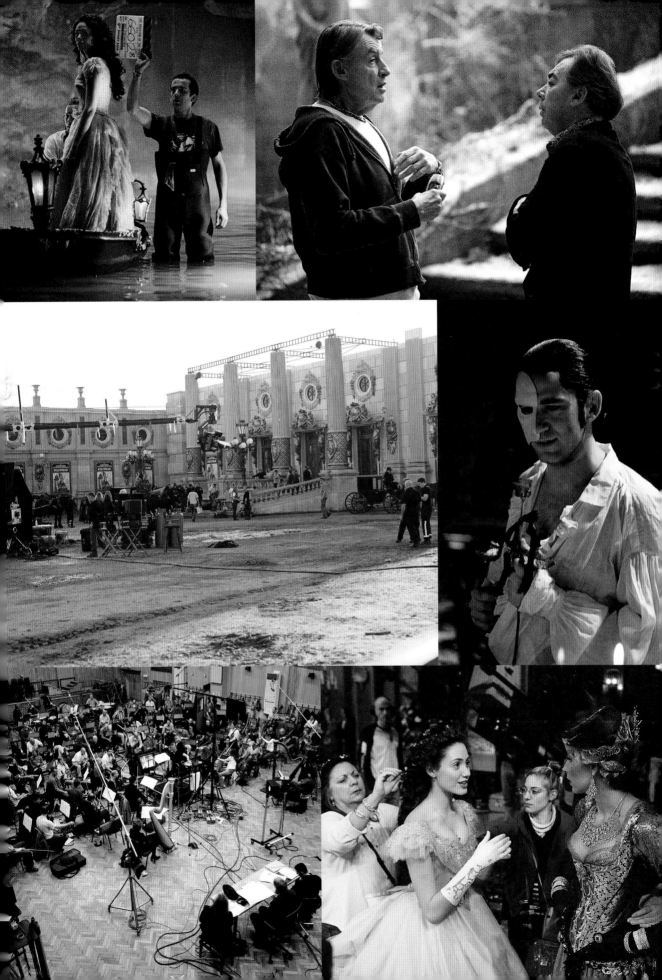

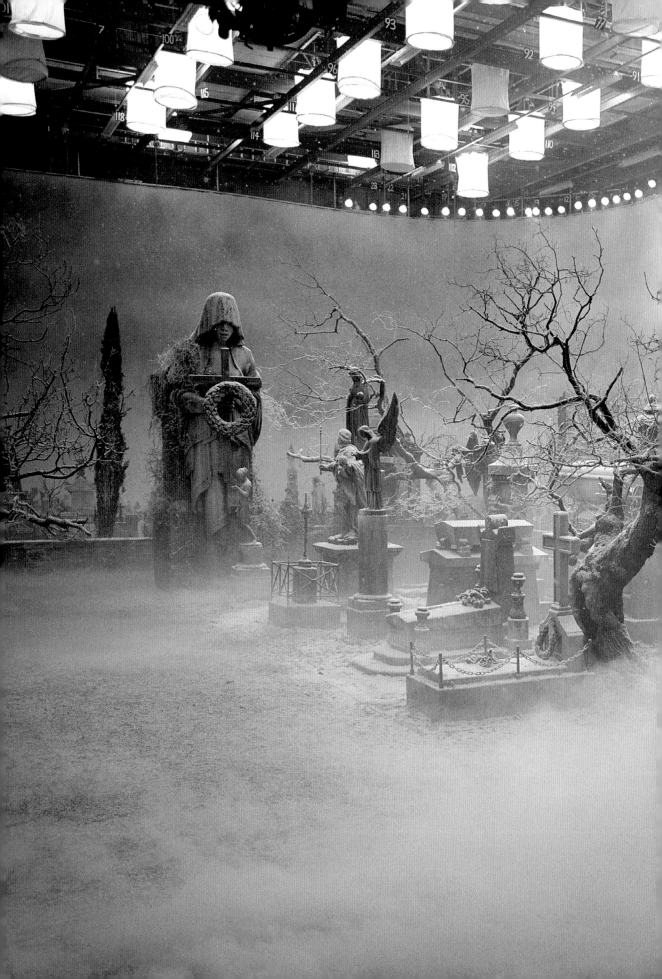

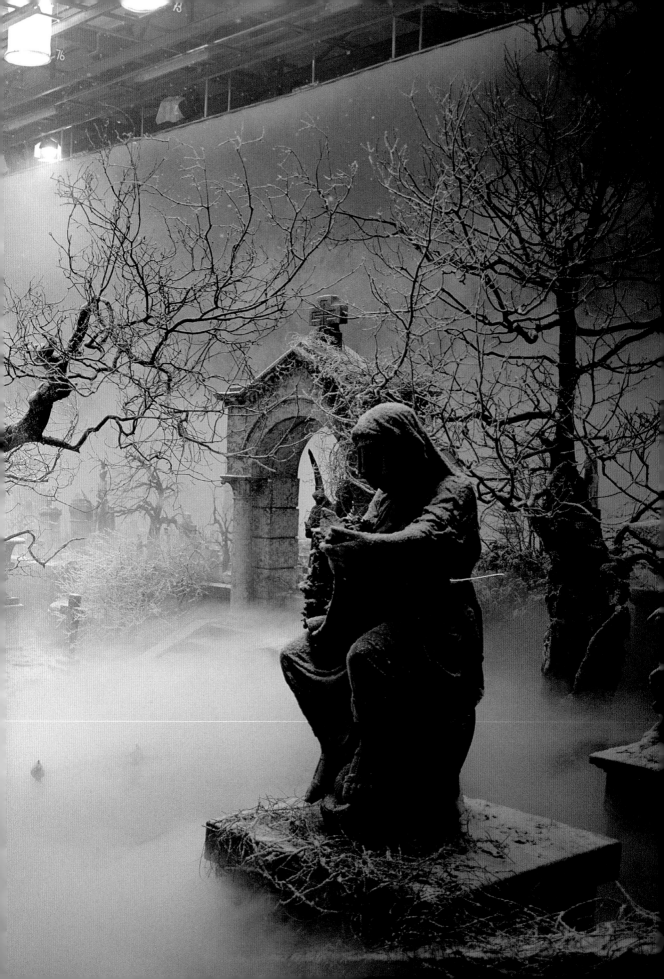

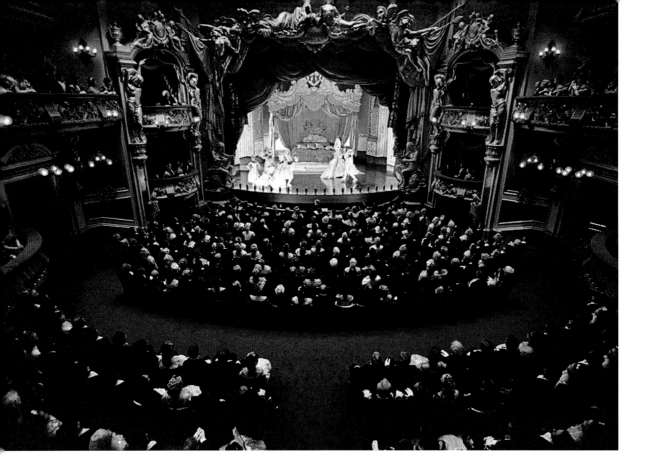

John Mathieson's cinematography was also nominated. The decision to build from scratch allowed a unique vision to develop. As executive producer Austin Shaw explained, "Joel wanted the feel of the film to have a heightened reality to fit in with the soaring Gothic romance of the storyline – so we really couldn't make it on location, as the visual would jar with the story. The opera house burns down at the end of the film so we needed to build our own – there are not many opera houses around the world who would allow us to do that. It followed that you have to build everything, to create a consistent look to the film."

Schumacher, like Harold Prince and Maria Björnson before him, made the pilgrimage to the Opéra Garnier in Paris for inspiration. The result was an 886-seat theatre adorned with golden statues and featuring deep red velvet upholstery, set off by a golden proscenium arch leading into the stage area and beyond. The backstage areas were built next to it, allowing Schumacher to film long linking shots following actors on and off stage – moving from the public arena into the private.

Some parts of the auditorium, though, were created using computer generated imagery. The set as built had only two tiers of seats, and so a third CGI

Above: The specially built auditorium, Tony Pratt's Opéra Populaire.

Opposite: Another chandelier, this one created by Tisserant in Paris, using 20,000 full-cut Swarovski crystal pendants.

Previous pages: The Oscar-nominated set built at Pinewood Studios, England.

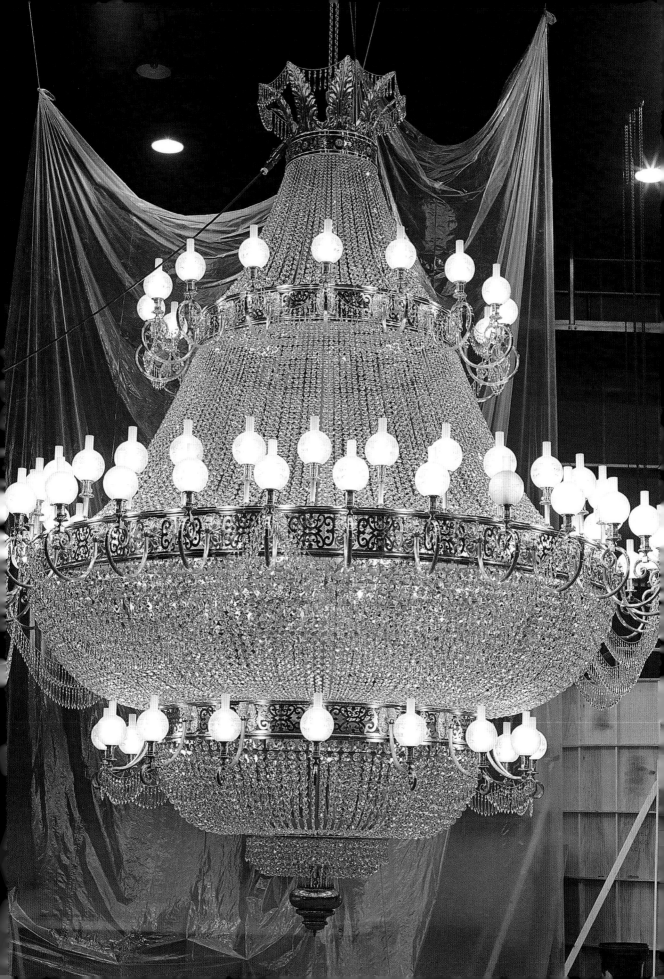

tier was added, together with a three-dimensional dome and, for some shots, the chandelier. The real chandelier, created by Tisserant in Paris, was made from 20,000 full-cut Swarovski crystal pendants. It was 17 ft high, over 13 ft wide and weighed a massive 2.2 tons – the ceiling of the stage at Pinewood had to be strengthened to cope with the load. A far lighter 'stunt' chandelier made of plastic was created for the climactic crash down into the stalls.

With three operas, two ballets, a masquerade ball and several love duets, there were plenty of opportunities for the costume and makeup departments to exhibit their creativity. Costume designer Alexandra Byrne and makeup designer Jenny Shircore had worked together previously to great acclaim on the film *Elizabeth* (1998), and needed a large team of helpers to deal with such a large project. The decision was made not to stick slavishly to a Victorian style, particularly with the makeup. As Shircore explained, "The research for the stage makeup of that period is thick pancake, cracked makeup. But Joel wanted everything to be beautiful, so it was an interesting combination of getting a Victorian look for the period while keeping it beautiful for the modern eye."

This otherworldly styling also allowed Byrne a great deal of freedom, particularly when creating costumes for the diva Carlotta. Her purple day dress alone contained nearly 90 ft of silk! Swarovski crystals were woven into hairpieces, wigs, dresses and jewellery, including Christine's engagement ring. Byrne's designs were nominated at the Academy Awards.

The Phantom's iconic mask was designed in collaboration between Schumacher, Byrne, Shircore and Gerard Butler as it needed to be flexible

Above: Minnie Driver as Carlotta, in a dress made from nearly 90 ft of silk.

Left: Gerard Butler in the Phantom mask, which was designed to ensure he could still sing.

Above: Oscar-nominated costume designer Alexandra Byrne.

Below right: Beyoncé Knowles performs "Learn to be Lonely" at the Academy Awards 2005.

Overleaf: Scenes from the 2004 film. Clockwise, from top left: Simon Callow as the producer; Gerard Butler as the Phantom; Emmy Rossum and Patrick Wilson as Christine and Raoul; the hanged stagehand; the Phantom smashes the mirror; the masked ball; Christine at her father's grave.

enough for Butler to act and sing while wearing it. On the days Butler was filmed without the mask, he endured many gruelling hours in makeup, often starting at 4am so he could be ready to begin filming at 10am.

The Phantom of the Opera movie was undoubtedly a success, earning three Academy Award nominations. At the 2005 Oscars ceremony, Andrew Lloyd Webber joined forces with US soul/pop star Beyoncé Knowles. The former Destiny's Child singer joined the peer on stage in Los Angeles to perform the song "Learn to be Lonely", specially written by Lloyd Webber with Charles Hart to close the film version, and for which the two men were jointly nominated. Lloyd Webber had previously picked up an Academy Award for *Evita*. " To be even nominated for an Oscar is extraordinary. We were very lucky the first time round," he said.

Much of the press's praise went the way of the previously little-known Emmy Rossum; plaudits included a Golden Globe nomination. Rossum, who admitted to having never seen any of the stage productions of *The Phantom of the Opera* prior to reading the screenplay, added a fresh new dimension to the role of Christine. Aged only 16 when she first auditioned and 18 on the film's release, she had helped to bring the show to the attention of the MTV generation and well deserved the acclaim she received.

As the award nominations attest, the film was a resounding success with the only people who really matter – the audience. At its release on DVD in May 2005, eager to sample and re-sample its Gothic glory, Phans once again showed their support in large numbers.

– 119 –

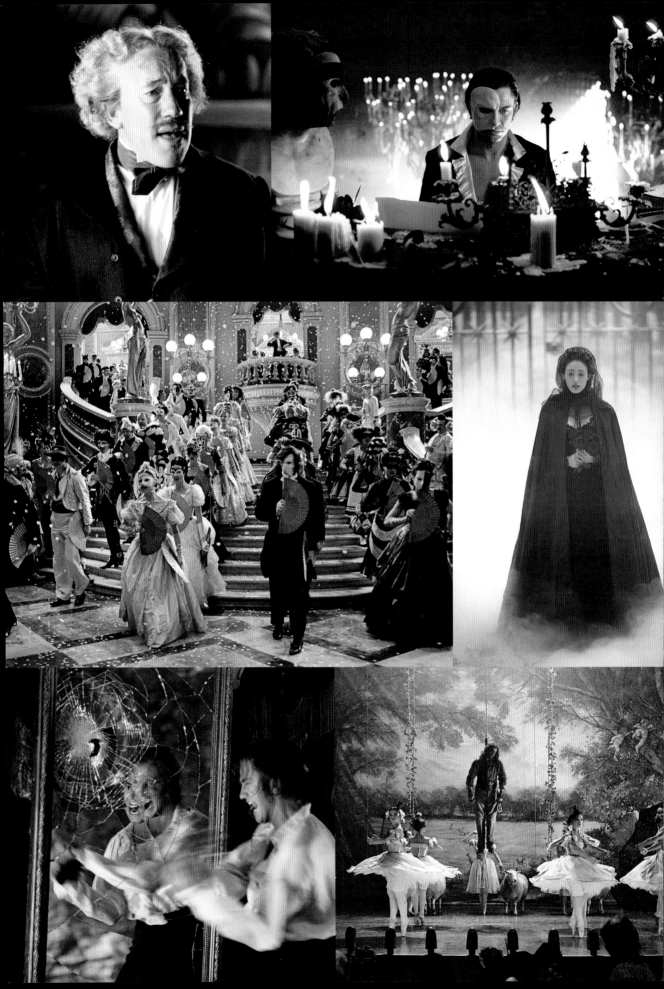

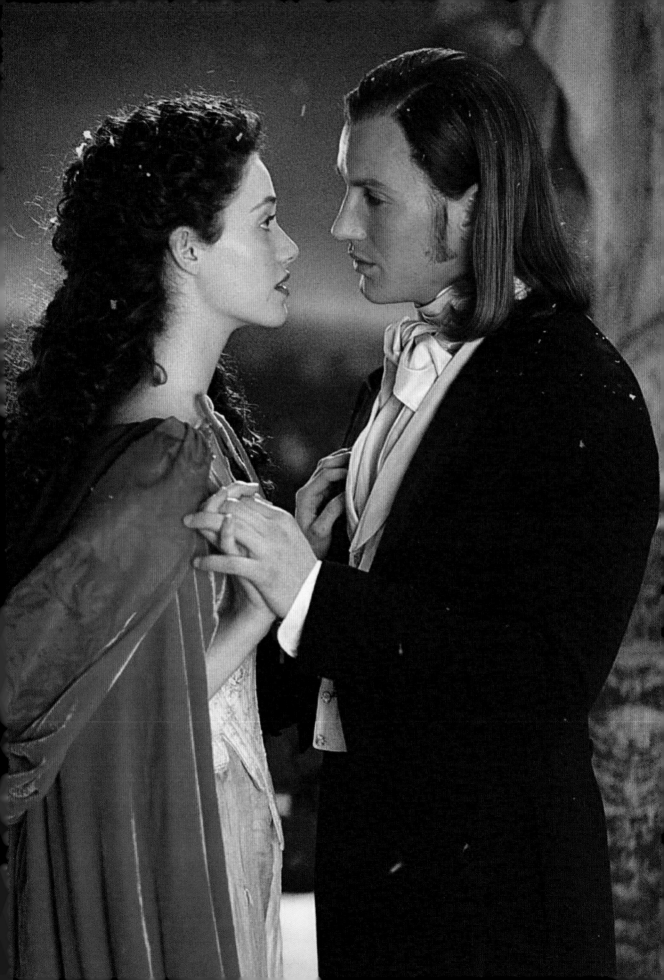

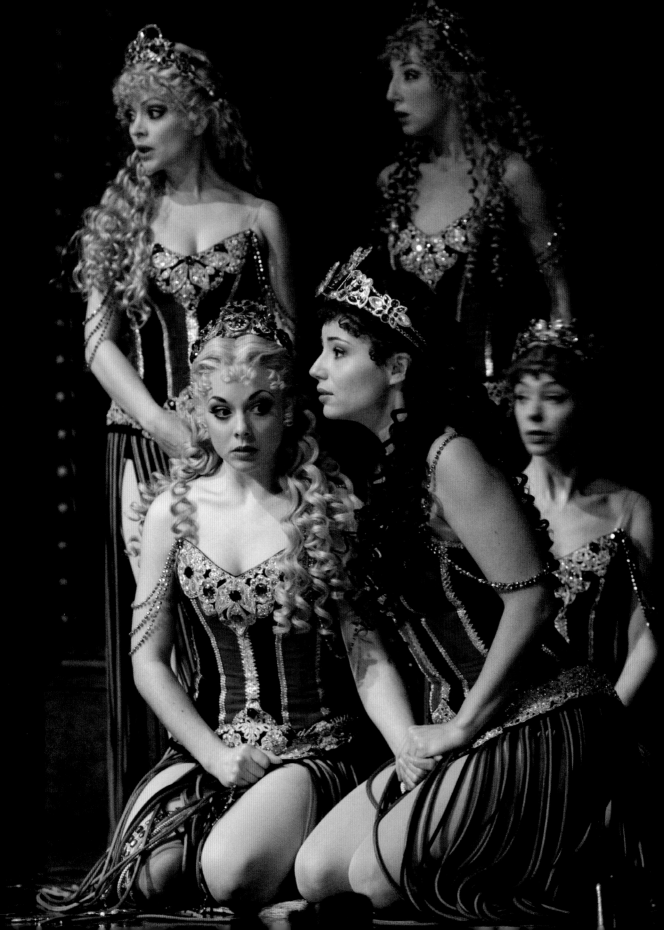

ACT V

*'In sleep he sang to me, in dreams he came…
that voice which calls to me and speaks my
name… And do I dream again? For now I find
the Phantom of the Opera is there –
inside my mind…'*

Christine, libretto Act I scene IV

LIBRETTO

This recording contains all the principal musical material of *The Phantom of the Opera*. Some cuts have been made to accommodate available space on record, but they have not affected the main body of the music. The full libretto (including spoken dialogue and the sequences that have been cut) is contained in this booklet. I should like to record my particular debt to David Caddick, my production musical director. Also my thanks to Mike Reed, the conductor, and to the *Phantom* orchestra.

*Andrew Lloyd Webber – January 1987 (*Liner Note from Original Cast recording)

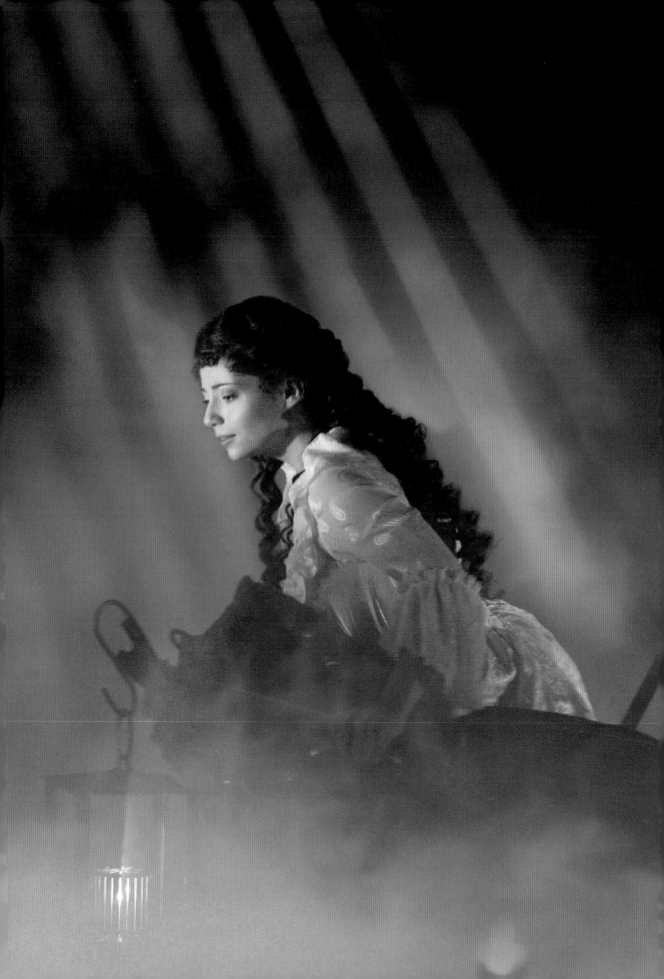

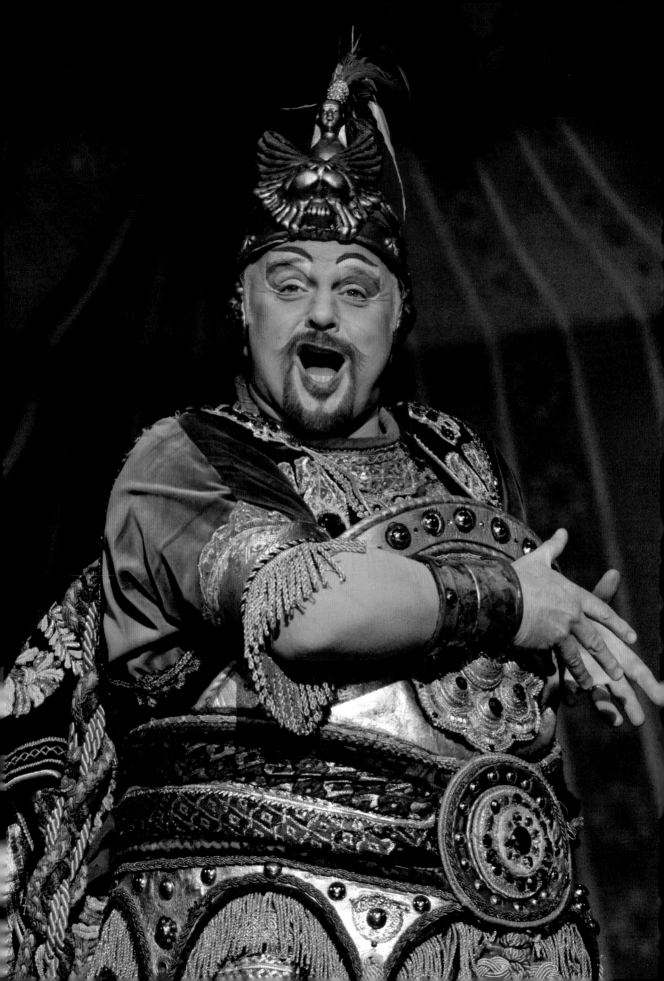

– Prologue –

THE STAGE OF THE PARIS OPÉRA, 1911

(The contents of the opera house is being auctioned off. An AUCTIONEER, PORTERS, BIDDERS and RAOUL, seventy now, but still bright of eye. The action commences with a blow from the AUCTIONEER's gavel)

1 AUCTIONEER
Sold. Your number, sir? Thank you.

Lot 663, then, ladies and gentlemen: a poster for this house's production of 'Hannibal' by Chalumeau.

PORTER
Showing here.

AUCTIONEER
Do I have ten francs? Five then. Five I am bid. Six, seven. Against you, sir, seven. Eight. Eight once. Selling twice. Sold, to Raoul, Vicomte de Chagny.

Lot 664: a wooden pistol and three human skulls, from the 1831 production of 'Robert le Diable' by Meyerbeer. Ten francs for this. Ten, thank you. Ten francs still. Fifteen, thank you, sir. Fifteen I am bid. Going at fifteen. Your number, sir?

Lot 665, ladies and gentlemen: a papier-mâché musical box, in the shape of a barrel-organ. Attached, the figure of a monkey in Persian robes, playing the cymbals. This item, discovered in the vaults of the theatre, still in working order.

PORTER *(holding it up)*
Showing here. *(He sets it in motion)*

AUCTIONEER
May I start at twenty francs?
Fifteen, then?
Fifteen I am bid.

(The bidding continues. RAOUL eventually buys the box for thirty francs)

Sold for thirty francs to the Vicomte de Chagny. Thank you, sir.

(The box is handed across to RAOUL. He studies it, as attention focuses on him for a moment)

RAOUL *(quietly, half to himself, half to the box)*
A collector's piece indeed… every detail exactly as she said…
She often spoke of you, my friend…
your velvet lining and your figurine of lead…
Will you still play, when all the rest of us are dead…?

(Attention returns to the AUCTIONEER, as he resumes)

AUCTIONEER
Lot 666, then: a chandelier in pieces. Some of you may recall the strange affair of the Phantom of the Opera: a mystery never fully explained. We are told, ladies and gentlemen, that this is the very chandelier which figures in the famous disaster. Our workshops have restored it and fitted up parts of it with wiring for the new electric light, so that we may get a hint of what it may look like when reassembled. Perhaps we may frighten away the ghost of so many years ago, with a little illumination, gentlemen?

2 *(The AUCTIONEER switches on the chandelier. There is an enormous flash, and the OVERTURE begins. During the Overture the opera house is restored to its earlier grandeur. The chandelier, immense and glittering, rises magically from the stage, finally hovering high above the stalls)*

– 127 –

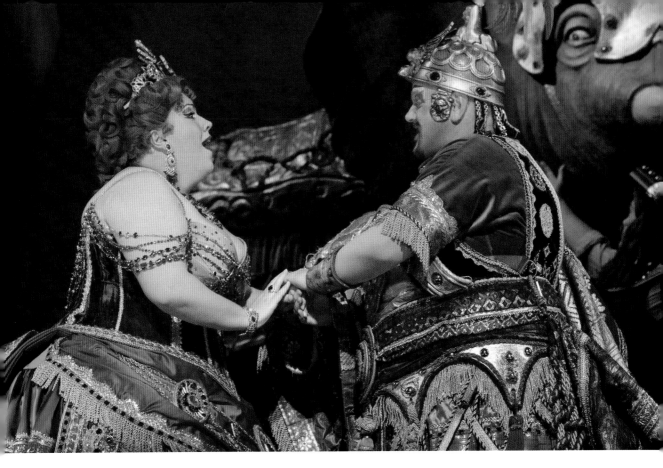

– Act One –

Scene One

REHEARSALS FOR 'HANNIBAL' BY CHALUMEAU

(We have reached the great choral scene in which HANNIBAL and his army return to save Carthage from the Roman invasion under Scipio. HANNIBAL is UBALDO PIANGI; ELISSA, Queen of Carthage (his mistress) is CARLOTTA GIUDICELLI. The two leading slave girls are played by MEG GIRY and CHRISTINE DAAÉ. MME. GIRY is the ballet mistress. M. REYER, the répétiteur, is in charge.

We join the opera towards the end of ELISSA's (CARLOTTA's) great aria. She is alone, holding a present from the approaching HANNIBAL, a bleeding severed head)

CARLOTTA *(at the climax of an extravagant cadenza)*
This trophy from our saviours, from the enslaving force of Rome!

(A STAGEHAND carries a ladder across the stage. OTHERS are seen still constructing parts of the scenery)

GIRLS' CHORUS
With feasting and dancing and song, tonight in celebration, we greet the victorious throng, returned to bring salvation!

MEN'S CHORUS
The trumpets of Carthage resound! Hear, Romans, now and tremble! Hark to our steps on the ground!

ALL
Hear the drums – Hannibal comes!

(PIANGI enters, as HANNIBAL)

PIANGI *(HANNIBAL)*
Sad to return to find the land we love threatened once more by Roma's far-reaching grasp.

REYER *(interrupting him)*
Signor… if you please: 'Rome'. We say 'Rome', not 'Roma'.

PIANGI
Si, si, Rome, not Roma. Is very hard for me.
(Practising) Rome… Rome…

(Enter LEFÈVRE, the retiring manager of the Opéra, with M. FIRMIN and M. ANDRÉ, to whom he has just sold it)

REYER *(to PIANGI)*
Once again, then, if you please, Signor: 'Sad to return…'

LEFÈVRE *(to ANDRÉ and FIRMIN)*
This way gentlemen, this way. Rehearsals, as you see, are under way, for a new production of Chalumeau's 'Hannibal'.

(Sensing a hiatus in the rehearsal, LEFÈVRE attempts to attract attention)

LEFÈVRE
Ladies and gentlemen, some of you may already, perhaps, have met M. André and M. Firmin…

(The new managers are politely bowing when REYER interrupts)

REYER
I'm sorry, M. Lefèvre, we are rehearsing. If you wouldn't mind waiting a moment?

LEFÈVRE
My apologies, M. Reyer. Proceed, proceed…

REYER
Thank you, Monsieur.

(Turning back to PIANGI)
'Sad to return…', Signor…

LEFÈVRE *(sotto voice to ANDRÉ and FIRMIN)*
M. Reyer, our chief répétiteur. Rather a tyrant, I'm afraid.

(The rehearsal continues)

PIANGI *(HANNIBAL)*
Sad to return to find the land we love threatened once more by Rome's far-reaching grasp. Tomorrow we shall break the chains of Rome. Tonight, rejoice – your army has come home.

(The BALLET GIRLS begin their dance. LEFÈVRE, ANDRÉ and FIRMIN stand centre-stage watching the ballet. They are in the way. The ballet continues under the following dialogue.)

LEFÈVRE *(indicating PIANGI)*
Signor PIANGI, our principal tenor. He does play so well opposite La Carlotta.

GIRY *(exasperated by their presence, bangs her cane angrily on the stage)*
Gentlemen, please! If you would kindly move to one side?

LEFÈVRE
My apologies, Mme. Giry.
(leading ANDRÉ and FIRMIN aside)
Madame Giry, our ballet mistress. I don't mind confessing, M. Firmin, I shan't be sorry to be rid of the whole blessed business.

FIRMIN
I keep asking you, Monsieur, why exactly are you retiring?

LEFÈVRE *(ignoring this, calls his attention to the continuing ballet)*
We take a particular pride here in the excellence of our ballets.

(MEG becomes prominent among the dancers)

ANDRÉ
Who's that girl, Lefèvre?

LEFÈVRE
Her? Meg Giry, Mme. Giry's daughter. Promising dancer, M. André, most promising.

(CHRISTINE becomes prominent. She has absent-mindedly fallen out-of-step)

GIRY *(spotting her, bangs her cane again)*
You! Christine Daaé! Concentrate, girl!

MEG *(quietly to CHRISTINE)*
Christine… What's the matter?

FIRMIN *(to LEFÈVRE)*
Daaé? Curious name.

LEFÈVRE
Swedish.

ANDRÉ
Any relation to the violinist?

LEFÈVRE
His daughter, I believe. Always has her head in the clouds, I'm afraid.

(The ballet continues to its climax and ends. The CHORUS resumes)

CHORUS
**Bid welcome to Hannibal's guests –
the elephants of Carthage!
As guides on our conquering quests,
Dido sends
Hannibal's friends!**

(The ELEPHANT, a life-sized mechanical replica, enters. PIANGI is lifted, in triumph, onto its back)

CARLOTTA *(ELISSA)*
**Once more to my
welcoming arms
my love returns
in splendour!**

PIANGI *(HANNIBAL)*
**Once more to those
sweetest of charms**

**my heart and soul
surrender.**

CHORUS
**The trumpeting elephants sound –
hear, Romans, now and tremble!
Hark to their step on the ground –
hear the drums!
Hannibal comes!**

(At the end of the chorus LEFÈVRE claps his hands for silence. The elephant is led off. Two STAGEHANDS are revealed operating it from within)

LEFÈVRE
Ladies and gentlemen – Madame Giry, thank you – may I have your attention please?
As you know, for some weeks there have been rumours of my imminent retirement.
I can now tell you that these were all true, and it is my pleasure to introduce to you the two gentlemen who now own the Opéra Populaire, M. Richard Firmin and M. Gilles André.

(Polite applause. Some bowing. CARLOTTA makes her presence felt)

Gentlemen, Signora Carlotta Giudicelli, our leading soprano for five seasons now.

ANDRÉ
Of course, of course.
I have experienced all your greatest rôles, Signora.

LEFÈVRE
And Signor Ubaldo Piangi.

FIRMIN
An honour, Signor.

ANDRÉ
If I remember rightly, Elissa has a rather fine aria in Act Three of 'Hannibal'. I wonder, Signora, if, as a personal favour, you would oblige us with a private rendition? *(Somewhat acerbic)* Unless, of course, M. Reyer objects…

CARLOTTA
My manager commands… M.Reyer?

REYER
My *diva* commands. Will two bars be sufficient introduction?

FIRMIN
Two bars will be quite sufficient.

REYER *(ensuring that CARLOTTA is ready)*
Signora?

CARLOTTA
Maestro?

(The introduction is played on the piano)

3 CARLOTTA
**Think of me,
think of me fondly,
when we've said
goodbye.
Remember me
once in a while –
please promise me
you'll try.**

**When you find
that, once
again, you long
to take your heart…**

(As CARLOTTA is singing, a backdrop crashes to the floor, cutting her off from half the cast)

MEG/BALLET GIRLS/CHORUS
**He's here:
the Phantom of the Opera…
He is with us…
It's the ghost…**

PIANGI *(looking up furiously)*
You idiots!
(He rushes over to CARLOTTA)
Cara! Cara! Are you hurt?

LEFÈVRE
Signora! Are you all right? Buquet? Where is Buquet?

PIANGI
Is no one concerned for our prima donna?

LEFÈVRE
Get that man down here!
(To ANDRÉ and FIRMIN)
Chief of the flies. He's responsible for this.

(The drop is raised high enough to reveal upstage an old stagehand, JOSEPH BUQUET, holding a length of rope, which looks almost like a noose)

LEFÈVRE
Buquet? For God's sake, man, what's going on up there?

BUQUET
**Please, Monsieur,
don't look at me:
as God's my witness
I was not at my post.**

**Please, Monsieur,
there's no one there:
and if there is, well
then, it *must* be a ghost…**

MEG *(looking up)*
He's there: the Phantom of the Opera…

ANDRÉ
**Good heavens!
Will you show a little courtesy?**

FIRMIN *(to MEG and the others)*
Mademoiselle, please!

ANDRÉ *(to CARLOTTA)*
These things do happen.

CARLOTTA
Si! These things *do* happen!
Well, until you stop these things happening, *this* thing does *not* happen!

Ubaldo! Andiamo!
(PIANGI dutifully fetches her furs from the wings)

– 129 –

PIANGI
Amateurs!

LEFÈVRE
I don't think there's much more to assist you, gentlemen. Good luck! If you need me, I shall be in Frankfurt.

(He leaves. The company looks anxiously at the NEW MANAGERS)

ANDRÉ
La Carlotta will be back.

GIRY
You think so, Messieurs? I have a message, sir, from the Opéra Ghost.

(The GIRLS twitter and twirl in fear)

FIRMIN
God in heaven, you're all obsessed!

GIRY
He merely welcomes you to his opera house and commands you to continue to leave Box Five empty for his use and reminds you that his salary is due.

FIRMIN
His salary?

GIRY
Monsieur Lefèvre paid him twenty thousand francs a month. Perhaps you can afford more, with the Vicomte De Chagny as your patron.

(Reaction to this from the BALLET GIRLS. CHRISTINE takes hold of MEG nervously)

ANDRÉ *(to GIRY)*
Madame, I had hoped to have made that announcement myself.

GIRY *(to FIRMIN)*
Will the Vicomte be at the performances tonight, Monsieur?

FIRMIN
In our box.

ANDRÉ
Madame, who is the understudy for this role?

REYER
There is no understudy, Monsieur – the production is new.

MEG
Christine Daaé could sing it, sir.

FIRMIN
The chorus girl?

MEG *(to FIRMIN)*
She's been taking lessons from a great teacher.

ANDRÉ
From whom?

CHRISTINE *(uneasily)*
I don't know, sir…

FIRMIN
Oh, not you as well!
(turning to ANDRÉ)
Can you believe it? A full house – and we have to cancel!

GIRY
Let her sing for you, Monsieur. She has been well taught.

REYER *(after a pause)*
From the beginning of the aria then, mam'selle.

CHRISTINE
Think of me,
think of me fondly,
when we've said
goodbye.
Remember me
once in a while –
please promise
me you'll try.

FIRMIN
André, this is doing nothing for my nerves.

ANDRÉ
Don't fret, Firmin.

CHRISTINE
When you find
that, once
again, you long
to take your heart back
and be free –
if you
ever find
a moment,
spare a thought
for me…

(Transformation to the Gala, CHRISTINE is revealed in full costume)

We never said
our love
was evergreen,
or as unchanging
as the sea –
but if
you can still
remember,
stop and think
of me…

Think of all the things
we've shared and seen –
don't think about the things
which might have been…

Think of me,
think of me waking,
silent and
resigned.

Imagine me,
trying too hard
to put you
from my mind.

Recall those days,
look back
on all those times,
think of all the things
we'll never do –
there will

never be
a day, when
I won't think
of you…

(Applause, bravos. Prominent among the bravos, those of the young RAOUL in the MANAGERS' box)

RAOUL
Can it be?
Can it be Christine?

Bravo!

(He raises his opera-glasses)

What a change!
You're really
not a bit the gawkish girl
that once you were…

(Lowering his opera-glasses)

She may
not remember
me, but
I remember
her…

CHRISTINE
We never said
our love
was evergreen,
or as unchanging
as the sea –
but please
promise me,
that sometimes,
you will think
of me!

Scene Two

AFTER THE GALA

(The curtain closes upstage. BALLET GIRLS, from the wings, gush around CHRISTINE who hands each a flower from her bouquet. REYER stiffly gives his approval)

GIRY *(to CHRISTINE)*
Yes, you did well. He will be pleased.
(To the DANCERS)
And you! You were a disgrace tonight!
Such *ronds de jambe*!
Such *temps de cuisse*!
Here – we rehearse. Now!

(She emphasises this with her cane. The BALLET GIRLS settle into rehearsal upstage, GIRY keeping time with her stick. Variations of this continue throughout the scene)

(CHRISTINE moves slowly downstage, away from the DANCERS, as her dressing room becomes visible. Unseen by her, MEG also moves away and follows her. As CHRISTINE is about to open the dressing room door, she hears the PHANTOM's voice out of nowhere)

4 PHANTOM'S VOICE
Bravi, bravi, bravissimi…

(CHRISTINE is bewildered by the voice. MEG, following, has not heard it. CHRISTINE turns in surprise, and is relieved to see her)

MEG
Where in the world
have you been hiding?
Really, you were
perfect!

I only wish
I knew your secret!
Who is this new
tutor?

CHRISTINE *(abstracted, entering the dressing room)*
Father once spoke
of an angel…
I used to dream
he'd appear…
Now as I sing,
I can sense him…
And I know
he's here

(Trance-like)

Here in this room
he calls me softly…
somewhere inside…
hiding…

Somehow I know
he's always with me…
he – the unseen
genius…

MEG *(uneasily)*
Christine, you must have
been dreaming…
stories like this can't
come true…

Christine, you're talking
in riddles…
and it's not
like you…

CHRISTINE *(not hearing her, ecstatic)*
Angel of Music!
Guide
and guardian!
Grant to me your
glory!

MEG *(to herself)*
Who is this angel?
This…

BOTH
Angel of Music!
Hide
no longer!

Secret and strange
angel…

CHRISTINE *(darkly)*
He's with me,
even now…

MEG *(bewildered)*
Your hands are cold…

CHRISTINE
All around me…

MEG
Your face, Christine,
it's white…

CHRISTINE
It frightens me…

MEG
Don't be frightened…

(They look at each other. The moment is broken by the arrival of GIRY)

GIRY
Meg Giry. Are you a dancer? Then come and practise.

(MEG leaves and joins the DANCERS)

My dear, I was asked to give you this.

(She hands CHRISTINE a note and leaves. CHRISTINE opens it and reads)

CHRISTINE
A red scarf… the attic… Little Lotte…

Scene Three

CHRISTINE'S DRESSING ROOM

(Meanwhile RAOUL, ANDRÉ, FIRMIN and MME. FIRMIN are seen making their way towards the dressing room, the MANAGERS in high spirits, bearing champagne)

ANDRÉ
A *tour de force!* No other way to describe it!

FIRMIN
What a relief! Not a single refund!

MME. FIRMIN
Greedy.

ANDRÉ
Richard, I think we've made quite a discovery in Miss Daaé!

FIRMIN *(to Raoul, indicating CHRISTINE's dressing room)*
Here we are, Monsieur le Vicomte.

RAOUL
Gentlemen, if you wouldn't mind. This is one visit I should prefer to make unaccompanied.
(He takes the champagne from FIRMIN)

ANDRÉ
As you wish, Monsieur.

(They bow and move off)

FIRMIN
They appear to have met before…

(RAOUL knocks at the door and enters)

RAOUL
Christine Daaé, where is your scarf?

CHRISTINE
Monsieur?

RAOUL
You can't have lost it. After all the trouble I took. I was just fourteen and soaked to the skin…

CHRISTINE
Because you had run into the sea to fetch my scarf. Oh, Raoul. So it *is* you!

RAOUL
Christine.
(They embrace and laugh. She moves away and sits at her dressing table)

5 RAOUL
'Little Lotte let her mind
wander…'

CHRISTINE
You remember that, too…

RAOUL *(continuing)*
'…Little Lotte thought: Am I
fonder of dolls…'

BOTH *(CHRISTINE joining in)*
'…or of goblins,
of shoes…'

CHRISTINE
'…or of riddles,
of frocks…'

RAOUL
Those picnics in the attic…
'…or of chocolates…'

CHRISTINE
Father playing the violin…

RAOUL
As we read to each other dark
stories of the North…

CHRISTINE
'No – what I love best, Lotte said,
is when I'm asleep in my bed,
and the Angel of Music sings
songs in my head!'

BOTH
'…the Angel of Music sings songs
in my head!'

CHRISTINE *(turning in her chair to look at him)*
Father said 'When I'm in heaven, child, I will send the Angel of Music to you'. Well, father is dead, Raoul, and I *have* been visited by the Angel of Music.

RAOUL
No doubt of it – And now we'll go to supper!

CHRISTINE
No, Raoul, the Angel of Music is very strict.

RAOUL
I shan't keep you up late!

– 131 –

CHRISTINE
No, Raoul…

RAOUL
You must change. I must get my hat.
Two minutes – Little Lotte.

(He hurries out)

CHRISTINE *(calling after him)*
Raoul!
(Quietly picking up her hand mirror)
Things have changed, Raoul.

(Tremulous music. CHRISTINE hears
the PHANTOM's voice, seemingly from
behind her dressing room mirror)

PHANTOM'S VOICE
Insolent boy!
This slave
of fashion,
basking in **your**
glory!

Ignorant fool!
This brave
young suitor,
sharing in **my**
triumph!

CHRISTINE *(spellbound)*
Angel! I hear you!
Speak –
I listen…
stay by my side,
guide me!

Angel, my soul was
weak –
forgive me…
enter at last,
Master!

PHANTOM'S VOICE
Flattering child,
you shall know me,
see why in shadow
I hide!

Look at your face
in the mirror –
I am there
inside!

(The figure of the PHANTOM becomes
discernible behind the mirror)

CHRISTINE *(ecstatic)*
Angel of Music!
Guide
and guardian!
Grant to me your
glory!

Angel of Music!
Hide
no longer!
Come to me, strange
angel…

PHANTOM'S VOICE
I am your Angel…
Come to me: Angel of Music…

(CHRISTINE walks towards the glowing,
shimmering glass. Meanwhile, RAOUL has
returned. He hears the voices and is puzzled.
He tries the door. It is locked)

RAOUL
Whose is that voice…?
Who is that in there…?

(Inside the room the mirror opens. Behind
it, in an inferno of white light, stands the
PHANTOM. He reaches forward and takes
CHRISTINE firmly, but not fiercely, by the wrist.
His touch is cold and CHRISTINE gasps)

PHANTOM
I am your Angel of Music…
Come to me: Angel of Music…

(CHRISTINE disappears through the
mirror, which closes behind her. The door
of the dressing room suddenly unlocks and
swings open, and RAOUL enters to find the
room empty)

RAOUL
Christine! Angel!

6 Scene Four

THE LABYRINTH
UNDERGROUND

(The PHANTOM and CHRISTINE take
their strange journey to the PHANTOM's
lair. Candles rise from the stage. We see
CHRISTINE and the PHANTOM in a boat
which moves slowly across the misty waters
of the underground lake)

CHRISTINE
In sleep
he sang to me,
in dreams
he came…
that voice
which calls to me
and speaks
my name…

And do
I dream again?
For now
I find
the Phantom of the Opera
is there –
inside my mind…

PHANTOM
Sing once
again with me
our strange
duet…
My power

over you
grows stronger
yet…

And though
you turn from me,
to glance
behind,
the Phantom of the Opera
is there –
inside your mind…

CHRISTINE
Those who
have seen your face
draw back
in fear…
I am
the mask you wear…

PHANTOM
It's me
they hear…

BOTH
Your/my spirit
and your/my voice,
in one
combined:
the Phantom of the Opera
is there –
inside your/my mind…

OFFSTAGE VOICES
He's there,
the Phantom of the Opera…
Beware
the Phantom of the Opera…

PHANTOM
In all
your fantasies,
you always
knew
that man
and mystery…

CHRISTINE
…were both
in you…

BOTH
And in
this labyrinth,
where night
is blind,
the Phantom of the Opera
is there/here –
inside your/my mind…

PHANTOM
Sing, my Angel of Music!

CHRISTINE
He's there,
the Phantom of the Opera…

Scene Five

BEYOND THE LAKE, THE NEXT MORNING

(Finally they arrive in the PHANTOM's lair. Downstage, the candles in the lake lift up revealing giant candelabras outlining the space. The boat turns into a bed. There is a huge pipe organ. The PHANTOM sits at the organ and takes over the accompaniment)

PHANTOM
I have brought you
to the seat of sweet
music's throne…
to this kingdom
where all must pay
homage to music…
music…

You have come here,
for one purpose,
and one alone…
Since the moment
I first heard you sing,
I have needed
you with me,
to serve me, to sing,
for my music…
my music…

(Changing mood)

7 Night-time sharpens,
heightens each sensation…
Darkness stirs and
wakes imagination…
Silently the senses
abandon their defences…

Slowly, gently
night unfurls its splendour…
Grasp it, sense it –
tremulous and tender…
Turn your face away
from the garish light of day,
turn your thoughts away
from cold, unfeeling light –
and listen to
the music of the night…

Close your eyes
and surrender to your
darkest dreams!
Purge your thoughts
of the life
you knew before!
Close your eyes,
let your spirit
start to soar!

And you'll live
as you've never
lived before…

Softly, deftly,
music shall surround you…
Feel it, hear it,
closing in around you…
Open up your mind,
let your fantasies unwind,
in this darkness which
you know you cannot fight –
the darkness of
the music of the night…

Let your mind
start a journey through a
strange, new world!
Leave all thoughts
of the world
you knew before!
Let your soul
take you where you
long to be!
Only then
can you belong
to me…

Floating, falling,
sweet intoxication!
Touch me, trust me,
savour each sensation!
Let the dream begin,
let your darker side give in
to the power of
the music that I write –
the power of
the music of the night…

(During all this, the PHANTOM has conditioned CHRISTINE to the coldness of his touch and her fingers are brave enough to stray to his mask and caress it, with no hint of removing it. The PHANTOM leads her to a large mirror from which he removes a dustcover and in which we see the image of CHRISTINE, a perfect wax-face impression, wearing a wedding gown. CHRISTINE moves slowly towards it, when suddenly the image thrusts its hands through the mirror toward her. She faints. The PHANTOM catches her and carries her to the bed, where he lays her down)

PHANTOM
You alone
can make my song take flight –
help me make the music of the
night…

Scene Six

THE NEXT MORNING

(As the light brightens, we see the

PHANTOM seated at the organ, playing with furious concentration. He breaks off occasionally to write the music down. There is a musical box, in the shape of a barrel organ, beside the bed. Mysteriously, it plays as CHRISTINE wakes up. The music keeps her in a half-trance)

8 CHRISTINE
I remember
there was mist…
swirling mist
upon a vast, glassy lake…

There were candles
all around,
and on the lake there
was a boat,
and in the boat
there was a man…

(She rises and approaches the PHANTOM, who does not see her. As she reaches for his mask, he turns, almost catching her. This happens several times.)

Who was that shape
in the shadows?
Whose is the face
in the mask?

(She finally succeeds in tearing the mask from his face. The PHANTOM springs up and rounds on her furiously. She clearly sees his face. The audience does not, as he is standing in profile and in shadow)

PHANTOM
Damn you!
You little prying
Pandora!
You little demon –
is this what you wanted to see?
Curse you!
You little lying
Delilah!
You little viper –
now you cannot ever be free!

Damn you…
Curse you…

(A pause)

Stranger
than you dreamt it –
can you even
dare to look
or bear to
think of me:
this loathsome
gargoyle, who
burns in hell, but secretly
yearns for heaven,
secretly…
secretly…

But, Christine…

Fear can
Turn to love – you'll
learn to see, to
find the man
behind the
monster: this...
repulsive
carcass, who
seems a beast, but secretly
dreams of beauty,
secretly...
secretly...

Oh, Christine...

(He holds out his hand for the mask, which she gives to him. He puts it on, turning towards the audience as he sings):

Come we must return –
those two fools
who run the theatre
will be missing you.

(The lair sinks into the floor as CHRISTINE and the PHANTOM leave)

9 Scene Seven

BACKSTAGE

(BUQUET mysteriously appears, a length of fabric serving as a cloak, and a piece of rope as the Punjab lasso. He is showing off to the BALLET GIRLS)

BUQUET
Like yellow parchment
is his skin...
a great black hole served
as the nose that never grew...

(Demonstrating his method of self-defence against the Punjab lasso, he inserts his hand between his neck and the noose, and then pulls the rope taut. With a mixture of horror and delight, the BALLET GIRLS applaud this demonstration)

(Explaining to them)

You must be always
on your guard,
or he will catch you with his
magical lasso!

(A trap opens up centre-stage, casting a shadow of the PHANTOM as he emerges. The GIRLS, linking hands, run off terrified. The PHANTOM, leading CHRISTINE, fixes his stare on BUQUET. Sweeping his cape around CHRISTINE, he exits with her. But before they go, GIRY has entered, observing. She turns on BUQUET)

GIRY
Those who speak
of what they know
find, too late, that prudent
silence is wise.

Joseph Buquet,
hold your tongue –
he will burn you with the
heat of his eyes...

10 Scene Eight

THE MANAGERS' OFFICE

(Desk, chairs, papers. FIRMIN scornfully eyeing a newspaper article)

FIRMIN
'Mystery
after gala night,'
it says, 'Mystery
of soprano's flight!'
'Mystified,
baffled Sûreté say,
we are mystified –
we suspect foul play!'

(He lowers the paper)

Bad news on
soprano scene –
first Carlotta,
now Christine!
Still, at least
the seats get sold –
gossip's worth
its weight in gold...

What a way to
run a business!
Spare me these
unending trials!
Half your cast disappears,
but the crowd still cheers!
Opera!
To hell with Gluck and Handel –
It's a scandal that'll
pack 'em in the aisles!

(ANDRÉ bursts in, in a temper)

ANDRÉ
Damnable!
Will they all walk out?
This is damnable!

FIRMIN
André, please don't shout…
It's publicity!
And the take is vast!
Free publicity!

ANDRÉ
But we have no cast…

FIRMIN *(calmly)*
But André,
have you seen the queue?

*(He has been sorting mail on his desk:
finding the two letters from the PHANTOM)*

Oh, it seems
you've got one too…

*(He hands the letter to ANDRÉ who opens
it and reads)*

ANDRÉ
'Dear André
what a charming gala!
Christine enjoyed a great success!
We were hardly bereft
when Carlotta left –
otherwise,
the chorus was entrancing,
but the dancing was a
lamentable mess!'

FIRMIN *(reading his)*
'Dear Firmin,
just a brief reminder:
my salary has not been paid.
Send it care of the ghost,
by return of post –
P.T.O.:
No-one likes a debtor,
so it's better if my
orders are obeyed!'

FIRMIN/ANDRÉ
Who would have the gall
to send this?
Someone with a puerile brain!

FIRMIN *(examining both letters)*
These are both signed 'O.G.'…

ANDRÉ
Who the hell is he?

BOTH *(immediately realising)*
Opera Ghost!

FIRMIN *(Unamused)*
It's really not amusing!

ANDRÉ
He's abusing
our position!

FIRMIN
In addition
he wants money!

ANDRÉ
He's a funny
sort of spectre…

BOTH
…to expect a
large retainer!
Nothing plainer –
he is clearly quite insane!

*(They are interrupted by the arrival of
RAOUL, who brandishes another of the
PHANTOM's notes)*

RAOUL
Where is she?

ANDRÉ
You mean Carlotta?

RAOUL
I Mean Miss Daaé –
where is she?

FIRMIN
Well, how should we know?

RAOUL
I want an answer –
I take it that you
sent me this note?

FIRMIN
What's all this nonsense?

ANDRÉ
Of course not!

FIRMIN
Don't look at us!

RAOUL
She's not with you, then?

FIRMIN
Of course not!

ANDRÉ
We're in the dark…

RAOUL
Monsieur, don't argue –
Isn't this the
letter you wrote?

FIRMIN
And what is it that we're
meant to have wrote?

(Realising his mistake)

Written!

*(RAOUL hands the note to ANDRÉ, who
reads it)*

ANDRÉ
'Do not fear for Miss Daaé.
The Angel of Music
has her under his wing.
Make no attempt to see her again.'

(The MANAGERS look mystified)

RAOUL
If you didn't write it, who did?

– 135 –

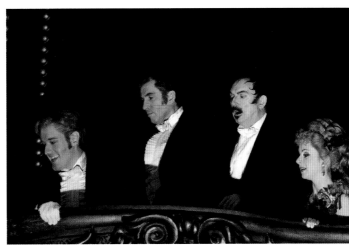

(*CARLOTTA bursts in. She too has a letter, which has cheered her no more than the others*)

CARLOTTA
Where is he?

ANDRÉ
Ah, welcome back!

CARLOTTA
Your precious patron –
where is he?

RAOUL
What is it now?

CARLOTTA (*to RAOUL*)
I have your letter –
a letter which I
rather resent!

FIRMIN (*to RAOUL*)
And did you send it?

RAOUL
Of course not!

ANDRÉ
As if he would!

CARLOTTA
You didn't send it?

RAOUL
Of course not!

FIRMIN
What's going on…?

CARLOTTA (*to Raoul*)
You dare to tell me
that this is not the
letter you sent?!

RAOUL
And what is it that I'm
meant to have sent?

(*RAOUL takes the letter and reads it*)

'Your days
at the Opéra Populaire are
numbered.
Christine Daaé
will be singing on your behalf
tonight.
Be prepared
for a great misfortune,
should you attempt
to take her place.'

(*The MANAGERS are beginning to tire of the intrigue*)

ANDRÉ/FIRMIN
Far too many
notes for **my** taste –
and most of them
about Christine!
All we've heard since we came

is Miss Daaé's name…

(*GIRY suddenly appears, accompanied by MEG*)

GIRY
Miss Daaé has returned.

FIRMIN (*dryly*)
I trust her midnight oil
is well and truly burned.

ANDRÉ
Where precisely is she now?

GIRY
I thought it best
that she went home…

MEG
She needed rest.

RAOUL
May I see her?

GIRY
No, Monsieur,
she will see no-one.

CARLOTTA
Will she sing?
Will she sing?

GIRY
Here, I have a note…

RAOUL/CARLOTTA/ANDRÉ
Let me see it!

FIRMIN (*snatching it*)
Please!

FIRMIN (*Opens the letter and reads. The PHANTOM's voice gradually takes over*)
'Gentlemen, I have now sent you several notes of the most amiable nature, detailing how my theatre is to be run. You have not followed my instructions. I shall give you one last chance…'

PHANTOM'S VOICE (*taking over*)
Christine Daaé has returned to you,
and I am anxious her career
should progress.
In the new production of 'Il Muto',
you will therefore cast Carlotta
as the Pageboy, and put Miss Daaé
in the rôle of Countess.
The rôle which Miss Daaé plays
calls for charm and appeal.
The rôle of the Pageboy is silent –
which makes my casting,
in a word, ideal.

I shall watch the performance from my normal seat in Box Five, which will be kept empty for me. Should

these commands be ignored, a disaster beyond your imagination will occur.

FIRMIN (*taking over*)
'I remain, gentlemen,
Your obedient servant, O.G.'

CARLOTTA
Christine!

ANDRÉ
Whatever next…?

CARLOTTA
It's all a ploy to
help Christine!

FIRMIN
This is insane…

CARLOTTA
I know who sent this:
(*Pointing an accusing finger*)
The Vicomte – her lover!

RAOUL (*ironical*)
Indeed?
(*To the OTHERS*)
Can you believe this?

ANDRÉ (*to CARLOTTA, in protest*)
Signora!

CARLOTTA (*half to the MANAGERS, half to herself*)
O traditori!

FIRMIN (*to CARLOTTA*)
This is a joke!

ANDRÉ
This changes nothing!

CARLOTTA
O mentitori!

FIRMIN
Signora!

ANDRÉ
You are our star!

FIRMIN
And always will be!

ANDRÉ
Signora…

FIRMIN
The man is mad!

ANDRÉ
We don't take orders!

FIRMIN (*announcing it to everyone*)
Miss Daaé will be playing
the Pageboy – the silent rôle…

– 136 –

ANDRÉ/FIRMIN
Carlotta will be playing the lead!

CARLOTTA (waxing melodramatic)
It's useless trying to
appease me!
You're only saying this
to please me!
Signori, è vero?
Non, non, non voglio udire!
Lasciatemi morire!
O padre mio!
Dio!

GIRY
Who scorn his word,
beware to those…

CARLOTTA (to MANAGERS)
You have reviled me!

GIRY
The angel sees,
the angel knows…

RAOUL
Why did Christine
fly from my arms…?

CARLOTTA
You have rebuked me!

ANDRÉ/FIRMIN
Signora, pardon us…

CARLOTTA
You have replaced me!

ANDRÉ/FIRMIN
Please, Signora,
we beseech you…

GIRY
This hour shall see
your darkest fears…

MEG/RAOUL
I must see her…

CARLOTTA
Abbandonata!
Deseredata!
O, sventurata!

GIRY
The angel knows,
the angel hears…

RAOUL
Where did she go…?

CARLOTTA
Abbandonata!
Disgraziata!

ANDRÉ/FIRMIN
Signora, sing for us!
Don't be a martyr…

RAOUL/GIRY/MEG
What new surprises
lie in store…?

ANDRÉ/FIRMIN
Our star…!

CARLOTTA
Non vo' cantar!

(ALL look at CARLOTTA as the MANAG-
ERS approach her lovingly)

ANDRÉ
Your public needs you!

FIRMIN
We need you, too!

CARLOTTA (unassuaged)
Would you not
rather have your
precious little
ingénue?

ANDRÉ/FIRMIN
Signora, no!
The world wants you!

(The MANAGERS adopt their most
persuasive attitudes)

ANDRÉ/FIRMIN
Prima donna,
first lady of the stage!
Your devotees
are on their knees
to implore you!

ANDRÉ
Can you bow out
when they're shouting
your name?

FIRMIN
Think of how they
all adore you!

BOTH
Prima donna,
enchant us once again!

ANDRÉ
Think of your muse…

FIRMIN
And of the queues
round the theatre!

BOTH
Can you deny
us the triumph
in store?
Sing, prima donna,
once more!

(CARLOTTA registers her acceptance, as
the MANAGERS continue to cajole and the
others reflect variously on the situation)

RAOUL
Christine spoke of an angel…

CARLOTTA (to herself in triumph)
Prima donna,
your song shall live again!

ANDRÉ/FIRMIN (to CARLOTTA)
Think of your public!

CARLOTTA
You took a snub,
but there's a public
who needs you!

GIRY (referring to CHRISTINE)
She has heard the voice
of the Angel of Music…

ANDRÉ/FIRMIN (to CARLOTTA)
Those who hear your voice
liken you to an angel!

CARLOTTA
Think of their cry
of undying
support!

RAOUL
Is this her Angel of Music…?

ANDRÉ (to FIRMIN)
We get our opera…

FIRMIN (to ANDRÉ)
She gets her limelight!

CARLOTTA
Follow where the limelight
leads you!

MEG
Is this ghost
an angel or a madman…?

RAOUL
Angel or madman…?

ANDRÉ/FIRMIN (aside)
Leading ladies are a trial!

CARLOTTA
Prima donna,
your song shall never die!

MEG
Voice of hell, or of heaven…?

GIRY
Heaven help you
those who doubt…

CARLOTTA
You'll sing again,
and to unending
ovation!

RAOUL
Orders! Warnings!

– 137 –

Lunatic demands!

GIRY
This miscasting
will invite damnation…

ANDRÉ/FIRMIN
Tears… oaths…
lunatic demands
are regular occurrences!

MEG
Bliss or damnation?
Which has claimed her…?

CARLOTTA
Think how you'll shine
in that final
encore!
Sing, prima donna,
once more!

GIRY
Oh fools,
to have flouted his warnings!

RAOUL
Surely, for her sake…

MEG
Surely he'll strike back…

ANDRÉ/FIRMIN
Surely there'll be further scenes –
worse than this!

GIRY
Think, before
these demands are rejected!

RAOUL
…I must see these
demands are rejected!

MEG
…If his threats
and demands are rejected!

ANDRÉ/FIRMIN
Who'd believe a diva
happy to relieve a
chorus girl, who's gone
and slept with the patron?
Raoul and the soubrette,
entwined in love's duet!
Although he may demur,
he must have been with her!

MEG/RAOUL
Christine must be protected!

CARLOTTA
O, fortunata!
Non ancor
abbandonata!

ANDRÉ/FIRMIN
You'd never get away

with all this in a play,
but if it's loudly sung
and in a foreign tongue,
it's just the sort of story
audiences adore, in
fact a perfect
opera!

RAOUL
His game is over !

GIRY
This is a game
you cannot hope to win!

RAOUL
And in Box Five
a new game will begin…

GIRY
For, if his curse
is on this opera…

MEG
But if his curse
is on this opera…

ANDRÉ/FIRMIN
Prima donna,
the world is at your feet!
A nation waits,
and how it hates
to be cheated!

CARLOTTA
The stress that falls upon a
famous prima donna!
Terrible diseases,
coughs and colds and sneezes!
Still, the driest throat
will reach the highest note,
in search of perfect
opera!

MEG/GIRY
…then I fear the outcome…

RAOUL
Christine plays the Pageboy,
Carlotta plays the Countess…

GIRY
…should you dare to…

MEG
…when you once again…

ALL
Light up the stage
with that age-old
rapport!
Sing, prima donna,
once more!

PHANTOM'S VOICE
So, it is to be war between us!
If these demands are not met, a

disaster beyond your imagination
will occur!

ALL
Once more!

Scene Nine

A PERFORMANCE OF 'IL MUTO' BY ALBRIZZIO

*(During the Overture RAOUL, ANDRÉ
and FIRMIN take their respective seats –
RAOUL in Box Five, the MANAGERS in
a box opposite)*

RAOUL
Gentlemen, if you would care to
take your seats? I shall be sitting in
Box Five.

ANDRÉ
Do you really think that's wise,
Monsieur?

RAOUL
My dear André, there would appear
to be no seats available, other than
Box Five.

*(The front cloth rises to reveal an 18th
century salon, a canopied bed centre-stage.
The COUNTESS is played by CARLOTTA,
SERAFIMO, the page boy, is disguised as
her maid and is played by CHRISTINE. At
this point they are hidden behind the drapes
of the bed, which are drawn.*

*In the room are TWO EPICENE MEN: one
a HAIRDRESSER and one a JEWELLER.
The JEWELLER is attended by MEG.
There is also an OLDER WOMAN, the
COUNTESS' confidante. All apart from
MEG are gossiping with relish about
the COUNTESS' current liaison with
SERAFIMO)*

CONFIDANTE
**They say that this youth
has set my Lady's
heart aflame!**

1ST FOP
**His Lordship, sure,
would die of shock!**

2ND FOP
**His Lordship is
a laughing-stock!**

CONFIDANTE
**Should he suspect her,
God protect her!**

ALL THREE
Shame! Shame! Shame!

**This faithless lady's
bound for Hades!
Shame! Shame! Shame!**

*(The canopy drapes part and we see
the COUNTESS kissing SERAFIMO
passionately. As the recitative begins,
the lights and music dim on stage, and*

– 138 –

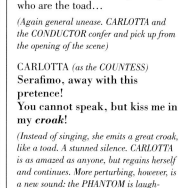

our attention turns to the MANAGERS in their box)

IN THE BOX

ANDRÉ
Nothing like the old operas!

FIRMIN
Or the old scenery…

ANDRÉ
The old singers…

FIRMIN
The old audience…

ANDRÉ
And every seat sold!

FIRMIN
Hardly a disaster beyond all imagination!

(They chuckle and nod to RAOUL in the opposite box. He acknowledges them)

ON STAGE

COUNTESS
Serafimo – your disguise is perfect.

(A knock at the door)

Why who can this be?

DON ATTILIO
Gentle wife, admit your loving husband.

ATTENTION BACK ON STAGE

(The COUNTESS admits DON ATTILIO. He is an old fool)

DON ATTILIO
My love – I am called to England on affairs of State, and must leave you with your new maid.
(Aside)
Though I'd happily take the maid with me.

COUNTESS *(aside)*
The old fool's leaving!

DON ATTILIO *(aside)*
I suspect my young bride is untrue to me. I shall not leave, but shall hide over there to observe her!

DON ATTILIO *(to COUNTESS)*
Addio!

COUNTESS
Addio!

BOTH *(to each other)*
Addio!

(He goes, pretending to leave, then hides and watches the action)

COUNTESS *(CARLOTTA)*
Serafimo – away with this pretence!

(She rips off SERAFIMO's skirt to reveal his manly breeches)

You cannot speak but kiss me in my husband's absence!
[11] Poor fool, he makes me laugh!
Haha,
Haha! etc.
Time I tried to get a better better half!

COUNTESS AND CHORUS
Poor fool, he doesn't know!
Hoho,
Hoho! etc.
If he knew the truth, he'd never, ever go!

(Suddenly, from nowhere, we hear the voice of the PHANTOM)

PHANTOM'S VOICE
Did I not instruct that Box Five was to be kept empty?

MEG *(terrified)*
He's here: the Phantom of the Opera…

(General reaction of bewilderment. CHRISTINE looks fearfully about her)

CHRISTINE
It's him… I know it… it's him…

CARLOTTA *(Finding a scapegoat in CHRISTINE, hisses at her)*
Your part is silent, little toad!

(But the PHANTOM has heard her)

PHANTOM'S VOICE
A toad, Madame? Perhaps it is you who are the toad…

(Again general unease. CARLOTTA and the CONDUCTOR confer and pick up from the opening of the scene)

CARLOTTA *(as the COUNTESS)*
Serafimo, away with this pretence!
You cannot speak, but kiss me in my *croak*!

(Instead of singing, she emits a great croak, like a toad. A stunned silence. CARLOTTA is as amazed as anyone, but regains herself and continues. More perturbing, however, is a new sound: the PHANTOM is laughing – quietly at first, then more and more hysterically)

CARLOTTA *(as the COUNTESS)*
Poor fool, he makes me laugh –
Hahahahaha!
Croak, croak, croak, croak, croak, croak, etc.

(As before, the PHANTOM's laughter rises. The croaking continues as the chandelier's lights blink on and off. The PHANTOM's laughter, by this time overpowering, now crescendos into a great cry):

PHANTOM'S VOICE
Behold! She is singing to bring down the chandelier!

(CARLOTTA looks tearfully up at the MANAGERS' box and shakes her head)

CARLOTTA
Non posso più…
I cannot… I cannot go on…

PIANGI *(rushing on)*
Cara, cara… I'm here…
is all right… Come… I'm here…

(ANDRÉ and FIRMIN hurry out of the box on to the stage. PIANGI ushers the now sobbing CARLOTTA offstage, while the MANAGERS tackle the audience)

FIRMIN
Ladies and gentlemen, the performance will continue in ten minutes' time…
(He addresses Box Five, keeping one eye on the chandelier as it returns to normal)
…when the role of the Countess will be sung by Miss Christine Daaé.

ANDRÉ *(improvising)*
In the meantime, ladies and gentlemen, we shall be giving you the ballet from Act Three of tonight's opera.

(To the CONDUCTOR)

Maestro – the ballet – now!

(The MANAGERS leave, the stage is cleared and music starts again.
The BALLET GIRLS enter, as a sylvan glade flies in. They begin the Dance of the Country Nymphs. Upstage, behind the drop, a series of threatening shadows of the PHANTOM. MEG is aware of them and dances out of step. When this culminates in one gigantic, oppressive, bat-like shadow, the garrotted body of JOSEPH BUQUET falls on to the stage, causing the sylvan glade to fly out. Pandemonium)

CHRISTINE *(calling for help)*
Raoul! Raoul!

(RAOUL runs on stage and embraces her)

RAOUL *(to CHRISTINE, leading her away)*
Christine, come with me…

CHRISTINE
No… to the roof. We'll be safe there.

(CHRISTINE and RAOUL hurry off)

FIRMIN *(attempting to placate the audience, as STAGEHANDS and POLICEMEN crowd on to the stage)*
Ladies and gentlemen, please remain in your seats. Do not panic. It was an accident… simply an accident…

Scene Ten

[12] THE ROOF OF THE OPÉRA HOUSE

(A statue of 'La Victoire Ailée' – the same as that which tops the proscenium. It is twilight. CHRISTINE and RAOUL rush on)

RAOUL
Why have you brought us here?

CHRISTINE
Don't take me back there!

RAOUL
We must return!

CHRISTINE
He'll kill me!

RAOUL
Be still now…

CHRISTINE
His eyes will find me there!

RAOUL
Christine, don't say that…

CHRISTINE
Those eyes that burn!

RAOUL
Don't even think it…

CHRISTINE
And if he has to kill
a thousand men –

RAOUL
Forget this waking nightmare…

CHRISTINE
The Phantom of the Opera will kill…

RAOUL
This Phantom is a fable…
Believe me…

CHRISTINE
…and kill again!

RAOUL
There is no Phantom of the Opera…

CHRISTINE
My God, who is this man…

RAOUL
My God, who is this man…

CHRISTINE
…who hunts to kill…?

RAOUL
…this mask of death…?

CHRISTINE
I can't escape from him…

RAOUL
Whose is this voice you hear…

CHRISTINE
…I never will!

RAOUL
…with every breath…?

BOTH
And in this
labyrinth,
where night is blind,
the Phantom of the Opera
is here:
inside your/my mind…

RAOUL
There is no Phantom of the Opera…

CHRISTINE
Raoul, I've been there –
to his world of
unending night…
To a world where
the daylight dissolves

into darkness…
darkness…

Raoul, I've seen him!
Can I ever
forget that sight?
Can I ever
escape from that face?
So distorted,
deformed, it
was hardly a face,
in that darkness…
darkness…

(Trance-like, then becoming more and more ecstatic)

But his voice,
filled my spirit
with a strange, sweet sound…
In that night
there was music
in my mind…
And through music
my soul began
to soar!
And I heard
as I'd never
heard before…

RAOUL
What you heard
was a dream
and nothing more…

CHRISTINE
Yet in his eyes
all the sadness
of the world…
Those pleading eyes,
that both threaten
and adore…

RAOUL *(comforting)*
Christine…
Christine…

PHANTOM *(unseen, a ghostly echo of RAOUL's words)*
Christine…

CHRISTINE
What was that?

(A moment, as their eyes meet. The mood changes)

[13] RAOUL
No more talk
of darkness,
Forget these
wide-eyed fears.
I'm here,
nothing can harm you –
my words will
warm and calm you.

Let me be
your freedom,
let daylight
dry your tears.
I'm here,
with you, beside you,
to guard you
and to guide you…

CHRISTINE
Say you love me
every
waking moment,
turn my head
with talk of summertime…

Say you need me
with you,
now and always…
promise me that all
you say is true –
that's all I ask
of you…

RAOUL
Let me be
your shelter,
let me
be your light.
You're safe:
No-one will find you –
your fears are
far behind you…

CHRISTINE
All I want
is freedom,
a world with
no more night…
and you,
always beside me,
to hold me
and to hide me…

RAOUL
Then say you'll share with
me one
love, one lifetime…
let me lead you
from your solitude…

Say you need me
with you
here, beside you…
anywhere you go,

let me go too –
Christine,
that's all I ask
of you…

CHRISTINE
Say you'll share with
me one
love, one lifetime…
say the word
and I will follow you…

BOTH
Share each day with
me, each
night, each morning…

CHRISTINE
Say you love me…

RAOUL
You know I do…

BOTH
Love me –
that's all I ask
of you…
(They kiss)

Anywhere you go
let me go too…
Love me –
that's all I ask
of you…
(CHRISTINE starts from her reverie)

14 CHRISTINE
I must go –
they'll wonder
where I am…
wait for me, Raoul!

RAOUL
Christine, I love you!

CHRISTINE
Order your
fine horses!
Be with them
at the door!

RAOUL
And soon you'll be beside me!

CHRISTINE
You'll guard me, and you'll
guide me…

(They hurry off. The PHANTOM emerges
from behind the statue)

PHANTOM
I gave you my music…
made your song take wing…
and now, how you've
repaid me:
denied me
and betrayed me…
He was bound to love you
when he heard you sing…

Christine…
Christine…

RAOUL/CHRISTINE (offstage)
Say you'll share with
me one
love, one lifetime…
say the word
and I will follow you…

Share each day with
me, each
night, each morning…

PHANTOM
You will curse the day
you did not do
all that the Phantom asked
of you…!

(As the roof of the opera house disap-
pears, the opera curtain closes and the
PRINCIPALS in 'Il Muto' appear through
it for their bows, CHRISTINE conspicu-
ously dressed in CARLOTTA's costume.
Simultaneously, we hear the maniacal
laughter of the PHANTOM and see him
high above the stage, perilously rocking
the chandelier. The lights of the chandelier
begin flickering and, at a great cry from
him, it descends, swinging more and more
madly over the orchestra pit)

– 141 –

PHANTOM
Go!!

(The chandelier falls to the stage at
CHRISTINE's feet)

END OF ACT ONE

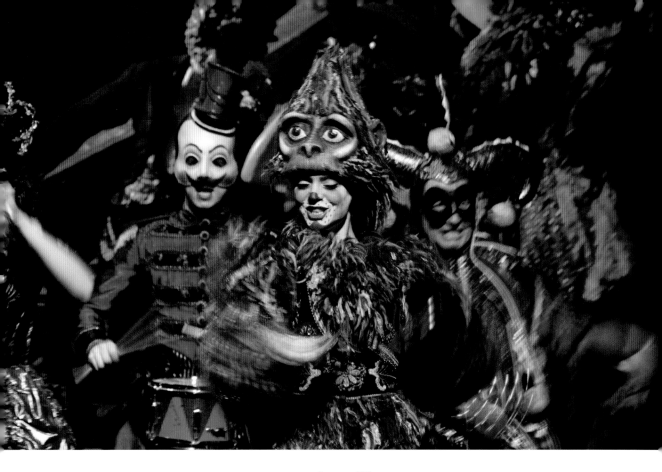

☐1 ENTR'ACTE

– Act Two –

Scene One

THE STAIRCASE OF THE OPÉRA HOUSE

(A gauze half conceals the tableau of guests at the opera ball. The guests (whom we cannot yet see clearly) are in fancy dress – a peacock, a lion, a dragon, Mephistopheles, a highwayman, a clown, knights, ladies, an executioner. M. ANDRÉ enters. He is dressed as a skeleton, in an opera cape. Almost immediately M. FIRMIN arrives. He is also dressed as a skeleton in an opera cape. The two skeletons see each other and approach nervously)

ANDRÉ
M'sieur Firmin?

FIRMIN
M'sieur André?

(Each raises his mask to the other. They recognise each other)

FIRMIN
Dear André,
what a splendid party!

ANDRÉ
The prologue
to a bright new year!

FIRMIN
Quite a night!
I'm impressed!

FIRMIN
Well, one does
one's best…

ANDRÉ/FIRMIN *(raising their glasses)*
Here's to us!

FIRMIN
I must say,
all the same, that
it's a shame that 'Phantom'
fellow isn't here!

(The gauze lifts fully to reveal the staircase of the opera house. The opera ball begins. Among the GUESTS are four carrying strange percussion instruments: a monkey with cymbals, a toy soldier with a drum, a triangle, bells. Together they play weirdly throughout)

☐2 CHORUS
Masquerade!
Paper faces on parade…
Masquerade!
Hide your face,
so the world will
never find you!

Masquerade!
Every face a different shade…
Masquerade!
Look around –
there's another
mask behind you!

Flash of mauve…
Splash of puce…
Fool and king…
Ghoul and goose…
Green and black…
Queen and priest…
Trace of rouge…
Face of beast…

Faces…
Take your turn, take a ride
on the merry-go-round…
in an inhuman race…

Eye of gold…
Thigh of blue…
True is false…
Who is who…?
Curl of lip…
Swirl of gown…
Ace of hearts…
Face of clown…

Faces…
Drink it in, drink it up,
till you've drowned
in the light…
in the sound…

RAOUL/CHRISTINE
But who can name the face…?

ALL
Masquerade!
Grinning yellows,
spinning reds…
Masquerade!
Take your fill –
let the spectacle
astound you!

Masquerade!
Burning glances,
turning heads…
Masquerade!
Stop and stare
at the sea of smiles
around you!

Masquerade!
Seething shadows,
breathing lies…
Masquerade!
You can fool
any friend who
ever knew you!

Masquerade!
Leering satyrs,
peering eyes…
Masquerade!
Run and hide –
but a face will
still pursue you!

(The ENSEMBLE activity becomes
background, as ANDRÉ, FIRMIN, MEG,
GIRY, PIANGI and CARLOTTA come to the
fore, glasses in hand)

GIRY
What a night!

MEG
What a crowd!

ANDRÉ
Makes you glad!

FIRMIN
Makes you proud!
All the crème
de la crème!

CARLOTTA
Watching us watching them!

MEG/GIRY
And all our fears
are in the past!

ANDRÉ
Six months…

PIANGI
Of relief!

CARLOTTA
Of delight!

ANDRÉ/FIRMIN
Of Elysian peace!

MEG/GIRY
And we can breathe at last!

CARLOTTA
No more notes!

PIANGI
No more ghost!

GIRY
Here's a health!

ANDRÉ
Here's a toast:
to a prosperous year!

FIRMIN
To the new chandelier!

PIANGI/CARLOTTA
And may its
splendour never fade!

FIRMIN
Six months!

GIRY
What a joy!

MEG
What a change!

FIRMIN/ANDRÉ
What a blessed release!

ANDRÉ
And what a masquerade!

(They clink glasses and move off. RAOUL
and CHRISTINE emerge. She is admiring
a new acquisition: an engagement ring
from RAOUL, which she has attached to a
gold chain around her neck)

CHRISTINE
Think of it!
A secret engagement!
Look – your future bride!
Just think of it!

RAOUL
But why is it secret?
What have we to hide?

CHRISTINE
Please, let's not fight…

RAOUL
Christine, you're free!

CHRISTINE
Wait till the time is right…

RAOUL
When will that be?
It's an engagement,
not a crime!

Christine,
What are you
afraid of?

CHRISTINE
Let's not argue…

RAOUL
Let's not argue…

CHRISTINE
Please pretend…

RAOUL
I can only hope I'll…

CHRISTINE
You will…

BOTH
…understand
in time…

(Dance section, in which CHRISTINE,
almost coquettish, almost jittery, goes from
man to man. But too many of her partners
seem to be replicas of the PHANTOM,
and each spins her with increasing force.
Eventually RAOUL rescues her and holds
her tightly. He whirls her back into the dance,
as the music heads towards its climax)

ALL
Masquerade!
Paper faces on parade!
Masquerade!
Hide your face,
so the world will
never find you!

Masquerade!
Every face a different shade!
Masquerade!
Look around –
There's another
mask behind you!

Masquerade!
Burning glances,
turning heads…
Masquerade!
Stop and stare
at the sea of smiles
around you!

Masquerade!
Grinning yellows,
spinning reds…
Masquerade!
Take your fill –

– 143 –

let the spectacle
astound you!

*(At the height of the activity a grotesque
figure suddenly appears at the top of the
staircase. Dressed all in crimson, with a
death's head visible inside the hood of his
robe, the PHANTOM has come to the party.
With dreadful wooden steps he descends the
stairs and takes the centre of the stage)*

PHANTOM
Why so silent, good messieurs?
Did you think that I had left you
for good?
Have you missed me, good
messieurs?
I have written you an opera!

*(He takes from under his robe an enormous
bound manuscript)*

Here I bring the finished score –
'Don Juan Triumphant'!

(He throws it to ANDRÉ)

I advise you
to comply –
my instructions
should be clear –
Remember,
there are worse things
than a shattered chandelier…

*(CHRISTINE, mesmerized, approaches as
the PHANTOM beckons her. He reaches
out, grasps the chain that holds the secret
engagement ring, and rips it from her
throat)*

Your chains are still mine –
you will sing for me!

*(ALL cower in suspense as the music
crescendos until, suddenly, his figure
evaporates)*

Scene Two

BACKSTAGE

*(GIRY is hurrying across. RAOUL
appears and calls after her)*

RAOUL
Madame Giry. Madame Giry…

GIRY
Monsieur, don't ask me – I know no
more than anyone else.

(She moves off again. He stops her)

RAOUL
That's not true. You've seen something,
haven't you?

GIRY *(uneasily)*
I don't know what I've seen… Please
don't ask me, Monsieur…

RAOUL *(desperately)*
Madame, for all our sakes…

GIRY *(she has glanced nervously about
her and, suddenly deciding to trust
him, cuts in)*

Very well. It was years ago. There was
a travelling fair in the city. Tumblers,
conjurors, human oddities…

RAOUL
Go on…

GIRY *(trance-like, as she retraces the
past)*
And there was… I shall never forget
him: a man… locked in a cage…

RAOUL
In a *cage*…?

GIRY
A prodigy, Monsieur! Scholar, architect,
musician…

RAOUL *(piecing together the jigsaw)*
A composer…

GIRY
And an inventor, too, Monsieur. They
boasted he had once built for the Shah
of Persia, a maze of mirrors…

RAOUL *(mystified and impatient,
cuts in)*
Who *was* this man…?

GIRY *(with a shudder)*
A freak of nature…
more monster
than man…

RAOUL *(a murmur)*
Deformed…?

GIRY
From birth, it seemed…

RAOUL
My God…

GIRY
And then…he went missing. He
escaped.

RAOUL
Go on.

GIRY
They never found him – it was said
he had died…

RAOUL *(darkly)*
But he didn't die, did he?

GIRY
The world forgot him,
but I never can…
For in this darkness
I have seen him again…

RAOUL
And so our
Phantom's this man…

GIRY *(starts from her daze and turns
to go)*
I have said too much, Monsieur.

*(She moves off into the surrounding
blackness)*
And there have been too many
accidents…

RAOUL *(ironical)*
Accidents?!

GIRY
Too many…

*(And, before he can question her
further, she has disappeared)*

RAOUL *(running after her)*
Madame Giry…!

Scene Three

THE MANAGERS' OFFICE

*(The PHANTOM's score lies open on the
desk. ANDRÉ is impatiently flicking
through it)*

3 ANDRÉ
Ludicrous!
Have you seen the score?

FIRMIN *(entering)*
Simply ludicrous!

ANDRÉ
It's the final straw!

FIRMIN
This is lunacy!
Well, you know my views…

ANDRÉ
Utter lunacy!

FIRMIN
But we daren't refuse…

ANDRÉ *(groans)*
Not another
chandelier…

FIRMIN
Look, my friend, what
we have here…

*(He has two notes from the PHANTOM, one
of which he hands to ANDRÉ, who opens it
and reads):*

ANDRÉ
'Dear André,
RE my orchestrations:
We need another first bassoon.
Get a player with tone –
and that third trombone
has to go!
The man could not be deafer,
so please preferably one
who plays in tune!'

FIRMIN *(reading his letter):*
'Dear Firmin,
vis à vis my opera:
some chorus-members must be
sacked.
If you could, find out which
has a sense of pitch –
wisely, though,
I've managed to assign a
rather minor role to those
who cannot act!'

*(They are interrupted by the arrival of
CARLOTTA and PIANGI, both furiously
brandishing similar notes)*

CARLOTTA
Outrage!

FIRMIN
What is it now?

CARLOTTA
This whole affair is
an outrage!

FIRMIN
Signora, please…

ANDRÉ
Now what's the matter?

CARLOTTA
Have you seen
the size of my part?

ANDRÉ
Signora, listen…

PIANGI
It's an insult!

FIRMIN
Not you as well!

PIANGI
Just look at this –
it's an insult!

FIRMIN
Please, understand…

ANDRÉ
Signor! Signora!

CARLOTTA
The things I have
to do for my art!

PIANGI (stabbing a finger at the open
score)
If you can call
this gibberish 'art'!

(RAOUL and CHRISTINE enter.
CARLOTTA bristles)

CARLOTTA (dryly)
Ah! Here's our little flower!

FIRMIN
Ah, Miss Daaé,
quite the lady
of the hour!

ANDRÉ (explaining)
You have
secured the largest role
in this 'Don Juan'.

CARLOTTA (half to herself)
Christine Daaé?
She doesn't have
the voice!

FIRMIN (hearing this, to CARLOTTA)
Signora, please!

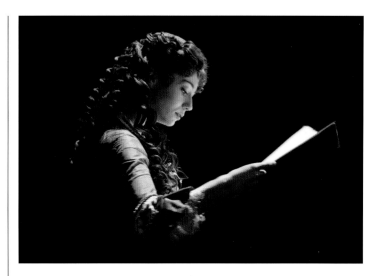

RAOUL (to the MANAGERS)
Then I take it
you're agreeing.

CARLOTTA (aside)
She's behind this…

ANDRÉ
It appears we have
no choice.

CARLOTTA (unable to contain herself
any longer, points accusingly)
She's the one
behind this!
Christine Daaé!

CHRISTINE (who has been silent till
now, incensed at this)
How dare you!

CARLOTTA
I'm not a fool!

CHRISTINE
You evil woman!
How dare you!

CARLOTTA
You think I'm blind!

CHRISTINE
This isn't my fault!
I don't want any
part in this plot!

FIRMIN
Miss Daaé, surely…

ANDRÉ
But why not?

PIANGI (baffled, to CARLOTTA)
What does she say?

FIRMIN (reasonably)
It's your decision –

(Suddenly rounding on her)
But why not?

CARLOTTA (to PIANGI)
She's backing out!

ANDRÉ
You have a duty!

CHRISTINE
I cannot sing it,
duty or not!

RAOUL (comforting)
Christine…
Christine…
You don't have to…
they can't make you…

(MEG and GIRY arrive, the latter bearing
another note from the PHANTOM)

GIRY
Please, Monsieur:
another note.

(The MANAGERS gesture: 'read it'. As
she reads, ALL react variously, as they are
singled out)

GIRY
'Fondest greetings
to you all!
A few instructions,
just before
rehearsal starts:
Carlotta must
be taught to act…'

(The PHANTOM's voice gradually takes
over from her)

PHANTOM'S VOICE
…not her normal trick
of strutting round the stage.
Our Don Juan must

– 145 –

lose some weight –
it's not healthy in
a man of Piangi's age.
And my managers
must learn
that their place is in
an office, not the arts.

As for Miss Christine Daaé…
No doubt she'll
do her best – it's
true her voice is
good. She knows, though,
should she wish to excel,
she has much still
to learn, if pride will
let her
return to me, her
teacher,
her teacher…

Your obedient friend…
*(The PHANTOM's voice fades out and
GIRY takes over)*

GIRY
'…and Angel…'
*(Attention now focuses on RAOUL, whose
eyes are suddenly bright with a new
thought)*

RAOUL
We have all been
blind – and yet the
answer is staring us
in the face…
This could be the
chance to ensnare our
clever friend…

ANDRÉ
We're listening…

FIRMIN
Go on…

RAOUL
We shall play his
game – perform his
work – but remember we
hold the ace…
For, if Miss Daaé
sings, he is certain
to attend…

ANDRÉ *(carried along by the idea)*
We make certain
the doors are barred…

FIRMIN *(likewise)*
We make certain
our men are there…

RAOUL
We make certain
they're armed…

RAOUL/ANDRÉ/FIRMIN *(savouring
their victory)*
The curtain falls –
his reign will end!
*(All have been listening intently. GIRY is
the first to express a reaction. CHRISTINE
remains silent and withdrawn)*

GIRY
Madness!

ANDRÉ
I'm not so sure…

FIRMIN
Not if it works…

GIRY
This is madness!

ANDRÉ
The tide will turn!

GIRY
Monsieur, believe me –
there is no way of
turning the tide!

FIRMIN *(to GIRY)*
You stick to ballet!

RAOUL *(rounding on GIRY)*
Then help us!

GIRY
Monsieur, I can't…

RAOUL
Instead of warning us…

RAOUL/ANDRÉ/FIRMIN
Help us!

GIRY
I wish I could…

RAOUL/ANDRÉ/FIRMIN
Don't make excuses!

RAOUL
Or could it be that
you're on his side?

GIRY *(to RAOUL)*
Monsieur, believe me,
I intend no ill…
(to ANDRÉ and FIRMIN)
But messieurs, be careful –
we have seen him kill…

ANDRÉ/FIRMIN *(to GIRY)*
We say he'll fall,
and fall he will!

CARLOTTA
She's the one behind this!
Christine!
This is all her doing!

PIANGI
This is the truth!
Christine Daaé!

RAOUL
This is his undoing!

ANDRÉ/FIRMIN *(to RAOUL)*
If you succeed,
you free us all –
this so-called 'angel'
has to fall!

RAOUL
Angel of Music,
fear my fury –
Here is where you fall!

GIRY *(to RAOUL)*
Hear my warning!
Fear his fury!

CARLOTTA
What glory can
she hope to gain?
It's clear to all
the girl's insane!

ANDRÉ *(to FIRMIN)*
If Christine sings
we'll get our man…

PIANGI
She is crazy!
She is raving!

FIRMIN *(to ANDRÉ)*
If Christine helps
us in this plan…

RAOUL
Say your prayers,
black angel of death!

CHRISTINE *(vainly pleading amidst the
tumult)*
Please don't…

ANDRÉ *(to FIRMIN)*
If Christine won't,
then no-one can…

GIRY *(to RAOUL)*
Monsieur, I beg you,
do not do this…

PIANGI/CARLOTTA:
Gran Dio!
Che imbroglio!

ANDRÉ/FIRMIN:
This will seal his fate!

CHRISTINE *(bursting through the hub-
bub with a great cry)*
If you don't stop,
I'll go mad!!!

(To RAOUL pleading)

Raoul, I'm frightened –
don't make me do this…
Raoul, it scares me –
don't put me through this
ordeal by fire…
he'll take me, I know…
we'll be parted for ever…
he won't let me go…

What I once used to dream
I now dread…
if he finds me, it won't
ever end…
and he'll always be there,
singing songs in my head…
he'll always be there,
singing songs in my head…

(ALL stare at her)

CARLOTTA
She's mad…

RAOUL *(to CHRISTINE)*
You said yourself
he was nothing
but a man…

Yet while he lives,
he will haunt us
till we're dead…

(CHRISTINE turns away, unhappily)

CHRISTINE
Twisted every way,
what answer can I give?
Am I to risk my life,
to win the chance to live?
Can I betray the man,
who once inspired my voice?
Do I become his prey?
Do I have any choice?

He kills without a thought,
he murders all that's good…
I know I can't refuse,
and yet, I wish I could…
Oh God – if I agree,
what horrors wait for me
in this, the Phantom's opera…?

RAOUL *(to CHRISTINE, very tenderly)*
Christine, Christine,
don't think that I don't care –
but every hope
and every prayer
rests on you now…

(CHRISTINE, overcome by her conflict-ing emotions, turns away and hurries out. RAOUL strides forward and addresses an imaginary PHANTOM)

RAOUL
So, it is to be war between us!

But this time, clever friend,
the disaster will be yours!

(As lights fade, ATTENDANTS stretch a red velvet rope across the downstage area. OTHERS bring on gilt chairs. CARLOTTA, PIANGI and GIRY move downstage to take their places for the next scene)

Scene Four

A REHEARSAL FOR 'DON JUAN TRIUMPHANT'

(REYER supervises the learning of the new piece from the piano. Present are PIANGI, CHRISTINE, CARLOTTA, GIRY and CHORUS)

> CHORUS
> **Hide your sword now, wounded knight! Your vainglorious gasconnade brought you to your final fight – for your pride, high price you've paid!**
>
> CHRISTINE
> **Silken couch and hay-filled barn – both have been his battlefield.**
>
> PIANGI *(wrong)*
> **Those who tangle with Don Juan…**
>
> REYER *(stopping him)*
> No, no, no! Chorus – rest, please.

Don Juan, Signor Piangi – here is the phrase.

(He demonstrates it)

'Those who tangle with Don Juan…'
If you please?

PIANGI *(still wrong)*
Those who tangle with Don Juan…

REYER
No, no. Nearly – but no.
'Those who tan, tan, tan…'

PIANGI *(still wrong)*
Those who tangle with Don Juan…

CARLOTTA *(to the OTHERS)*
His way is better. At least he make it sound like music!

GIRY *(to CARLOTTA)*
Signora – would you speak that way in the presence of the composer?

CARLOTTA *(deaf to the implications of this remark)*
The composer is not here. And if he were here, I would…

GIRY *(cutting in, ominous)*
Are you certain of that, Signora…?

REYER
So once again – after seven.

(He gives the note and counts in)

Five, six, seven…

PIANGI *(wrong again)*
Those who tangle with Don Juan…

(Gradually EVERYONE starts either to talk or to practise the phrase simultaneously)

CARLOTTA
Ah, più non posso! What does it matter what notes we sing?

GIRY
Have patience, Signora.

CARLOTTA
No-one will know if it is right, or if it is wrong.
No-one will care if it is right, or if it is wrong.

CARLOTTA *(mocking)*
**Those who tangle
with Don Juan!**

PIANGI *(trying again)*
Those who tan… tan…

(To CHRISTINE)

Is right?

CHRISTINE *(to PIANGI)*
Not quite, Signor:
Those who *tan… tan…*

REYER *(attempting to restore order)*
Ladies… Signor Piangi… if you please…

(REYER thumps the piano keys, then leaves the piano, and attempts to attract attention using signals. At the height of the mayhem, the piano suddenly begins to demonstrate the music unaided. It plays with great force and rhythm. ALL fall silent and freeze, then suddenly start to sing the piece robotically and accurately. As they continue to sing, CHRISTINE moves away from the group)

ALL EXCEPT CHRISTINE
Poor young maiden! For the thrill on your tongue of stolen sweets You will have to pay the bill – tangled in the winding sheets!

(As the ENSEMBLE becomes background, CHRISTINE, transfixed, sings independently)

CHRISTINE
**In sleep
he sang to me,
in dreams
he came…
that voice
which calls to me**

– 147 –

and speaks
my name…

(The scene begins to change. Trance-like, CHRISTINE moves slowly upstage. We hear the distant sound of bells)

4 Little Lotte
thought of everything and
nothing…
Her father promised her
that he would send her the Angel
of Music…
Her father promised her…
Her father promised her…

Scene Five

A GRAVEYARD

(A mausoleum with hanging moss. In the centre, a pyramid of skulls in front of a cross)

CHRISTINE
You were once
my one companion…
you were all
that mattered…
You were once
a friend and father –
then my world
was shattered…

Wishing you were
somehow here again…
wishing you were
somehow near…
Sometimes it seemed,
if I just dreamed,
somehow you would
be here…

Wishing I could
hear your voice again…
knowing that I
never would…
Dreaming of you
won't help me to do
all that you dreamed
I could…

Passing bells
and sculpted angels,
cold and monumental,
seem, for you,
the wrong companions –
you were warm and gentle…

Too many years
fighting back tears…
Why can't the past
just die…?

Wishing you were
somehow here again…
knowing we must

say goodbye…
Try to forgive…
teach me to live…
give me the strength
to try…

No more memories,
no more silent tears…
No more gazing across
the wasted years…
Help me say
goodbye.

(The PHANTOM emerges from behind the cross)

5 PHANTOM *(very soft and enticing)*
Wandering child…
so lost…
so helpless…
yearning for my
guidance…

(Bewildered, CHRISTINE looks up, and murmurs breathlessly)

CHRISTINE
Angel… or father…
friend… or
Phantom?
Who is it there,
staring…?

PHANTOM *(more and more hypnotic):*
Have you
forgotten your Angel…?

CHRISTINE
Angel… oh, speak…
What endless
longings
echo in this
whisper…!

(RAOUL appears in the shadows and watches for a moment, transfixed)

PHANTOM *(now drawing CHRISTINE towards him)*
Too long you've wandered
in winter…

RAOUL *(to himself, a murmur)*
Once again
she is his…

PHANTOM
Far from my
far-reaching gaze…

RAOUL
Once again
she returns…

CHRISTINE *(increasingly mesmerized)*
Wildly my mind
beats against you…

PHANTOM
You resist…

PHANTOM/CHRISTINE
Yet your/the soul
obeys…

RAOUL
…to the arms
of her angel…
angel or demon…
still he calls her…
luring her back, from the grave…
angel or dark seducer…?
Who are you, strange
angel…?

PHANTOM
Angel of Music!
You denied me,
turning from true beauty…
Angel of Music!
Do not shun me…
Come to your strange
Angel…

CHRISTINE
Angel of Music!
I denied you,
turning from true beauty…
Angel of Music!
My protector…
Come to me, strange
Angel…

(CHRISTINE moves towards the figure of the PHANTOM)

PHANTOM *(beckoning her)*
I am your Angel of Music…
Come to me: Angel of Music…

RAOUL *(suddenly calling out)*
Angel of darkness!
Cease this torment!

(Inexorably, the PHANTOM continues to beckon CHRISTINE)

PHANTOM
I am your Angel of Music…
Come to me: Angel of Music…

RAOUL *(in desperation)*
Christine! Christine, listen to me!
Whatever you may believe, this
man…
this thing… is *not* your father!

(To the PHANTOM)

Let her go! For God's sake, *let her go*! Christine!

(Coming out of her trance, CHRISTINE turns and mouths the word)

CHRISTINE
Raoul…

– 148 –

(She runs to RAOUL, who embraces her protectively. The PHANTOM freezes for a moment and then suddenly seizes a pike, upon which is impaled a skull. At a movement from him, a flash of fire streaks from the gaping mouth of the skull, and lands at RAOUL's feet)

PHANTOM
Bravo, Monsieur!
Such spirited words!

(Another fireball)

RAOUL
More tricks, Monsieur?

PHANTOM
Let's see, Monsieur,
how far you dare go!

(Another fireball)

RAOUL
More deception? More violence?

CHRISTINE (to RAOUL)
Raoul, no…

(RAOUL has begun to walk, slowly and resolutely, towards the PHANTOM, the fireballs always landing just ahead of him)

PHANTOM
That's right, that's right,
Monsieur –
keep walking this way!

(Two more fireballs)

RAOUL
You can't win her love by making her your prisoner.

CHRISTINE
Raoul, don't…

RAOUL (to CHRISTINE)
Stay back!

PHANTOM
I'm here, I'm here,
Monsieur:
the angel of death!
Come on, come on,
Monsieur,
Don't stop, don't stop!

(Three more fireballs. RAOUL is almost at the PHANTOM's feet. A confrontation is imminent, when CHRISTINE suddenly rushes across to RAOUL)

CHRISTINE
Raoul! Come back…

(She pulls him away)

PHANTOM
Don't go!

(As they are exiting, the PHANTOM declaims in fury):

So be it! Now let it be war upon you both!

(At a gesture from the PHANTOM, there is a flash of lightning and the stage erupts into flame)

Scene Six

THE OPERA HOUSE ON THE NIGHT OF THE PREMIÈRE OF 'DON JUAN TRIUMPHANT'

(The orchestra is tuning. A whistle sounds – the CHIEF FIRE OFFICER is reviewing two FIRE MARSHALLS in tin helmets. A worklight on a stand illuminates them. Also present are RAOUL, ANDRÉ and FIRMIN, supervising the proceedings, and a MARKSMAN, at present hidden in the pit)

CHIEF
You understand your instructions?

FIREMEN (severally)
Sir!

CHIEF
When you hear the whistle, take up your positions. I shall then instruct you to secure the doors. It is essential that all doors are properly secured.

FIRMIN
Are we doing the right thing, André?

ANDRÉ
Have you got a better idea?

CHIEF
Monsieur le Vicomte, am I to give the order?

RAOUL
Give the order.

(The CHIEF blows his whistle. The FIREMEN fan out, leaving RAOUL, the CHIEF and the MANAGERS on stage)

RAOUL (to the MARKSMAN)
You in the pit – do you have a clear view of this box?

MARKSMAN (appearing from the pit)
Yes, sir.

RAOUL
Remember, when the time comes, shoot. Only if you have to – but shoot. To kill.

MARKSMAN
How will I know, sir?

RAOUL
You'll know.

FIRMIN
Monsieur le Vicomte, are you confident that this will work? Will Miss Daaé sing?

RAOUL
Don't worry, Firmin. André?

ANDRÉ
We're in your hands, sir.

CHIEF
My men are now in position, sir.

RAOUL
Go ahead, then.

(Sounding his whistle again, the CHIEF shouts into the auditorium):

CHIEF
Are the doors secure?

(Exit doors are slammed all over the building, the FIREMEN answering one by one: 'Secure!' The orchestra falls silent. Very quietly, from nowhere, we hear the VOICE of the PHANTOM)

PHANTOM'S VOICE
I'm here: The Phantom of the Opera…

(ALL look round apprehensively. FIREMEN start to run in the direction of the VOICE)

PHANTOM'S VOICE (from somewhere else)
I'm here: The Phantom of the Opera…

(Again, they follow the VOICE. This happens several times, the PHANTOM's VOICE darting more and more bewilderingly from place to place. Finally it is heard from Box Five, and in the confusion, the MARKSMAN fires a shot. RAOUL rounds on the MARKSMAN furiously)

RAOUL
Idiot! You'll kill someone. I said: only when the time comes!

MARKSMAN
But, Monsieur le Vicomte…

(The PHANTOM's VOICE cuts in, filling the building. All look up)

PHANTOM'S VOICE
No 'buts'! For once, Monsieur le Vicomte is right…

**Seal my
fate tonight – I
hate to have to
cut the fun short,
but the joke's
wearing thin…
Let the audience in…
Let my opera begin!**

Scene Seven

'DON JUAN TRIUMPHANT'

(The set of the final scene of 'Don Juan Triumphant'. A huge hall with an arch. Behind the arch, which has curtains, is a bed. A fine table, laid for two. PASSARINO, DON JUAN's servant, is directing the STAFF as they make the room ready. They are a crowd of sixteenth-century ruffians and hoydens, proud of their master's reputation as a libertine)

CHORUS
Here the sire may serve the dam, here the master takes his meat!
Here the sacrificial lamb utters one despairing bleat!

CARLOTTA AND CHORUS
Poor young maiden! For the thrill on your tongue of stolen sweets you will have to pay the bill – tangled in the winding sheets!

Serve the meal and serve the maid!
Serve the master so that, when
tables, plans and maids are laid,
Don Juan triumphs once again!

*(SIGNOR PIANGI, as DON JUAN, emerges
from behind the arch. MEG, a gypsy dancer,
pirouettes coquettishly for him. He throws
her a purse. She catches it and leaves)*

DON JUAN
Passarino, faithful friend,
once again recite the plan.

PASSARINO
Your young guest believes I'm
you –
I, the master; you, the man.

DON JUAN
When you met you wore my cloak,
with my scarf you hid your face.
She believes she dines with me,
in her master's borrowed place!
Furtively, we'll scoff and quaff,
stealing what, in truth, is mine.
When it's late and modesty
starts to mellow, with the wine…

PASSARINO
You come home! I use your voice –
slam the door like crack of doom!

DON JUAN
I shall say: 'come – hide with me!
Where, oh, where? Of course –
my room!'

PASSARINO
Poor thing hasn't got a chance!

DON JUAN
Here's my hat, my cloak and
sword.
Conquest is assured,
if I do not forget myself and
laugh…

*(DON JUAN puts on PASSARINO's cloak
and goes into the curtained alcove where the
bed awaits. Although we do not yet know
it, the Punjab Lasso has done its work, and
SIGNOR PIANGI is no more. When next we
see DON JUAN, it will be the PHANTOM.
Meanwhile, we hear AMINTA (CHRISTINE)
singing happily in the distance)*

AMINTA *(CHRISTINE – offstage,
entering)*
'…no thoughts
within her head,
but thoughts of joy!
No dreams
within her heart,
but dreams of love!'

PASSARINO *(onstage)*
Master?

DON JUAN *(PHANTOM – behind the
curtain)*
Passarino – go away!
For the trap is set and waits for
its prey…

*(PASSARINO leaves. CHRISTINE
(AMINTA) enters. She takes off her cloak
and sits down. Looks about her. No-one.
She starts on an apple. The PHANTOM,
disguised as DON JUAN pretending to
be PASSARINO, emerges. He now wears
PASSARINO's robe, the cowl of which hides
his face. His first words startle her)*

DON JUAN *(PHANTOM)*
You have come here
in pursuit of
your deepest urge,
in pursuit of
that wish,
which till now
has been silent,
silent…

I have brought you,
that our passions
may fuse and merge –
in your mind
you've already
succumbed to me,
dropped all defences,
completely succumbed to me –
now you are here with me:
no second thoughts,
you've decided,
decided…

6 Past the point
of no return –
no backward glances:
the games we've played
till now are at
an end…
Past all thought
of 'if' or 'when' –
no use resisting:
abandon thought,
and let the dream
descend…

What raging fire
shall flood the soul?
What rich desire
unlocks its door?
What sweet seduction
lies before
us…?

Past the point
of no return,
the final threshold –
what warm,
unspoken secrets
will we learn?

Beyond the point
of no return…

AMINTA *(CHRISTINE)*
You have brought me
to that moment
where words run dry,
to that moment
where speech
disappears
into silence,
silence…

I have come here,
hardly knowing
the reason why…
In my mind,
I've already
imagined our
bodies entwining,
defenceless and silent –
and now I am
here with you:
no second thoughts,
I've decided,
decided…

Past the point
of no return –
no going back now:
our passion-play
has now, at last,
begun…
Past all thought
of right or wrong –
one final question:
how long should we
two wait, before
we're one…?

When will the blood
begin to race,
the sleeping bud
burst into bloom?
When will the flames
at last, consume
us…?

BOTH
Past the point
of no return,
the final threshold –
the bridge
is crossed, so stand
and watch it burn…
We've passed the point
of no return…

*(By now the audience and the POLICE
have realised that SIGNOR PIANGI is dead
behind the curtain, and it is the PHANTOM
who sings in his place. CHRISTINE
knows it too. As final confirmation, the
PHANTOM sings)*

PHANTOM
**Say you'll share with
me one love,
one lifetime…
Lead me, save me
from my solitude…**

(He takes from his finger a ring and holds it out to her. Slowly she takes it and puts it on her finger)

**Say you want me
with you,
here beside you…
Anywhere you go
let me go too –
Christine,
that's all I ask of…**

*(We never reach the word 'you', for CHRISTINE quite calmly reveals the PHANTOM's face to the audience. As the FORCES OF LAW close in on the horrifying skull, the PHANTOM sweeps his cloak around her and vanishes.
MEG pulls the curtain upstage, revealing PIANGI's body garrotted, propped against the bed, his head gruesomely tilted to one side. She screams)*

*TRANSFORMATION TO:
REVERSE VIEW OF THE STAGE*

(POLICE, STAGEHANDS, etc. rush on to the stage in confusion. Also: ANDRÉ, FIRMIN, RAOUL, GIRY, CARLOTTA and MEG)

CARLOTTA
What is it? What has happened?
Ubaldo!

ANDRÉ
Oh, my God… my God…

FIRMIN
We're ruined, André – ruined!

GIRY *(to RAOUL)*
Monsieur le Vicomte! Come with me!

CARLOTTA *(rushing over to PIANGI's body)*
Oh, my darling, my darling… who has done this…?

(hysterical, attacking ANDRÉ)
You! Why did you let this happen?

(She breaks down, as PIANGI's body is carried off on a stretcher)

GIRY
Monsieur le Vicomte, I know where they are.

RAOUL
But can I trust you?

GIRY
You must. But remember: your hand at the level of your eyes!

RAOUL
But why…?

GIRY
Why? The Punjab lasso, Monsieur. First Buquet. Now Piangi.

MEG *(holding up her hand):*
Like this, Monsieur. I'll come with you.

GIRY
No Meg! No, you stay here!

(to RAOUL)
Come with me, Monsieur. Hurry, or we shall be
too late…

Scene Eight

THE LABYRINTH UNDERGROUND

(Meanwhile, down below, we see the PHANTOM and CHRISTINE in the boat, crossing the underground lake)

7 PHANTOM *(furiously propelling the boat onwards)*
**Down once more
to the dungeon
of my black despair!
Down we plunge
to the prison
of my mind!
Down that path
into darkness
deep as hell!**

(He rounds on her, bitterly)

**Why, you ask,
was I bound and chained
in this cold and dismal place?
Not for any
mortal sin, but the
wickedness of
my abhorrent face!**

(He hears the offstage voices of the pursuing MOB)

MOB *(offstage)*
**Track down this murderer!
He must be found!**

PHANTOM *(moving off again)*
**Hounded out by
everyone!
Met with hatred
everywhere!
No kind word from
anyone!**

**No compassion
anywhere!**

**Christine, Christine…
Why, why…?**

(RAOUL and GIRY appear above. They make their way down, meeting a pack of rats. GIRY screams and lowers her guard. The rats and the RATCATCHER pass them. GIRY raises her hand again)

GIRY
Your hand at the level of your eyes!

RAOUL
…at the level of your eyes…

MOB *(offstage)*
Your hand at the level of your eyes!

GIRY
He lives across the lake, Monsieur. This is as far as I dare go.

RAOUL
Madame Giry, thank you.

(She turns to go back up the slope. RAOUL looks at the water. He removes his coat and plunges in. The MOB appears at the top of the slope. They come down to the lake edge, their torches flickering)

MOB
**Track down this
murderer –
He must be found!
Hunt out this
animal,
who runs to ground!
Too long he's
preyed on us –
but now we know:
the Phantom of the Opera
is there,
deep down below…**

He's here: the Phantom of the Opera…

(They turn back up the slope. Perhaps there is another way in. The gate to the lair descends, as the rest of the lair appears)

Scene Nine

BEYOND THE LAKE

(The dummy of CHRISTINE sits crumpled on a large throne. The PHANTOM drags CHRISTINE roughly out of the boat. She frees herself and backs away as he stares blackly out front. Braving her terror, she addresses him fiercely)

CHRISTINE
**Have you gorged yourself
at last, in your
lust for blood?**

(No reply)

Am I now to be
prey to your
lust for flesh?

PHANTOM *(coldly)*
That fate, which
condemns me
to wallow in blood
has also
denied me
the joys of the flesh...
this face –
the infection
which poisons our love...

*(He takes the bridal veil from the dummy,
and moves slowly towards her)*

This face,
which earned
a mother's fear
and loathing...
A mask,
my first
unfeeling scrap of clothing...

(He places the veil on her head)

Pity comes
too late –
turn around
and face your fate:
an eternity of this
before your eyes!

*(They are almost touching. She looks
calmly and coldly into his face)*

CHRISTINE
This haunted face
holds no horror
for me now...
It's in your soul
that the true
distortion lies...

*(The PHANTOM suddenly senses RAOUL's
presence. Behind the portcullis, RAOUL
climbs out of the water)*

PHANTOM
Wait! I think, my dear,
we have a guest!

(To RAOUL)

Sir, this is indeed
an unparalleled delight!
I had rather hoped
that you would come.
And now my wish comes true –
you have truly made my night!

RAOUL *(pleading, grasping the bars of
the gate)*
Free her!
Do what you like,
only free her!
Have you no pity?

PHANTOM *(to CHRISTINE, dryly)*
Your lover makes
a passionate plea!

CHRISTINE
Please, Raoul, it's useless...

RAOUL
I love her!
Does that mean nothing?
I love her!
Show some compassion...

PHANTOM *(snarls furiously at RAOUL)*
The world showed no
compassion to me!

RAOUL
Christine...
Christine...

(To PHANTOM)

Let me see her...

PHANTOM *(dryly)*
Be my guest, sir...

*(He gestures, and the fence rises. RAOUL
enters)*

Monsieur, I
bid you welcome!
Did you think that
I would harm her?
Why should I make
her pay
for the sins which
are yours?

*(So saying, he takes the Punjab lasso
and, before RAOUL has a chance to move,
catches him by the neck. The end of the
rope, of which the PHANTOM has let go,
remains magically suspended in mid-air).*

(taunting)

Order your fine horses now!
Raise up your hand to the level
of your eyes!
Nothing can save you now –
except perhaps Christine...

(He turns to her)

Start a new life with me –
Buy his freedom with your love!
Refuse me, and you send your
lover to his death!
This is the choice –
This is the point of no return!

CHRISTINE *(to the PHANTOM)*
The tears I might have shed
for your dark fate
grow cold, and turn to tears
of hate...

RAOUL *(despairing)*
Christine, forgive
me, please forgive me...

I did it all
for you, and all for
nothing...

CHRISTINE *(looking at the PHANTOM,
but to herself)*
Farewell,
my fallen idol
and false friend...
One by one
I've watched
illusions shattered...

PHANTOM *(to CHRISTINE)*
Too late for
turning back,
too late for
prayers and
useless pity...

RAOUL *(to CHRISTINE)*
Say you love him,
and my
life is over!

PHANTOM
Past all hope
of cries for help:
no point in fighting –

RAOUL
Either way
you choose,
he has to win...

PHANTOM
For either way
you choose,
you cannot win!

So, do you end
your days with me,
or do you send
him to his grave?

RAOUL *(to PHANTOM)*
Why make her lie
to you, to save
me?

CHRISTINE
Angel of Music...

PHANTOM
Past the point
of no return –

RAOUL
For pity's sake,
Christine, say no!

CHRISTINE
...why this torment?

PHANTOM
...the final threshold...

– 152 –

RAOUL
Don't throw your life
away for my sake…

CHRISTINE
When will you see
reason…?

PHANTOM
His life is now the prize
which you must earn!

RAOUL
I fought so hard
to free you…

CHRISTINE
Angel of Music…

PHANTOM
You've passed the point
of no return…

CHRISTINE
…you deceived me –
I gave my mind
blindly…

PHANTOM *(to CHRISTINE)*
You try my patience –
make your choice!

(She reflects for a moment, then with resolution moves slowly towards the PHANTOM)

CHRISTINE *(quietly at first, then with growing emotion)*
Pitiful creature
of darkness…
What kind of life
have you known…?

God give me courage
to show you
you are not
alone…

(Now calmly facing him, she kisses him long and full on the lips. The embrace lasts a long time. RAOUL watches in horror and wonder.
The PHANTOM takes a lighted candle and holds it above RAOUL's head. A tense moment. But the suspended rope suddenly falls harmlessly – the PHANTOM has burnt the thread by which the noose was held. Resigned, he addresses RAOUL, as we hear the offstage voices of the approaching MOB)

MOB *(Some)*
Track down this
murderer –
he must be found!
Hunt out this
animal,
who runs to ground!

Too long he's
preyed on us –
but now we know:
the Phantom of the Opera
is there,
deep down below…

MOB *(Others)*
Who is this monster,
this murdering beast?
Revenge for Piangi!
Revenge for Buquet!
This creature
must never go free…

PHANTOM
Take her – forget me – forget all
of this…
Leave me alone – forget all
you've seen…
Go now – don't let them find you!
Take the boat – leave me here –
go now,
don't wait…
Just take her and go – before it's
too late…
Go…
Go now – go now and leave me!

(RAOUL and CHRISTINE move off towards the boat. The PHANTOM looks mockingly at his mask. The musical box starts up magically, and he listens to it)

Masquerade…
Paper faces on parade…
Masquerade…
Hide your face,
so the world will
never find you…

(CHRISTINE re-enters and walks slowly towards him. She takes off her ring and gives it to the PHANTOM)

PHANTOM
Christine, I love you…

(She hurries off. The PHANTOM puts the ring on his finger)

CHRISTINE *(In the distance, to RAOUL, as the boat pulls away in the shadow)*
Say you'll share with
me, one
love, one lifetime…
say the word
and I will follow you…

RAOUL
Share each day with me…

CHRISTINE
…each night…

BOTH
…each morning…

PHANTOM *(looking after her)*
You alone
can make my song take flight –
it's over now, the music of the
night…

(The PHANTOM walks slowly towards the throne. He takes his place on it, sitting on his cloak. The MOB, including MEG, appears above, climbing down the portcullis. As the MOB enters the lair, the PHANTOM wraps his cloak around himself and disappears. MEG crosses to the throne and picks up his mask in her small hand)

– 153 –

END OF ACT TWO

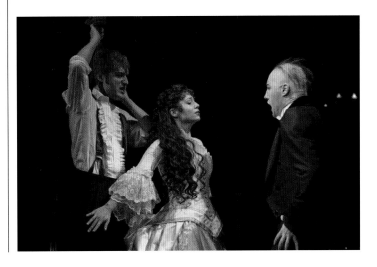

PHANTOM FACTS

THE PHANTOM OF THE OPERA IS A RECORD-BREAKING PRODUCTION
THAT IS NOW FAMILIAR TO AUDIENCES WORLDWIDE.

65,000
performances
worldwide

**Las Vegas:
Most expensive
Phantom
production**
Adding a production budget
of $35 million to $40
million to build the theatre

Canada
September 1989

United States
January 1988

Toronto:
Original production
10-year run

**Hollywood:
Final show in
18-year US tour**
The final curtain fell at
the Pantages Theater
in 2010

Mexico
December 1999

27
countries have
hosted *The Phantom
of the Opera*

**New York: Broadway's
longest-running show**
Landmark show was reached in 2006

Brazil
April 2005

Argentina
March 2009

130 million
tickets sold
worldwide

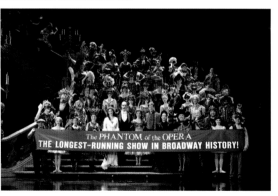

$5.6 billion
estimated worldwide
grosses

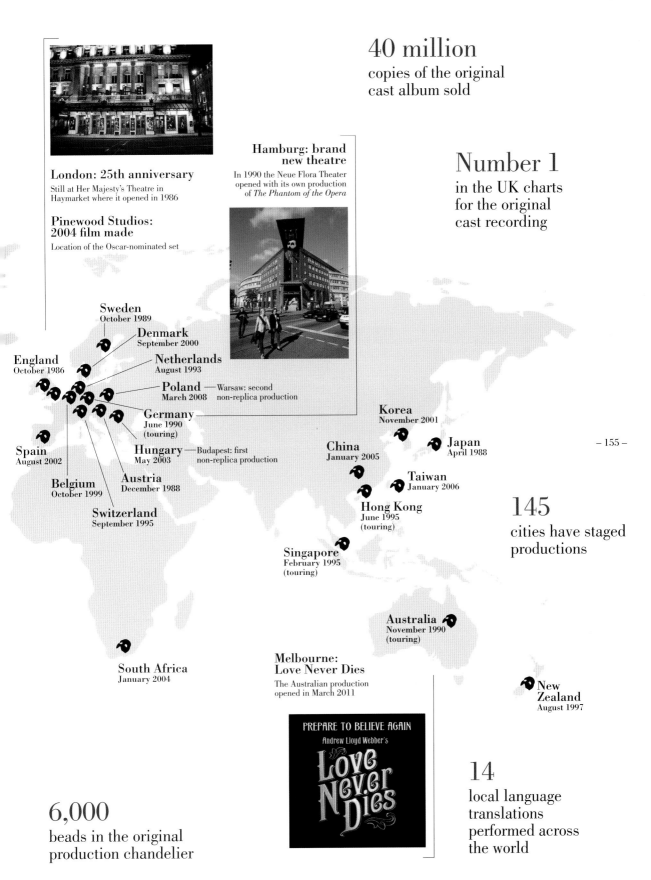

40 million
copies of the original
cast album sold

London: 25th anniversary
Still at Her Majesty's Theatre in
Haymarket where it opened in 1986

**Pinewood Studios:
2004 film made**
Location of the Oscar-nominated set

**Hamburg: brand
new theatre**
In 1990 the Neue Flora Theater
opened with its own production
of *The Phantom of the Opera*

Number 1
in the UK charts
for the original
cast recording

Sweden
October 1989

Denmark
September 2000

Netherlands
August 1993

England
October 1986

Poland — Warsaw: second
March 2008 non-replica production

Germany
June 1990
(touring)

Spain
August 2002

Hungary — Budapest: first
May 2003 non-replica production

Belgium
October 1999

Austria
December 1988

Switzerland
September 1995

Korea
November 2001

Japan
April 1988

China
January 2005

Taiwan
January 2006

Hong Kong
June 1995
(touring)

Singapore
February 1995
(touring)

145
cities have staged
productions

South Africa
January 2004

Australia
November 1990
(touring)

**Melbourne:
Love Never Dies**
The Australian production
opened in March 2011

**New
Zealand**
August 1997

PREPARE TO BELIEVE AGAIN
Andrew Lloyd Webber's
Love
Never
Dies

6,000
beads in the original
production chandelier

14
local language
translations
performed across
the world

THE PHANTOM OF THE OPERA TIMELINE

The history of the Phantom begins with Gaston Leroux's Nineteenth-Century Gothic novel. Varoius interpretations in film take the story from the silent classic of 1920s through glorious technicolor of the mid century, to rock opera in the 1970s. In the 1980s Andrew Lloyd Webber is struck by the romance of the tale and the story of the Phantom as we know it today begins.

The Phantom of the Opera through the decades

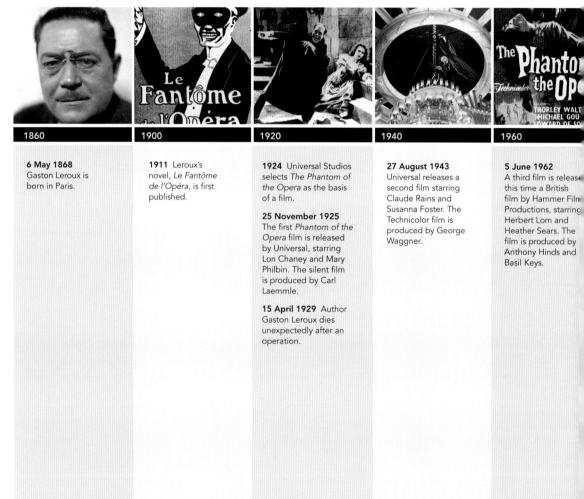

1860	1900	1920	1940	1960

6 May 1868
Gaston Leroux is born in Paris.

1911 Leroux's novel, *Le Fantôme de l'Opéra*, is first published.

1924 Universal Studios selects *The Phantom of the Opera* as the basis of a film.

25 November 1925 The first *Phantom of the Opera* film is released by Universal, starring Lon Chaney and Mary Philbin. The silent film is produced by Carl Laemmle.

15 April 1929 Author Gaston Leroux dies unexpectedly after an operation.

27 August 1943 Universal releases a second film starring Claude Rains and Susanna Foster. The Technicolor film is produced by George Waggner.

5 June 1962 A third film is released, this time a British film by Hammer Film Productions, starring Herbert Lom and Heather Sears. The film is produced by Anthony Hinds and Basil Keys.

1980	1990	2000	2010

1984 Ken Hill stages a production at the Theatre Royal, Stratford East.

1985 Lloyd Webber and producer Cameron Mackintosh debut a rough draft of the first act to a select audience at a festival in Sydmonton.

5 July 1986 Several songs were premiered at Sydmonton.

9 October 1986 *The Phantom of the Opera* debuts in the West End starring Michael Crawford and Sarah Brightman in the lead roles of the Phantom and Christine Daaé respectively and Steve Barton as Raoul. Directed by Harold Prince, at Her Majesty's Theatre.

26 January 1988 The show opens at New York's Majestic Theater with original cast members Crawford, Brightman and Barton reprising their original roles.

22 April 1988 *The Phantom of the Opera* opens in Japan.

31 May 1989 *The Phantom of the Opera* opens in Los Angeles where it runs for four years and then transfers to San Francisco.

20 September 1989 *The Phantom of the Opera* opens in Toronto.

1990 Discussions about a sequel to the story begin.

2 June 1990 The second US tour of *The Phantom of the Opera* opens in Chicago and ends in Los Angeles in November 1998.

18 December 1990 *The Phantom of the Opera* opens in Melbourne.

13 December 1992 The third US tour of *The Phantom of the Opera* opens in Seattle. It closed in October 2011, having toured continuously for almost 18 years and given 7,283 performances in 167 engagements in 76 cities.

15 August 1993 *The Phantom of the Opera* opens in Scheveningen. It played for 1,094 performances and became the longest running show in the Netherlands.

19 October 1993 First UK tour of *The Phantom of the Opera* opens in Manchester.

9 October 1996 The original London production of *The Phantom of the Opera* celebrates its 10th anniversary.

February 2002 *The Phantom of the Opera* wins the Laurence Olivier Award for the Most Popular Show.

1 June 2003 Non-replica production of *The Phantom of the Opera* opens in Budapest.

10 December 2004 Produced by Lloyd Webber, *The Phantom of the Opera* film is released in the UK and US. The adaptation of the Lloyd Webber musical is directed by Joel Schumacher. The film stars Gerard Butler as the Phantom and Emmy Rossum as Christine.

18 December 2004 *The Phantom of the Opera* opens at the Shanghai Grand Theatre.

20 April 2005 *The Phantom of the Opera* opens in São Paolo.

24 June 2006 Harold Prince re-directs *Phantom – The Las Vegas Spectacular* in a theatre built specifically for the show at a cost of $40 million.

17 March 2008 Non-replica production of *The Phantom of the Opera* opens in Warsaw.

9 March 2010 *Love Never Dies*, Lloyd Webber's sequel to *The Phantom of the Opera*, debuts in the West End.

23 October 2010 Still at Her Majesty's Theatre, *The Phantom of the Opera* celebrates its 10,000th performance in the West End.

2 January 2011 *The Phantom of the Opera* on Broadway breaks its own weekly box office record, grossing $1.39 million.

21 May 2011 *Love Never Dies* opens at Melbourne's Regent Theatre in Australia.

1 & 2 October 2011 Three special performances of *Phantom of the Opera at the Albert Hall* at London's Royal Albert Hall mark the 25th anniversary.

9 October 2011 The 25th birthday of the original London production.

26 January 2012 *The Phantom of the Opera*'s New York production celebrates its 24th anniversary.

CREDITS

94 Designed by Dewynters/Really Useful Group Limited
95 Courtesy of Transworld Publishers
96 left Catherine Ashmore/Really Useful Group Limited
96 right Jeff Busby/Really Useful Group Limited
97 top Catherine Ashmore/Really Useful Group Limited
97 bottom James Curley/Rex Features
98-101 Jeff Busby/Really Useful Group Limited
102 Alex Bailey/Really Useful Group Limited
104 top Rex Features
104 bottom Universal/The Kobal Collection
105 Redferns/Getty Images
106 top Everett Collection/Rex Features
106 bottom Bettman/Corbis
107 top Photos 12/Alamy
107 bottom The Kobal Collection
108 MovieMagic/Alamy
109 Photos 12/Alamy
110-118 Alex Bailey/Really Useful Group Limited
119 top Frederick M. Brown/Getty Images
119 bottom Kevin Winter/Getty Images
120-121 Alex Bailey/Really Useful Group Limited
122-153 Michael Le Poer Trench/Cameron Mackintosh Ltd.
154 top Designed by Dewynters/Really Useful Group Limited
154 bottom Joan Marcus/The Phantom Company
155 top left Olyn Blair/Alamy
155 top right World Pictures/Photoshot
155 bottom Really Useful Group Limited
156 left Martinie/Roger-Viollet/Getty
156 centre left Kharbine-Tapabor/Jean Vigne/The Art Archive
156 centre AF archive/Alamy
156 centre right Photos 12/Alamy
156 right MovieMagix/Alamy
157 left Clive Barda/ArenaPAL
157 centre left Alan Davidson
157 centre right Alex Bailey/Really Useful Group Limited
157 Designed by Dewynters/Really Useful Group Limited
160 Alan Davidson

Michael Heatley has contributed to many rock music encyclo-pedias, including *The Virgin Encyclopedia of Rock* (1996), and music biographies. He has written for magazines including *Music Week*, *Billboard* and *Record Collector*. His most recent titles for Anova include *Music That Shook The World* (2008), *Stars and Guitars* (2010) and *The Girl in The Song* (2010). The author would like to thank Sam Owens for her valued assistance.

Portions of text are based on George Perry's 1987 book, *The Complete Phantom of the Opera*, with permission

This edition first published in the United Kingdom in 2012 by
Pavilion Books
10 Southcombe Street
London W14 0RA

An imprint of Anova Books Company Limited

Text © Pavilion Books and The Really Useful Group
Limited 2011, 2012
Design and layout © Pavilion Books 2011, 2012

Reproduction by DOT Gradations Ltd, UK
Printed and bound by 1010 Printing International Ltd, China

Commissioning editor Fiona Holman
Editor Tamsin Perrett
Designer Briony Hartley
Picture editor Jennifer Veall

www.anovabooks.com

Every effort has been made to obtain permission from all image copyright holders. If any information is incorrect, please contact the publishers.

Overleaf: Michael Crawford as the Phantom and Sarah Brightman as Christine lead the cast in a curtain call on Broadway, 1988.

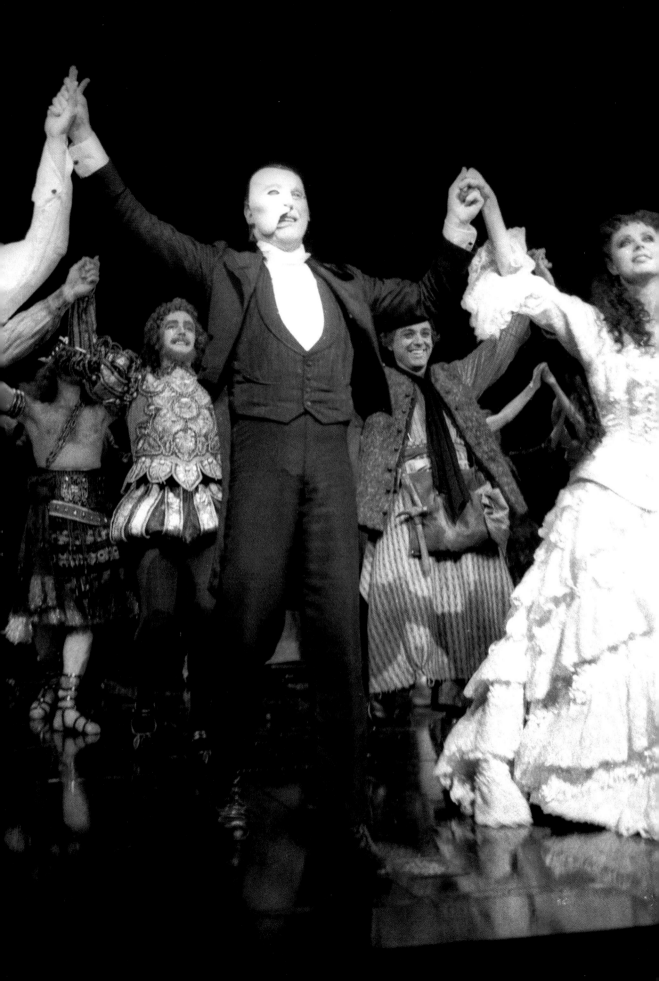